Wild Vision

In Celebration of the Natural World

By John Beatty

Vertebrate Publishing, Sheffield.
www.v-publishing.co.uk

Wild Vision

In Celebration of the Natural World

VP Vertebrate Publishing – Crescent House, 228 Psalter Lane, Sheffield S11 8UT.
www.v-publishing.co.uk

First published in 2011 by Vertebrate Publishing, an imprint of Vertebrate Graphics Ltd.
Text and images Copyright © John Beatty 2011.
Foreword Copyright © Jim Perrin 2011.

John Beatty has asserted his rights under the Copyright, Designs and Patents Act
1988 to be identified as author of this work.

www.wild-vision.com

A CIP catalogue record for this book is available from the British Library.

ISBN: 978-1-906148-29-4
10 9 8 7 6 5 4 3 2 1

Front cover image: King Penguin *Aptenodytes patagonicus*. Colourful throat markings
relate to adult maturity and nuptial attraction. Volunteer Point, Falkland Islands.

Back cover image: Aerial dawn photograph of complex barchan sand dunes in
Sossusvlei, Namib Naukluft Desert, Namibia.

For my wild ones,
Robin Beatty and Jodie Beatty

&

for my beloved late sister Pauline Hampson,
who knew *otherness* in nature.

Every effort has been made to obtain the necessary permissions with reference to
copyright material, both illustrative and quoted. We apologise for any omissions in
this respect and will be pleased to make the appropriate acknowledgements in any
future edition.

VG Designed and typeset in *Adobe Garamond* and *The Sans* by Nathan Ryder –
Vertebrate Graphics Ltd, Sheffield. www.v-graphics.co.uk

Printed and bound in Slovenia by Latitude Press Ltd.

CONTENTS

'With experiences we can go into another
world, and come back.'
GEORGE MALLORY (1886–1924)

FOREWORD

'It is not what you look at, but what you see.'

Henry David Thoreau

The path climbed at a slight tangent alongside waterfalls to the Bealach Arnasdail. When I reached the pass, dense cloud that had stalked across Loch Hourn from Ladhar Bheinn swallowed me up, and with it every object hitherto in view. There was no option but to check the general direction of the sole ascending path against the compass every so often, and climb on into the mist. You can regard this as inconvenience, or as a gift, and I would rather view it as the latter. At times like these you focus down on the angel in the detail of a landscape. Even on these at-first-glance-barren slopes, there was much to see. There were blue globes and green seed-heads like tiny green mace of sheep's bit. The elegantly curved and lined leaf-arrangements of northern rock-cress grew in astonishing profusion; hawkweed waved jauntily; red flowering grasses; thyme with tiny purple flowers spreading overall; tormentil starring the grass; the sedums and saxifrages and moss-campion; frills of sage-green lichen on the rocks as I climbed higher.

For the ear, too, riches: there was the astonishing silence of the Scottish Highlands as compared to more popular and southerly hill-regions. Perhaps there came the occasional hiss of air through a raven's pinions, or the sound of water flowing, or a brief slither of loosened stone; but otherwise, all was quiet. Along a lofty summit ridge to the broken Ordnance Survey column and cairn of Beinn Sgritheall, with the sense of narrowness and of the drops on either side, and nothing but the intimate and the immediate to be seen, the cloud momentarily lightening above, a glow of veiled sunlight, a suggestion almost of blue, there came that sense and promise of immanence, of the inhering good – of a more-than-merely-physical presence, that brings us back to our hills and wild places time and again.

We are talking dimensions of experience here. You might argue that they are individual, subjective. I would posit their potential aspect. This day in the Western Highlands – surely the loveliest place in creation (were it not for the midges) – I had a companion with me and throughout our climb this companion griped and wailed. 'Nothing to be seen' was the burden of the complaint. There was plenty to be seen, though what might have been expected was not available to view. In every object within our field of vision there was a certain magic, and mystery too, and thus also with evidence from the other senses.

If there is one photographer who could capture the intense emanation of every object I saw that day,

the way its inherent quality registered and rooted in my consciousness, it is John Beatty. Through his technical skill as a photographer, which is very great, and through a marvellous acuity of vision, he has the capacity to render his subjects with a transfiguring intensity in which the hitherto-unperceived essence shines through. To return to that notion of gift, he allows us to see objects, places, animals, birds, as though anew or for the first time. The cloudiness of our vision for once, through these images, is scoured away, and we focus down on the inhering glory.

Do not doubt how remarkable is this bounty.

To concentrate for a moment on the nature of mist – its misleading properties, its capacity to confound expectation, its tendency to obscure – I'm reminded of Gwydion the trickster in the medieval Welsh tales, and his ruse of casting cloaks of mist in order to deceive, confound, secure his own ends. He has survived into our contemporary worlds and cultures, where his name is legion. Let us consider, for example, the recent preoccupation with the notion of 'wild' – the proliferation of books with this word embedded in their titles; written by those of scant knowledge. Written by those whose acquaintance with the wild is seldom more than notional and brief. Clearly they signify a human need – for directness of experience

unmediated by sophistication. But they seldom come close to its authentic expression. I'm reminded here of one of the later critical books by the great twentieth-century American man-of-letters Lionel Trilling. It's entitled *Sincerity and Authenticity*, and the collocation, the co-dependence, of those two concepts is masterful. Without authenticity, there is no sincerity. Scan through that glut of recent books on the wild and you will be hard-pressed to find the rich, true, rigorous, long-pursued records of authentic experience that alone give authority and insight. Scan through the images in this present volume and they inhere in every one.

These recorded moments garnered from a lifetime's promiscuous wilderness experience, the life-essence leaping from every single frame, are authenticity's very testimony. They are the life-work of a man whose whole career and purpose has been committed to recording the wild, the natural, the beautiful – the work of a man who knows his subject through and through and has given it his most painstaking attention through decade after decade of increasing familiarity and knowledge. Ask this man where the dotterel breeds and he will show you; ask him where the white hare – *lepus timidus* – runs, and he may take you there – does take you there with his camera and the vision it enshrines; ask him about the seethe of life at the

floe-edge in Lancaster Sound as the earth tilts beyond the equinox ever more rapidly towards the light, and he will tell you. As few can or could.

And you, if you have come to appreciate authenticity – if you have learnt to put self aside and bestow the gift of attention on the immanent beauty of the world we inhabit – if you have opened your eyes and pierced the mists – will find much between these covers that wisely, knowingly, celebrates; and thus gladdens the heart.

Jim Perrin
Ariège, January 2011

INTRODUCTION

The silver light of altitude, then boundless space, dimmed in an instant. A familiar shudder rattled the overhead lockers as we descended through grey Pennine weather. Deltas of rain streamed across my window.

'*Cabin crew, eleven minutes to landing.*'

We made the final approach to Manchester Airport over Dove Dale. Far below, indistinct glimpses of green became a living map, known to me from childhood, one that has taught and inspired me for half a century.

I searched for more detail in the landscape. The unmistakable circular mounds and ditches of Arbor Low appeared.[1] Shadowless below the pall, but strangely prominent from the air, this Neolithic wonder of The Peak remains testament to man's former close relationship with nature. To a period of history when the land was harshly demanding, populous with spirits; to a time when man was searching for meaning in the landscape and the heavens alike. Beyond the field-wall patterns, and the sheep flocks and the farms, are the vast and scarifying pits of Buxton's limestone quarries, crude excavations eating away into coral reefs of geological ages. The tawny grass ridges of Shining Tor and Lyme Park appear below, evoking a landscape

of memories and childhood explorations, early wanderings with a burgeoning thirst for adventure tugging at my heart. Lantern Wood with its ghostly tower for hide-and-seek, Park Moor and the 'secret valley' all enraptured me as a child; learning the names of a countryside overflowing with living things. Here was where I played; making dams in the stream, collecting stones and seeds, antlers and toadstools, to take home and to identify with books.

A heavy clunk signalled the lowering of the undercarriage. We skimmed heather moorland – the high plateau of Kinder Scout, its dark blanket bog like a living sponge, defined around its edges by rocky outcrops, escarpments as familiar as close friends: Crowden Tower, Sandy Heys, Ashop Head, William Clough, whose gullies and wind-fretted tors have both challenged and sheltered me along the apprentice's road to climbing and mountaineering.

All my life I have tried to be an observer, to be aware of other lives around me. Freedom to wander and play during my childhood was probably the crucial factor in this. There was little contact with television, no computers, no internet, no electronic games. Just a bicycle, a fistful of raw runner beans, sixpence in my

(1) *Arbor Low: A Guide to the Monuments* (Peak Park Joint Planning Bd, 1996). ISBN: 090754374X.

pocket and all day to build dens or rafts and finally wander home caked in mud. All I wanted were the small and marvellous adventures of childhood, and the freedom of woods and ponds and ditches near home. By the time I was a student teacher, playing outdoors had become altogether more serious. Rock climbing, potholing, and long energetic mountain walks were increasing my thirst for engaging more closely with nature.

During my ten years of teaching in the geography and PE departments of a Cheshire comprehensive school, holiday mountaineering exploits tightened their grip on my imagination. The thrill of running power-fully over long mountain skylines, pulling strongly up rock faces, or leaning into the biting north wind of a February Scottish summit were experiences so visceral and alluring, I wanted more… and so decided to forego teaching, leave behind what had been a very happy time, tighten my belt and make a more connected life to the source of these stirrings, connected to nature.

In 1981 I applied to the British Antarctic Survey to work as a general assistant on a geological field science programme. Each year the Natural Environment Research Council create only a handful of positions such as this for mountaineers familiar with travelling in heavily-glaciated mountain terrain.[2] Being in Antarctica for seven months changed my life. The isolation from modern communications, the critical navigation and decision making in remote, unmapped mountain glaciers, was the intense experience I needed.[3] To be immersed in nature and science, weather, topography and such amazing wildlife encounters helped my understanding in ways independent from the conventional outside world. Here was a self-balanc-ing ecosystem utterly dependent on ocean currents below and layers of atmosphere above – a living entity vulnerable to the slightest changes of temperature induced by effects that originated thousands of miles away, an accelerating vulnerability as old technologies failed to take heed of their impact on the environment.

I was living in a crisis-hit frozen paradise, and that focused all my future thinking around the importance of safe-guarding vulnerable habitats, wherever they might be.

At the end of the 1980s I began to accompany and tutor on photographic holidays with a small English company run by Alfred and Suzanne Gregory – both of them outstanding photographers. 'Greg', as he was familiarly known, led the trips. He had climbed to within a stone's throw of the summit of Everest two days before Hillary and Tenzing made the first ascent. His Everest portfolio became world-renowned (and is still widely reproduced) as the finest visual record of the successful 1953 Everest expedition.[4] Greg became an inspiring friend who had a huge influence on my early development as a professional photographer. Another significant mentor was the mountain photographer Galen Rowell. Equally at home with both words and images, Galen created a welcome new link between the conservative and elite photo-forums and the leading adventure and nature publications of the day.[5]

(2) During the 1970s I gained experience in alpinism through five summer seasons climbing classic alpine routes in France and Italy, and in 1978 I made an early traverse of the Cuillin Mountains of Skye in full, hard winter conditions, at that time regarded an important mountaineering achievement. (3) Field operations in Antarctica are initiated by research scientists at the Cambridge headquarters of the British Antarctic Survey, then each expedition is controlled on-site by base commanders at the field operation bases in Antarctica. I was stationed at Rothera Point on Adelaide Island. Each summer season around six field parties were active from each base, entailing snow scooter journeys (or previously by dog sled) for a three-month duration into the remote glacial landscape of the Antarctic Peninsula. In 1981 the Natural Environment Research Council gave every field assistant and officer in the Survey an allowance of one message of 300 words via telex per month to be radioed back to the UK to a relative or friend. All contracts were issued for a minimum of nine months duration. (4) A classic account of the successful first ascent of Everest was written by Alfred Gregory, *Alfred Gregory's Everest* (Constable, 1993). ISBN: 0094722404. See also Gregory's life's work: Alfred Gregory, *Photographs from Everest to Africa* (Viking, 2008). ISBN: 9781920989613. (5) Galen Rowell championed small, single lens reflex (SLR) cameras, considering them more appropriate for expedition and remote travel, and in doing so he challenged the prosaic attitudes that existed in art photo circles. His commentaries on the philosophy and techniques of outdoor photojournalism are widely considered and applauded. Recommended reading is his best-selling book *Mountain Light* (Sierra Club Books, 1986). ISBN: 9780871563675 (current edition).

Through expeditions and journeys made over twenty-five years, I always carried a camera, and began to experiment with photographs that reflected the connections and relationships experienced in the harshest of elemental places. One particular expedition, crossing the inland ice cap of Greenland in 1981, was the most exacting mental hardship I had ever encountered. With no means of communication, our team man-hauled sledges for forty-four days across a landscape of solid ice to celebrate the centenary crossing by Fridtjof Nansen.[6] On an utterly remote skerry in the western approaches of the Atlantic I lived with reserved and watchful Scottish-Gaelic islanders, to witness a spectacular, traditional and sustainable harvest of seabirds.[7] On Baffin Island in the high Arctic, black water came down from the north, suddenly and violently, as we observed the mysterious narwhal gliding silently along by the shingle beach. I collected polished pebbles from the labyrinths of echoing canyons of Colorado, and caught the stench of noxious gasses hissing from rivers of molten magma high on an Icelandic glacier. I took counsel from the quiet grace of albatross in the Falklands. I fought for my life in a mountain storm in the Italian Alps. These are ways I wish to engage with the natural world, to understand the world, to feel I belong. The stories herein recall the sense of enchantment and wonder that happen when one is most committed and alert, and the times when I listen quietly and nature speaks to me. We live in times of extreme environmental change and invasive media, when there are so many erosive forces that threaten our sense of belonging. It is vital – more than ever – to preserve our identification with place through imaginative and creative processes.

If I see clouds in the distance I imagine that they are ranges of light snowy summits that I might reach in a long day's walk across the moors above my home. Clouds can appear like huge mountains that make human ingenuity appear minute beside the immensity of nature. These mountains rise up to fill the need for a recollection of wildness from a world bounded by the human struggle. This is why the mountainside makes us feel free. It has always made me feel free. I am happiest on the high slopes of a hill, as the wind rounds up, and the vistas explode on all sides, having climbed upward into the lonely openness.

(6) Fridtjof Nansen, *The First Crossing of Greenland* (Birlinn, 2003). ISBN: 9781841582160. A new edition of Nansen's classic text from 1890. (7) John Beatty, *Sula: Seabird Hunters of Lewis* (Michael Joseph Ltd, 1992). ISBN: 0718136349. An account of my expedition.

Occasionally I have encountered etchings of shapes and signs in rocks, cave walls and tree trunks – ancient art that clearly communicates visual memories, events and symbols. These artists were expressing a landscape-rooted narrative of their lives. A sun, a baby, a tree, a wild animal revered or hunted, once etched in stone becomes a timeless story, engaging our curiosity. These images are of real worlds that existed for living peoples, who needed to communicate urgently – inwardly with their eyes, outwardly with their hands – seeing with the eye, the hand, the heart. Landscape and memory are witnesses to the birth of storytelling.

My own visual explorations slowly began to express a more intimate dimension, concerned more with the inner journey than its outward response. The beauty I discovered, and the sense of otherness in nature, caused me to review my own feelings about the value and meaning of life itself. A life in photography offered a way to return the gift I was receiving, which was entry to the path of wonder and healing.

The plane dipped over brown industrial complexes and endless houses, chimneys, churches, parks, trees. Tiny people below were driving, walking, moving endlessly about their lives. I would drive back over the brown moors to my home, to loving people, a quiet centre, a place to belong.

Outside now, the soft evening light courses across the honey heather slopes of the black moor. I switch off the computer. The hills will be consumed in the darkness of night. The wild moor looms within me. The wild out there is the wild within.

This book is a collection of personal visual essays that try to express some of the heart and spirit and immediacy of experiences and encounters in the natural world. In them, I have tried to discover a voice that speaks for the earth. And itself is rooted in the land.

John Beatty
Bamford, January 2011

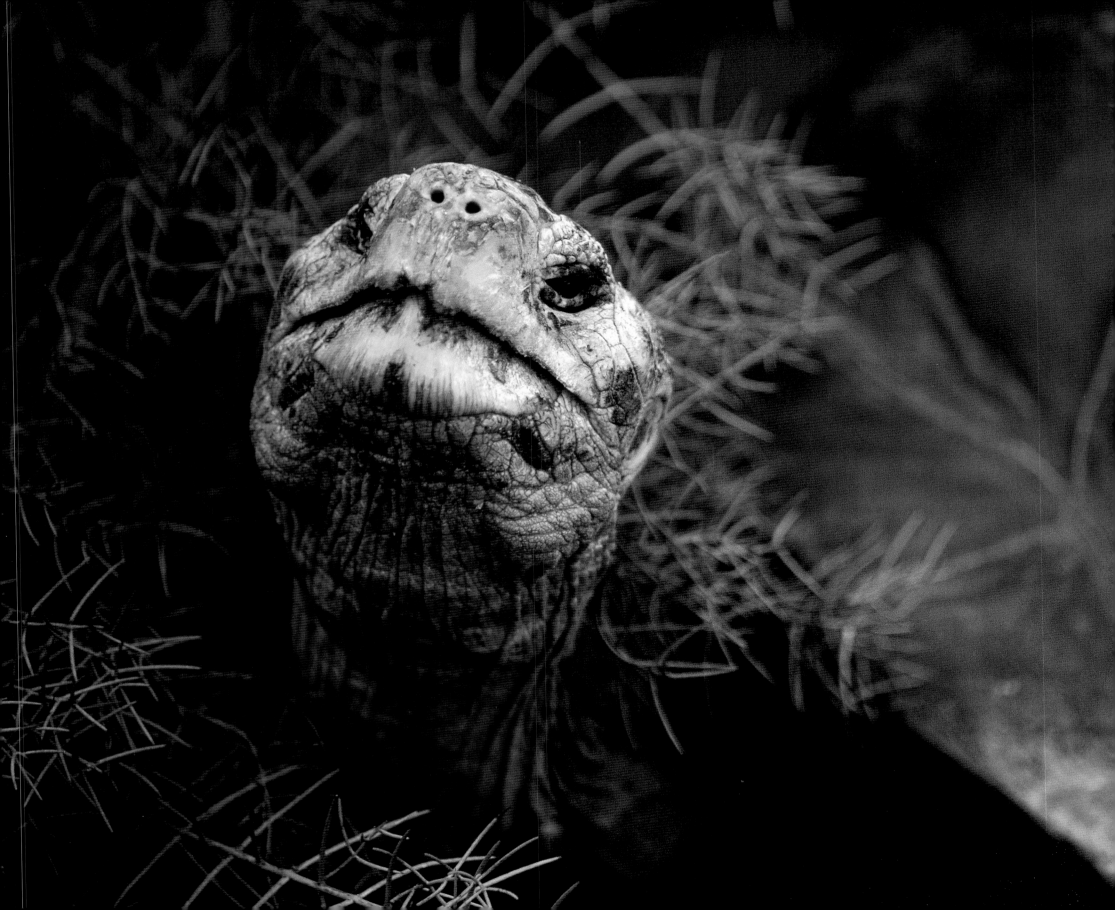

CHAPTER 1

Origins and Species

'Devoted from my earliest youth to the study of nature, feeling with enthusiasm the wild beauties of a country guarded by mountains and shaded by ancient forests, I experienced in my travels, enjoyments which have amply compensated for the privations.'

FROM *EQUINOCTIAL REGIONS OF AMERICA*
BY ALEXANDER VON HUMBOLDT (1769–1859)

PLATE 01

Giant Galápagos Land Tortoise *Chelonoidis nigra* is a relict survivor of its isolation high on the remote volcanic craters of the islands. Charles Darwin famously identified shell variations in each island population. Alcedo Crater, Isla Isabela, Galápagos Islands.

I began my own personal explorations of South America in 1981. They were to lead me from the Atlantic to the Pacific Ocean in a series of opportunities that have been an inspiring and unforgettable part of my life as a photographer of wild places. This chapter contains stories from my experiences in Patagonia, Amazonas, Chile, on the Falkland and Galápagos Islands, and along the mysterious Parana River.

In the fifteenth century European maritime nations began to explore the world by sending out expeditions both east and west across oceans to discover, chart and claim new territories, searching for the wealth of new resources and setting up trade routes. This Age of Discovery, as it has been called, began in 1519 when Ferdinand Magellan, the Portuguese explorer and master navigator, landed in Patagonia, discovering wild tribes of local Tehuelche Indians hunting flocks of guanaco across the pampas and foothills of the inland mountains. His expedition became the first to find a passage from the Atlantic to Pacific oceans through what became known as the Strait of Magellan.

On the expedition's return from making the first circumnavigation of the world, word spread rapidly about the possible riches of South America. Further explorations followed by Jesuit missionaries, and then

Spanish Conquistadors who made expeditions across the whole region with an undisciplined army of soldiers, explorers and adventurers. Their overwhelming dominance and eventual destruction of the indigenous Empires of Incas and Aztecs was led first by Cortes and then Pizarro. European diseases, such as smallpox, influenza and bubonic plague, were introduced to remote populations and were much more fatal than the wars, devastating previously isolated native peoples.

Between 1799 and 1804, Alexander von Humboldt, a German naturalist and geographer, sailed to the Venezuela and Columbia regions of the north (called at the time, New Granada). He explored the interiors of both countries, collecting flora and fauna, and his observations about similarities with the coast of west Africa suggested early theories of plate tectonics. Humboldt's work was noted and regarded by a young Charles Darwin.

It was not until 1831, during a heightened interest in these remote countries, that Captain Robert Fitzroy, newly appointed master of HMS Beagle, required a geologist to accompany an expedition to circumnavigate and chart the coastline of South America. The geologist's name was Charles Darwin, who at the time was finishing his university degree in Natural Theology at Christ's College, Cambridge. Darwin, already impressed by

the new works on natural philosophy by John Herschel, had gained a small reputation for collecting beetles and was fascinated by the proposition that the biblical creation of the world was probably a natural process controlled by the hand of God. This appealed to Fitzroy, who was intent on Christianising everyone he came into contact with, therefore he sought Darwin as both a young exciting scientist and complimentary travelling companion.

The journey lasted five years. Darwin spent most of his time ashore collecting specimens – rocks, plants and creatures – many of which were clearly new to science. He proposed fanciful explanations about his observations in a series of detailed notes in an appendix to Fitzroy's journal, *Narrative of the Surveying Voyages of His Majesty's Ships Adventure and Beagle*. Darwin's notes constituted the third of four volumes and were called *The Voyage of the Beagle, Journal and Remarks, 1832–1835* published in 1839. After the famous landings in the Galápagos Islands where he observed anomalies in the traits of surviving species, he compared these with comments made by Herschel later in Cape Town that '*that mystery of mysteries, the replacement of extinct species by others*' as '*natural in contradistinction to a miraculous process.*'

When organising his notes as the ship sailed home, Darwin wrote that if his growing suspicions about the mockingbirds, and the tortoises of Galápagos were correct, '*such facts undermine the stability of Species.*' Later, he famously wrote that such facts '*seemed to me to throw some light on the origin of species.*'[1]

(1) Charles Darwin, *On The Origin of Species by Means of Natural Selection, or the Preservation of Favoured Races in the Struggle for Life* (London: John Murray, 1859). ISBN: 1435393864. Darwin published his most famous work after 23 years of struggle, doubts, contemplation and further research.

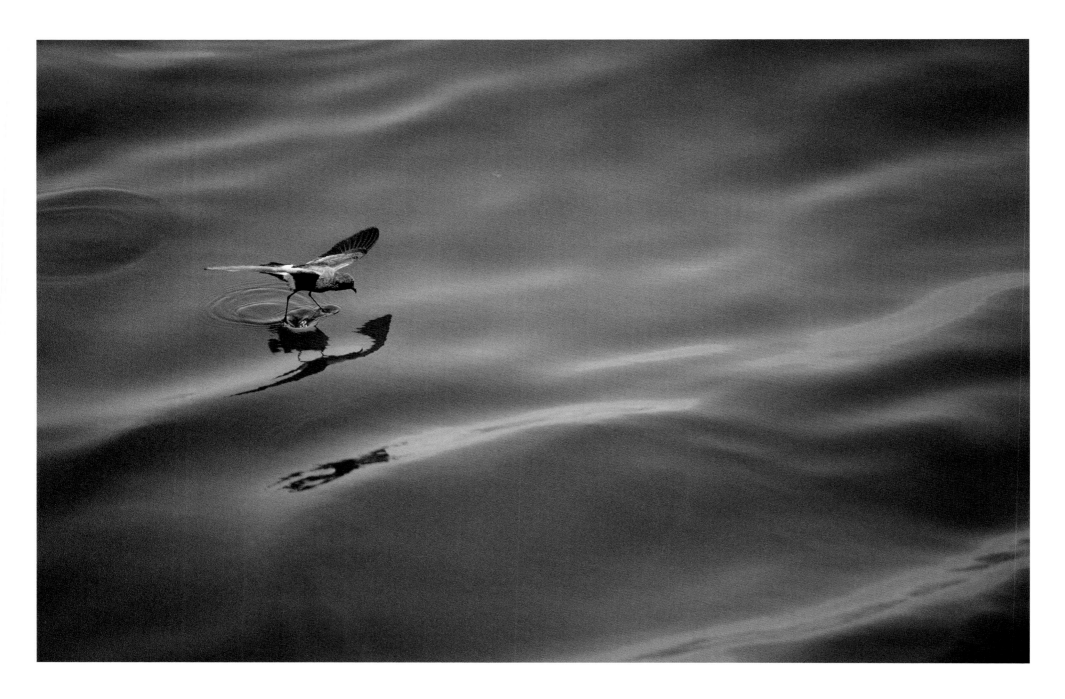

PLATE 02

White-vented or Elliot's Storm Petrel *Oceanites gracilis* feeds by dancing on the sea surface collecting tiny floating plankton and organic oils. Latitude: 0°40'0" S Longitude: 90°33'0" W. Central Pacific Ocean, near Galápagos Islands.

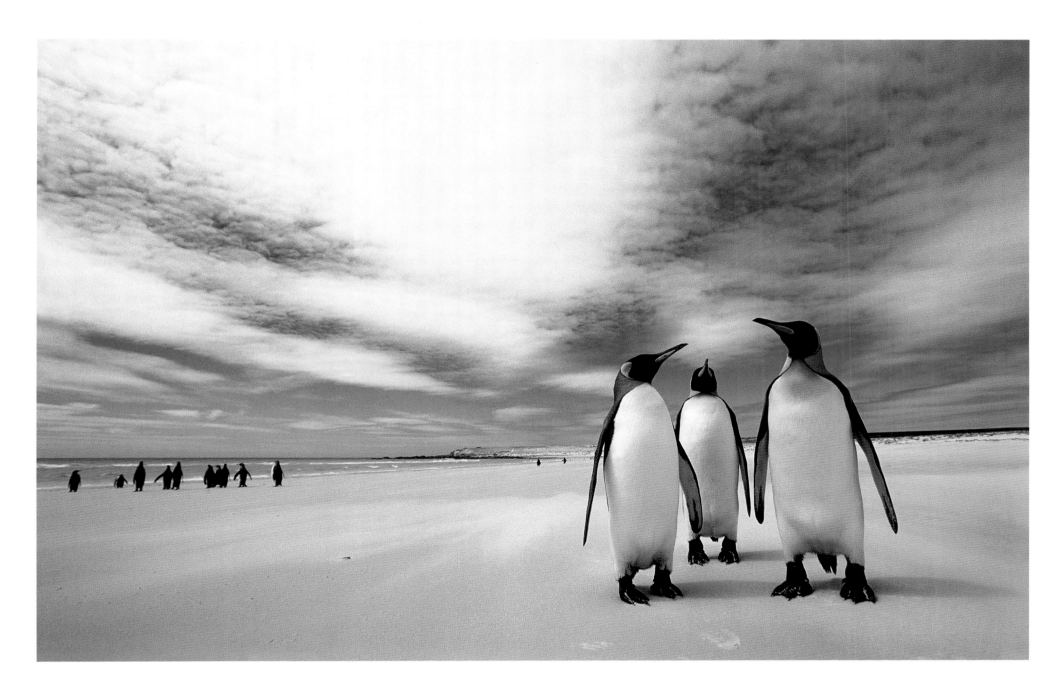

PLATE 03

King Penguins *Aptenodytes patagonicus* gather annually to breed in large numbers at Volunteer Point, a remote peninsula shoreline in East Falkland, Southern Ocean.

FALKLAND ISLANDS

Our small brave boat the RRS John Biscoe heaved itself over every crest as the rhythmical shudder of the droning propeller churned the grey waters astern. Below decks I could hear Mike singing his sea shanties and Nige's melodeon breathing a melancholy tune amidst the deep clanging of the bow chain in the forecastle.

After two days at sea from the desert sunshine of the Argentine coast, petrels and albatrosses began to visit us. At first the more common black-browed, then an occasional light-mantled sooty. With eyes constantly searching a horizon of mountainous seas, we knew that the great prize was a glimpse of a wandering albatross, the most majestic flyer of all, but these rarely appear north of southerly latitude sixty. With the decks awash with heavy spray, the thin dark line on the horizon hinted at our imminent arrival at the desolate ocean outpost of Port Stanley in the Falkland Islands. I was arriving as a general field assistant bound for the Antarctic Peninsula with the British Antarctic Survey in 1981. To arrive in South America by sea is to be part of maritime history.

As soon as the Biscoe made her final turn past the Cape Pembroke lighthouse into Gypsy Cove the seas flattened with the wind, and the weak sunshine gave a welcome warmth on my face. The sweet smell of land, after days at sea, was intoxicating. The village came out

to the harbour to greet us as if we were newly arrived migrants from another planet. Smiles, embraces and hands were wrung as we stepped on to the wooden pier.

It was Christmas 1981, and though there were rumours of disquiet over sovereign issues, the daily round of farming, families and fishing seemed like an island idyll to me. Port Stanley was a thriving outpost of small, brightly painted wooden houses in a cluster round the waterfront. The old stone church and Government House were prominent on the main road. The incongruity of meeting a British policeman, and then across the road two ancient red telephone kiosks that retain button A and B. But what marked the legacy of the community more than anything to me, was the double arch of whale-bones in the entrance to the Cathedral gardens.

I walked out west for the rest of that day towards the Cape. Atlantic tussock lined the pitted tarmac, ground nesting shearwaters croaked and whistled from deep in their burrows. At the southerly beach I stripped and swam in the waves, enraptured in the nature, the freedom, the simplicity. The water was alive with seabirds diving, the bleached sand littered with shells of crustaceans shattered by storms. Dressed by now only in shorts, I walked barefoot along the shimmering asphalt surface of the Port Stanley airfield listening to

summer larks singing in the clear air, and plovers piping in the grass around about. Across the lane the flowered machair backed exquisite marram dunes and in the silver sea beyond, penguins played the tide.

Only four months later, in an act of self destruction, V-bombers would destroy this landing strip in preparation for invasion.

Thirty years have now passed since that first visit. The Falkland Islands have endured much disturbance and re-establishment. Undiscovered anti-personnel mines still lie hidden on the western beaches, demanding complete exclusion. But the old charms and echoes still drift in the peat smoke fires and the laughter of the Stanley bars. A strange outpost indeed, a strange vestige of empire. In recent years I have returned to the Falklands, not en route to anywhere, but to experience once again the ineffable beauty and strangeness of these islands.

At the end of the surfaced single lane track that took us out for two hours west around the Berkeley Sound, beneath Diamond and Hawk Hill, we approached Port Louis, the Falkland Islands' first colony established by the French in 1764. Beyond, lay Johnson Harbour at the head of Chabot Creek, a thriving settlement that owns all the land out to Volunteer Point. This was the end of all roads, for ahead of us the low land opened to a blanket bog of hillocks and tussocky grasses. Starwort, marigolds and water-milfoil edged the boggy pools.

A sea fret had set in as we navigated this trackless and barren peninsula, to arrive after an hour, surprised to discover a small green and red cabin by a sheltering stand of non-native beech and sitka spruce. The residents, a couple from Rotherham, England, tired of life in a faster lane, greeted us and recommended the best ways to experience the wonders of Volunteer Point. Weak sunshine had lifted the mist sending opalescent light across probably the most spectacular white shell sand beach I'd ever seen. It stretched for a full kilometre in both directions, backed by a low dune belt of machair with carpets of summer flowers, sword grass and chickweed interspersed by brackish pools. The tide rippled sand, studded here and there with shards of molluscs, edged by silent white surf and the pure turquoise sea beyond.

>>

Volunteer Point supports the most northerly breeding colony of King penguins in the southern oceans. A large, moulting mass of them creched with their downy young on the backshore, while perhaps up to fifty adult individuals ambled across the open beach toward the sea on fishing expeditions. Standing about three feet tall and with long flippers for flying underwater, the Kings are an extraordinary species with highly evolved mechanisms for keeping warm in the harshest conditions of the Southern Ocean. Despite the feathers being extremely dense and layered up to four deep, it is the subcutaneous fat under the skin that really keeps them warm in the sea. The black feathers of the back absorb the sunlight with each individual feather having a clump of down at its base. The blood circulation to the featherless feet is controlled by a close approximation of warmed arterial blood passing close to colder venous blood returning to the heart, so standing for long periods on ice is not a problem. The colourful feathers around the neck of the Kings serve both a recognition and courtship function.

I wandered the beach in a state of amazement at the Dalian landscape of silver rippled sands, where clusters of penguins shuffled in and out of the cold Atlantic surf. Others stood in the ground drift of hissing sand, as if bemused by the drama of their own being. They appeared to me as highly sociable, communicating with gestures and glances of which I had no knowledge. I felt too conspicuous out there, so I quietly knelt down in the sand. For those moments, I disappeared from the world, as penguins gathered closely around. The wild sky above was streaked by cobalt, a sure sign of clearing storms far out at sea. Some relief, for the following day I was bound for South Georgia.

The bright orange windsock lashing horizontally at the airstrip is the first sign that Saunders Island is subject to almost continuous ravaging by the elements. We landed safely enough with several bounces over the grass in our Britten-Norman Islander. Taxiing to a halt, we jumped out into the morning sunshine, as the thrashing windsock was wrestled into a bag. All the highest shrubs are sculpted by the blasting cold winds off the sea. Bent and ravaged as they are, they provide shelter to occasional visiting songbirds each year, which bravely sing in the machair and coarse sheep pastures.

We were here to visit a cliff-nesting colony of black-browed albatross on the seaward, west side of Saunders. Along the grassy cliff top, crowded already with guarno reeking colonies of rockhopper penguins and king cormorant, is a windy zone where up to two hundred nesting pairs gather each year on storm ledges above a wild and streaming sea. The nests, equidistant

from each other, are dry yorkshire puddings of mud about ten centimetres tall, set on flat rocks and salty tussocks of campion. The albatross is all about flight. To see them lifted from their nests and, with one sweep of outspread wings, glide away over the hissing wave crests is to see one of nature's great aviators perfectly in tune with its world. I crouched and lay in amongst the colony for two hours watching the gentle interplay of birds. The attentive shifting on the eggs, the partner swapping incubation roles, the languorous wing stretching, the bill clacking – all gestures of gentle communication. And then they are gone, way out there, over the cold seas of the petrel and the porpoise, to feed on surface squid and krill so essential in the complex food chain of the southern oceans.[2]

(2) All the species of albatross in the Southern Ocean have been suffering from the recent burgeoning industry of long-line fishing for the valuable Patagonian toothfish. Baited fishing lines up to a kilometre in length and only half a metre below the surface are accidentally ensnaring the birds. New legislation, some compromise and educational initiatives have partially ameliorated the problems, with fishermen sinking the lines to a deeper level below the surface.
It was almost exactly around this region of the South Atlantic where it is believed that the legendary mountaineer and expedition yachtsman Bill Tilman disappeared, with all hands, with his boat En Avant in 1977, when he was bound for the Antarctic peaks of Smith Island via Cape Horn. Tilman wrote eight classic books about his maritime explorations: *The Eight Sailing/Mountain-Exploration Books* (Diadem, 1987). ISBN: 0898861438. Dorothy Richardson, parent of Tilman crew member Simon Richardson, researched and wrote an interesting book about the disappearance of En Avant: *The Quest of Simon Richardson* (Gollancz, 1986). ISBN: 0575038535.

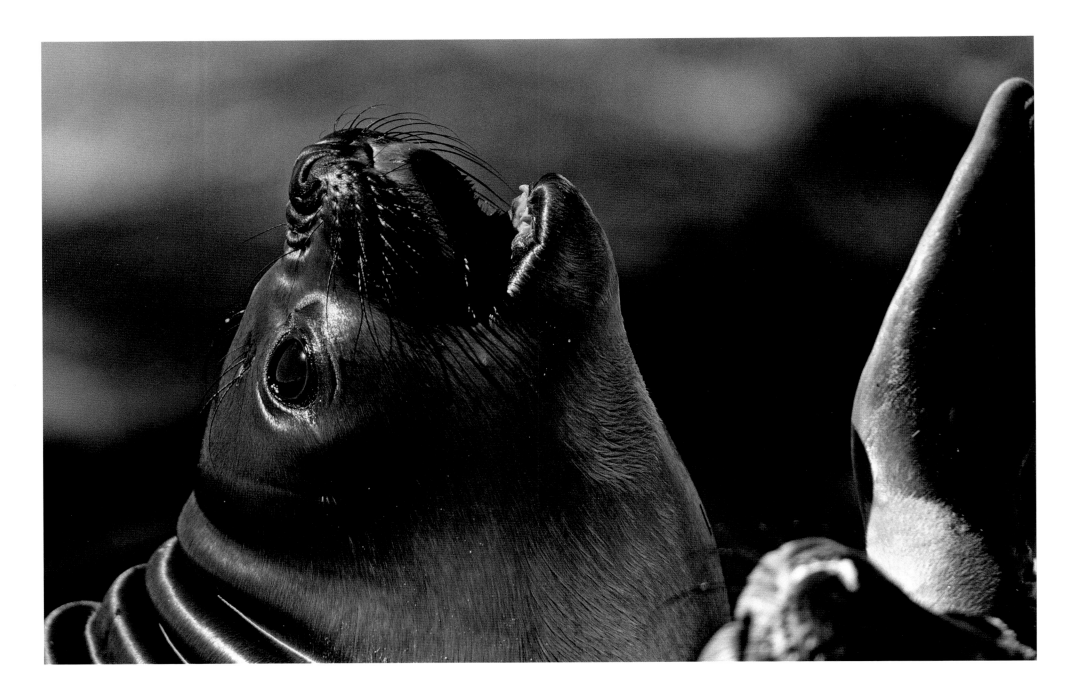

PLATE 04
Southern or South American Sea Lion *Otaria flavescens*. Immature females
remain inshore for several months after weaning, learning to swim,
feeding and vocalising skills. Pebble Island, West Falkland.

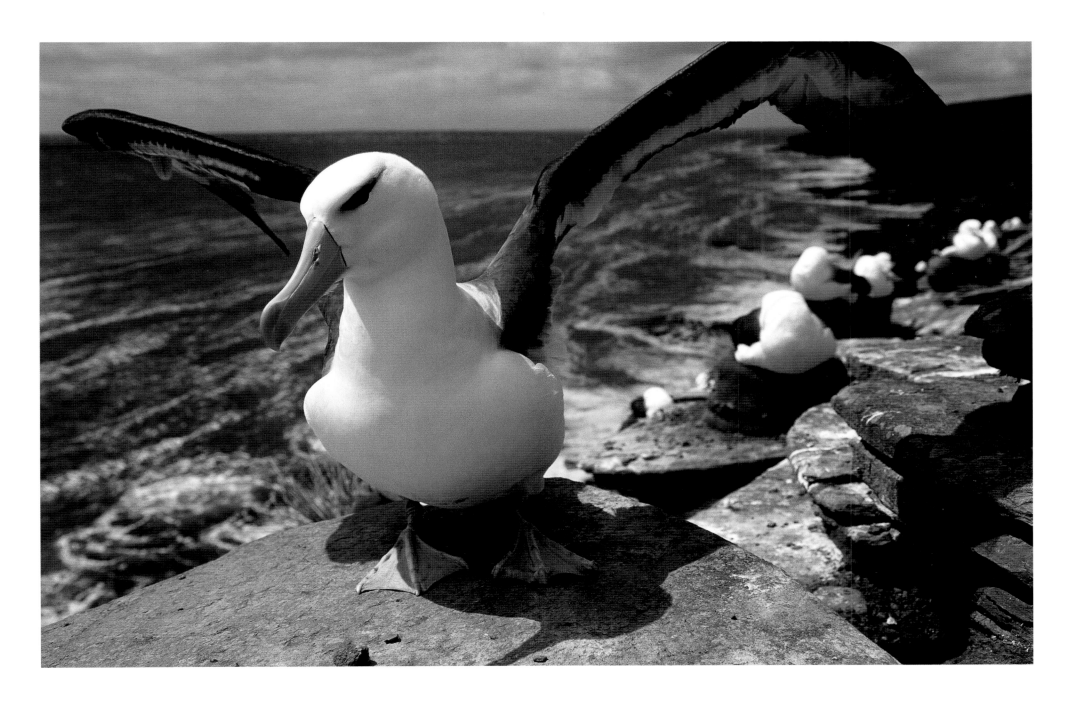

PLATE 05

Black-browed Albatross *Thalassarche melanophris* travel the South Atlantic ocean outside the nesting season. Two thirds of the world's population breed on the Falkland Islands. Saunders Island, West Falkland.

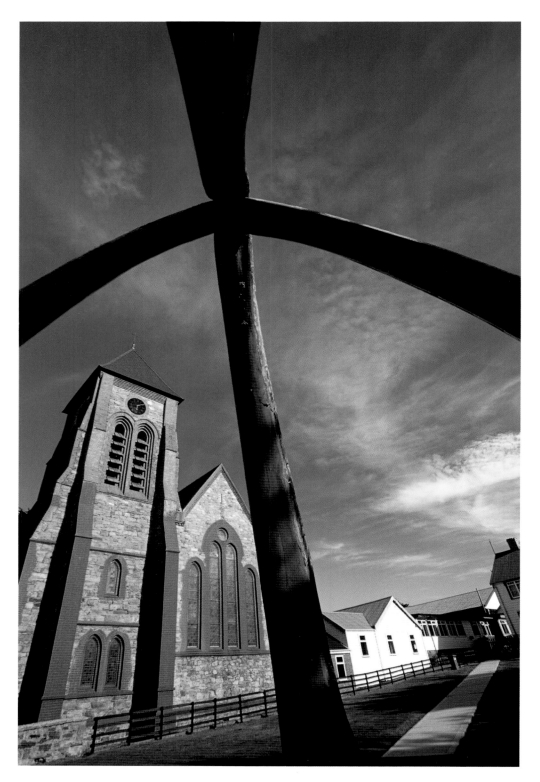

PLATE 06

Christ Church Cathedral, Port Stanley was built in 1892, and is the southernmost church in the world. The famous whale-bone arch in the gardens is made from two blue whale jaws and was erected in 1933, representing the township's whaling past. Port Stanley, West Falkland.

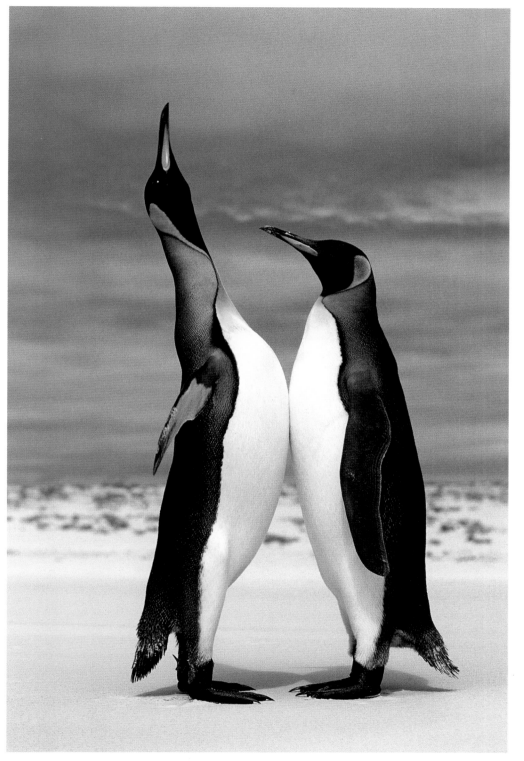

PLATE 07

King Penguins *Aptenodytes patagonicus* engaged in courtship gestures. King Penguins will frequently change partners for each breeding cycle rather than pairing up with the same partner. Volunteer Point, East Falkland.

ARGENTINA

On 13 April 1834 HMS Beagle anchored in the mouth of the Santa Cruz river on the Atlantic coast of Argentina. For sixteen days, three whale-boats and twenty-five men – including Captain Robert Fitzroy and Charles Darwin – sailed and dragged the boats upstream in a westerly direction heading for the Andes, convinced that the geological processes of the sea's action had made this slice through the continent. All along the river, Darwin surveyed the topography and the flora and the fauna as they made slow progress against the current. He observed polished river pebbles, eroded and terraced river banks, the tracks of indigenous Indians, hoof and spear marks in the mud, and concluded with enormous interest that the natural forces that shaped this land could not have been caused by a biblical flood, as was currently surmised. So controversial was this thesis, that Darwin waited another twelve years to publish his conclusions about glacial action in mountainous terrain. The river became shallower and more torrential and the expedition turned back east, never reaching the Andes.

Darwin wrote in his diary:

'Like the navigators of old when approachin an unknown land, we examined and watched for the mos trivial sign of a change. The drifted trunk of a tree, or boulder of primitive rock, was hailed with joy, as if we ha seen a forest growing on the flanks of the Cordillera. Th top, however, of a heavy bank of clouds, which remaine almost constantly in one position, was the most promisin sign, and eventually turned out a true harbinger. At first th clouds were mistaken for the mountains themselves, instea of the masses of vapour condensed by their icy summits.' 24 April 1834

Had they continued, the expedition would have discovered that the headwaters of the Santa Cruz river were two vast glacial lakes, Viedma to the north, and Argentino to the south. Lago Argentino is 1,466 square kilometres in extent, and is the largest freshwater lake in Patagonia with long extending arms that penetrate the remote Southern Patagonian Ice Field. Together they contain the world's third largest reserve of fresh water. Since then, generations of explorers, including Shipton and Tilman, have ventured here to experience the unique combination of vast plains, mountains and colossal glacial systems of Patagonia.

On the shores of Lago Argentino, where the Perito Moreno glacier grinds the bedrock and carves gigantic shards of ice, there are dense forests of a hardy tree called the southern beech. Here, in the last remnant Pacific temperate rainforests in the world, is a hugely diverse ecosystem surviving the most savage of weather and harbouring extraordinary species like the Patagonian puma and Austral parakeet.

The Perito Moreno glacier is thirty kilometres long, five kilometres wide and up to a seven hundred metres deep. It is one of only three Patagonian glaciers that is not retreating, and one of forty-eight glaciers fed by the Southern Patagonian Ice Field. This huge glacier is named after an Argentine scientist and explorer Francisco Moreno who made three early expeditions into Patagonia. During the second of these explorations near the Nahuel Huapi lakes in 1880, he was captured and condemned to death by Tehuelche indians, but escaped the very day before his execution. The name 'Perito', meaning technical expert, was a name given to him by colleagues from the Argentine Science Foundation in 1902.

Across the border into Chile and southwest of Lago Argentino is a last upthrust of Andean peaks, a small range of jagged granite spires that have enchanted explorers and mountaineers for generations.

Torres del Paine is an uproar of wild peaks raked by violent winds blowing north from Antarctica. It was here in Patagonia that I first realised the immense power of the forces of nature. Near the Salto Grande waterfall, beneath the Los Cuernos del Paine, I clung to a rock as a whirlwind roared by and ripped the surface clean off Lake Nordenskjöld, casting a great sheet of water across the surrounding scrub. Above me gothic towers of smooth-walled rock reared skyward, icy lenticular clouds hung weirdly like livid mushrooms over the peaks. A black shape – a condor – glided effortlessly over a distant bluff. Translucent icebergs in Lago Grey were beached by driving winds and may take years to die. What forces are these, that scour and build, that thrust and deposit?

I pulled my anorak hood up over my head as lashing rain blinded my vision. A sudden calm, I looked out across a pure green lake beneath a leaden sky. The guanaco were moving again, shaking water from their backs. An ash-headed goose and goslings nibbled grass at my feet. The grey fox, out hunting mice again, trotted circles in wet berberis. Shafts of mountain light searching the high valleys echoed with far off waterfalls. There is no weather here, only elemental forces. What wild forces indeed, at the outer edges of the world!

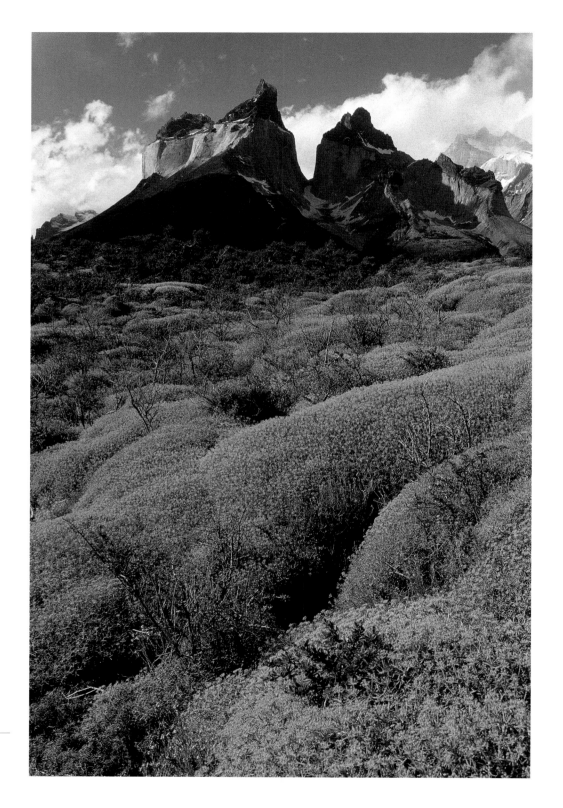

PLATE 08

Below the Horns of Paine, Cuernos del Paine, are spiny
Mulinum spinosum plants that form cushions as
protection against the wind. Lago Nordenskjöld,
Torres del Paine, Argentina.

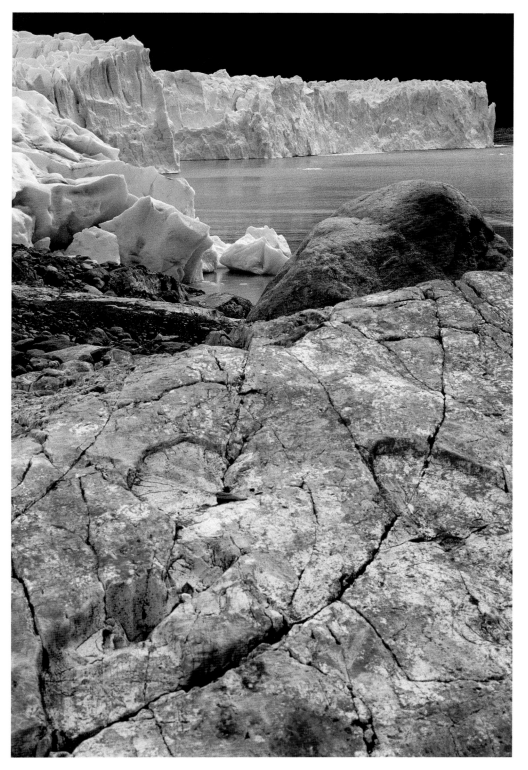

Granitic bedrock scarred by the constant movement of active glaciation. The Perito Moreno glacier's front is 5km wide, with an average height of 74m. The glacier and Southern Patagonian Ice Field is the world's third largest store of fresh water. Lago Argentino, Argentina.

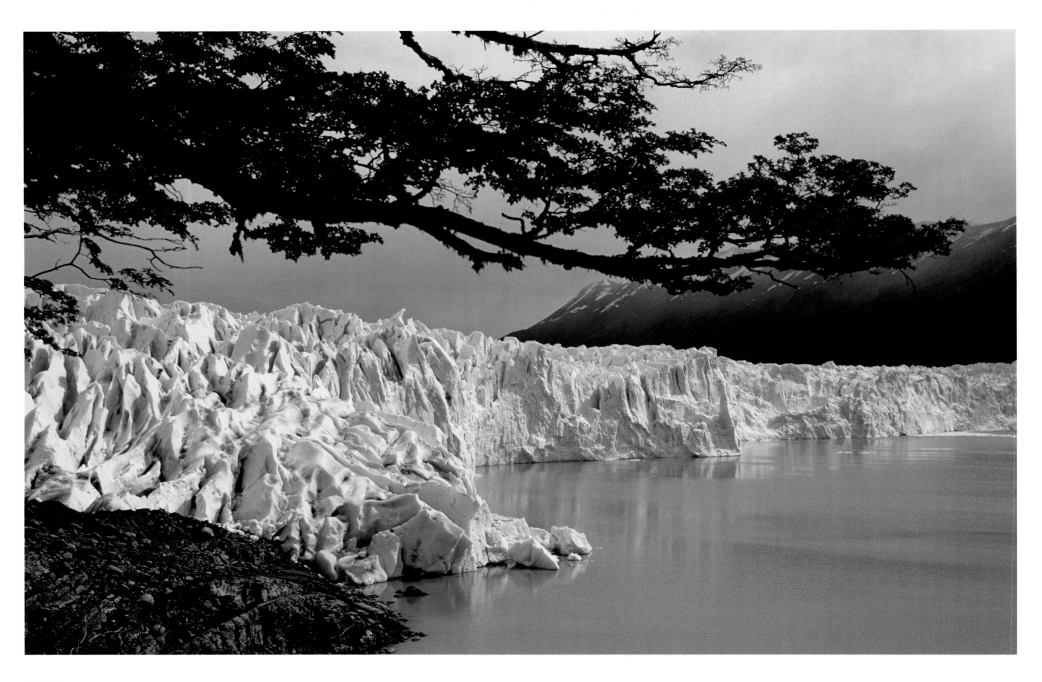

The Perito Moreno glacier was named after the explorer Francisco Moreno,
a pioneer and explorer who studied the region in the 19th century. The glacier,
which extends for 250sq km and is fed by 48 other glaciers, is one of only three
Patagonian glaciers that is still advancing. Lago Argentino, El Calafate, Argentina.

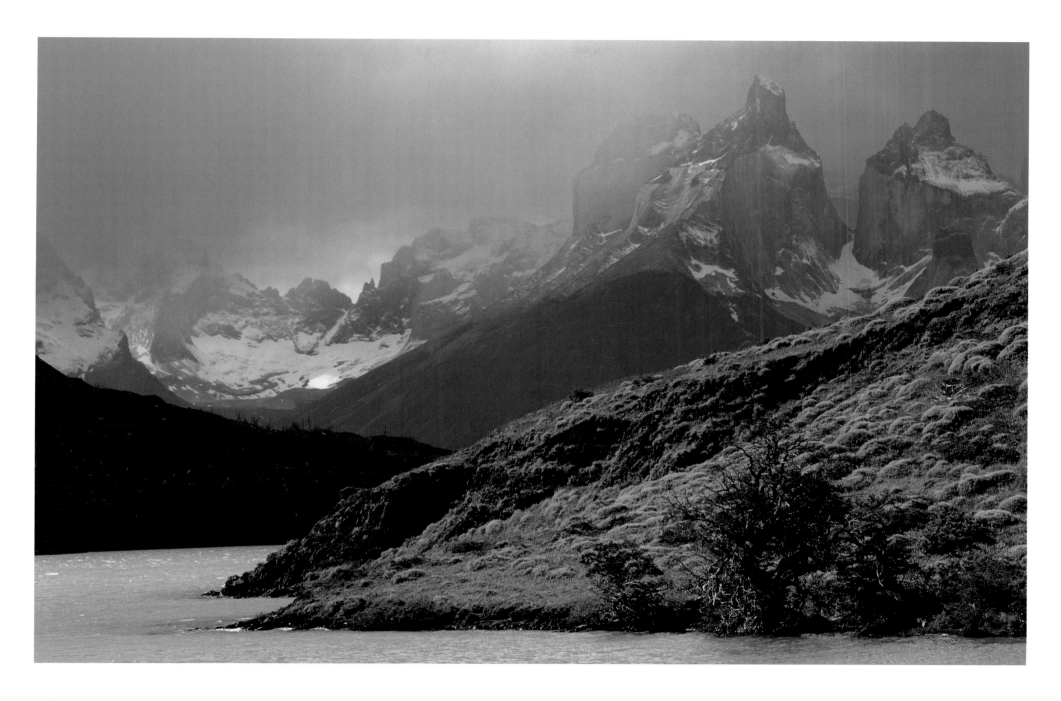

PLATE 11
Lago Pehoe and the alpine peak of Cerro Paine Grande, 2,750m. Lago Pehoe is fed by the Paine River, which rises high in the mountains where the Andean condor and wild guanaco are common inhabitants. Torres del Paine, Southern Chile.

IGUASSU FALLS

Deep in the forests of Brazil the Parana River accelerates toward a rocky basaltic escarpment. At this point, 547 kilometres inland, the river is quite shallow yet up to 2.7 kilometres wide, and plunges over an enormous gorge in three hundred thundering waterfalls.

The mouth of the Amazon River was discovered in 1500, which led to numerous exploratory settlements being established by Portuguese traders intent on opening up hardwood and silver resources from the forest regions. One of these stockade sites was at Asunción on the River Paraguay. By 1541 Álvar Núñez Cabeza de Vaca was dispatched to relieve the settlement. The expedition headed into the incredible lowland wilderness of dense forests and huge rivers in the Serra do Mar region. On discovering the headwaters of the Parana and unsure of their reception by the indigenous Tupi Guarani forest people, some took to canoes, with others on foot with horses, continuing west with 250 men. In January 1542 they reached the falls:

'The current of the Yguazú was so that the canoes were carried furiously down river, for near this spot there is a considerable fall and the noise made by the water leaping down some high rocks into a chasm may be heard a great distance off and the spray rises two spears high and more over the fall.'

This was the first account by Europeans of the discovery of Iguassu Falls.

The Brazilian rainforests are like natural cities; they have huge populations, but not people. The original people, the Guarani in this 'Missiones' district, were Christianized in the 1600s by the Jesuit Missions, and have now abandoned the forest. The Parana River like a roaring mainstreet, vies for noise dominance with the electrifying background of insect and bird life that utterly fills the air. From pre-dawn to sunset, wave upon wave of changing insect drones and buzzes create a cacophony, a wall of sound. Beyond the insect din the river's voice is a terrifying pulse of booming explosions, a tumult of vapour and compressed jetting air. A massive volume of crashing water takes to the air in over 270 cataracts, and is forced between a narrow gorge of basaltic cliffs. In the deepest gullet, the Giganto del Diablo – *The Devil's Throat* – the entire river plunges into an abyss of rainbows and cloud. There is silence above the falls then an inexorable speeding up of the current and a ghastly slide over the edge. I stared in frozen horror at the power and the beauty. River islands below the main falls are densely forested with coral trees, and brimming with azaleas and orchids. Bromeliads cling to the branches displaying exotic scented flowers for the hummingbirds, butterflies

and tanagers to take nectar. The names of the hummers paint their own images: the gilded sapphire, the glittering-bellied emerald, the violet-capped woodnymph! Flocks of dusky swifts screech around the rising mists within the vertical falls, diving in and out of the watery curtains. In late afternoon, when warming air currents change with the sun's descent, black vultures rise from their riverine roosts and float in a languid vortex over the river searching for carrion on which to prey. The cooling of the evening air and lowering light is balanced by an onset of a million more voices of the insect night.

These waterfalls are the water garden wonders of the world.

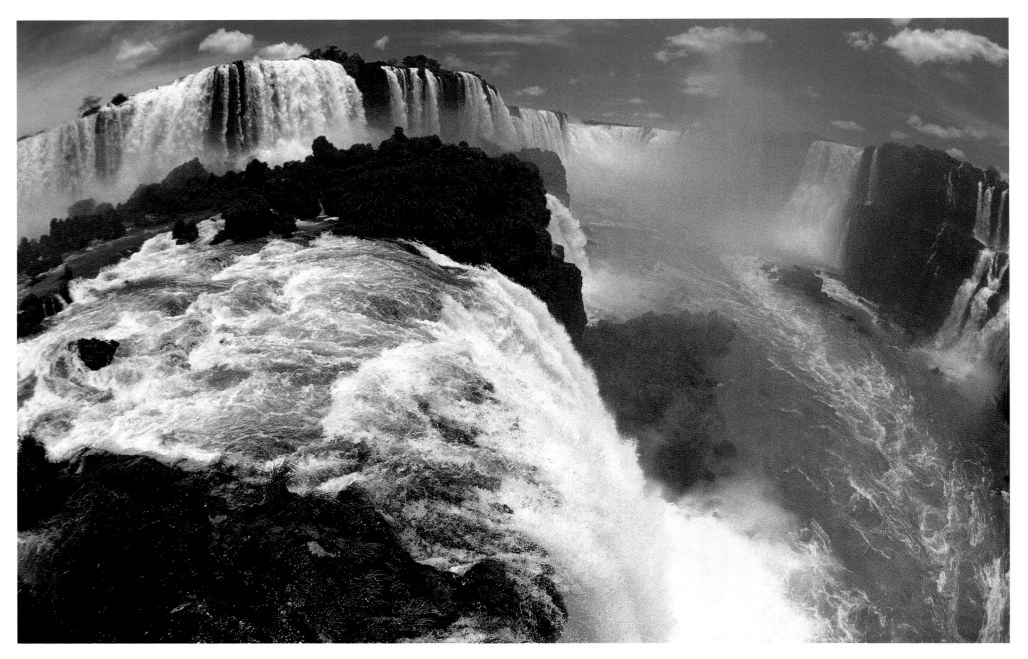

PLATE 12

The first European explorer to find Iguassu Falls was Álvar Núñez Cabeza de Vaca, a Spanish Conquistador, who came upon them in 1541. The falls remained hidden until re-discoverey in the late 19th century. With over 270 cataracts, these waterfalls are among the most powerful in the world and span the Argentine-Brazilian border.

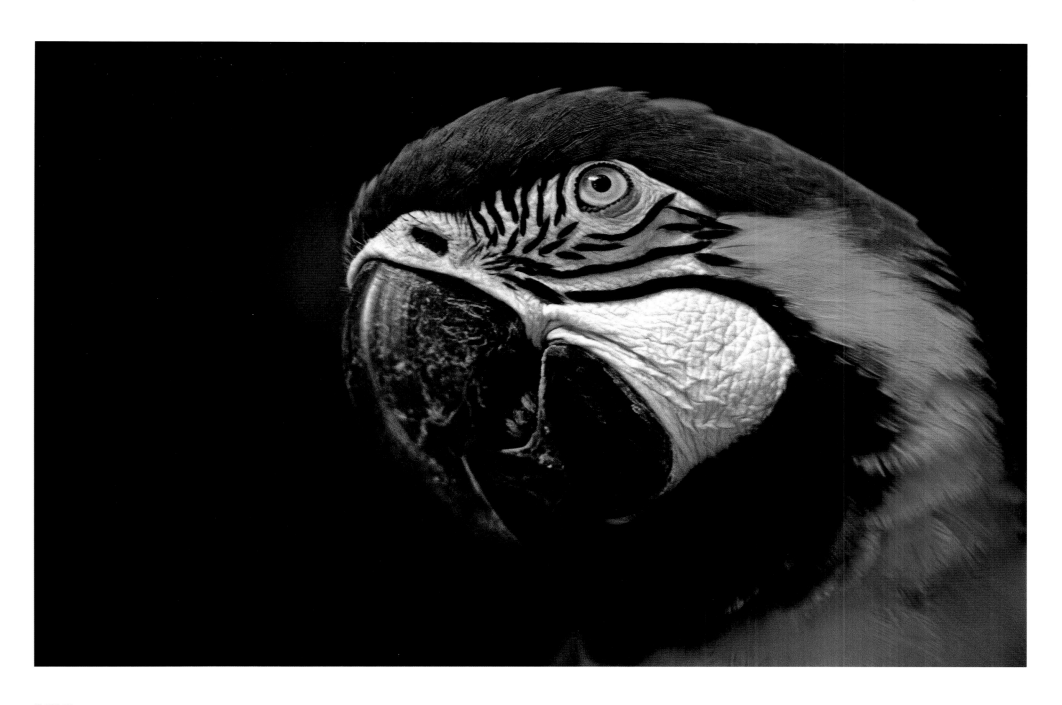

PLATE 13

The Blue-and-yellow Macaw *Ara ararauna* is a sociable parrot often seen flying
in large flocks to feed. Macaws mate for life and breed across most of tropical
South America, nesting high in tree holes in the forest. Iguassu falls, Brazil.

ISLAS ENCANTADOS – THE ENCHANTED ISLANDS OF GALÁPAGOS

Galápagos has always been a magical word for me, ever since reading about the islands and watching a television programme about them as a young boy. The programme, by Sir Peter Scott, was called *Look* – a naturalist's travelogue of exploration, long before ecotourism arrived on our shores. In it I saw exotic reptiles and birds massed in profusion, apparently tame in the presence of humans, and wild beaches fit for a castaway, a Robinson Crusoe paradise.

Considered by science to be one of the most active volcanic regions of the world, the remote Galápagos Islands, which lie 525 kilometres from the coast of Ecuador astride the Equator, have been designated as a UNESCO World Heritage Site and National Park due to their unique endemic land fauna and marine life. Thirteen islands and a hundred islets and rocks have emerged from the sea as volcanoes throughout the last four million years, the islands of Isabela and Fernandina being the most recent to appear. A sub-crustal plume of the earth's mantle has pushed upward to create shield volcanoes lying along a junction of tectonic plates resulting in regular seismic activity. Extensive hot lava flows occurred on Fernandina as recently as 2009.

The central Pacific location of the Galápagos Islands lies at another junction as well. In this part of the ocean, two ocean currents of very differing temperatures collide. From the south, streaming up the coast of South America from Antarctic waters, comes the cold Humboldt current which meets the much warmer North Equatorial current that flows around the Tropics. The effect is twofold. On one hand the cold current from the south brings rich planktonic organisms that create the base of a vibrant food chain, whilst the stability of climatic patterns is dependent on the warmer current from the north, creating seasonal light rain that is essential for the wide variety of vegetation.

It is thought the islands were first discovered in 1535 by Tomas Berlanga, the bishop of Panama, who fetched up here after being blown off course en route to Peru to settle a dispute with Pizarro and his lieutenants after the conquest of the Incas. Soon after, word of his adventures about desert-like islands, strange creatures and rich sea life became known to buccaneers like William Ambrose Cowley who drew the first navigational chart of the island group in 1684. Little exploration took place for many years. Galápagos was rarely visited except when it became a deep ocean refuge for pirates plundering passing galleons. Long distance mariners began to visit to replenish fresh water and meat supplies, because the giant tortoises that were

collected could remain alive in the ship's hold for up to a year without care, providing fresh meat for many months at sea. Whalers and sealers came too, all playing their part in reducing the populations of animals so close to extinction.

The first scientific studies in the islands came in 1835 when Charles Darwin famously visited with Robert Fitzroy's round-the-world survey expedition on HMS Beagle (1831–1836). What Darwin observed here and went on to publish was said to be the source of all his ideas and research which he brought together in *On The Origin of Species*, published in 1859, where he suggested distinct species related to places, not just varieties, a fact readily witnessed in the archipelago of Galápagos. His hypothesis about variations in the local mockingbirds, finches and giant tortoises throughout the islands was crucial to his evidence of natural selection in explaining evolution.

Indeed, it has been the abundance and uniqueness of creatures that has brought me here on four occasions. To experience the close proximity of such dramatic species is to recognise one's humility within the wonders of nature in the raw. I remember snorkelling one afternoon off a group of rocks called the Devil's Crown. The tidal currents were alarmingly strong there, so I floated quietly along with the drift instead of fighting it. Another world of life was flowing below me, southern sea lions played 'football' with a puffer fish, a fleet of forty hammerhead sharks glided by over the sandy seabed just metres away. Later that evening we took a dinghy into some nearby mangrove lagoons to wait and watch for flotillas of golden rays flying silently under the boat searching for molluscs in the mud. Another season took me out to Tower Island in the north to photograph the courtship displays of the magnificent frigate bird, with its wildly scarlet nuptial throat pouches, the males laying their wings outspread in tops of bushes, feather-shaking and shivering their display and nervously whistling an ecstatic call. The moving grace of waved albatross' clacking bills in mating ritual, and thousands of marine iguanas like baby dragons clinging to boulders unperturbed as they were mercilessly pounded by heavy ocean waves.

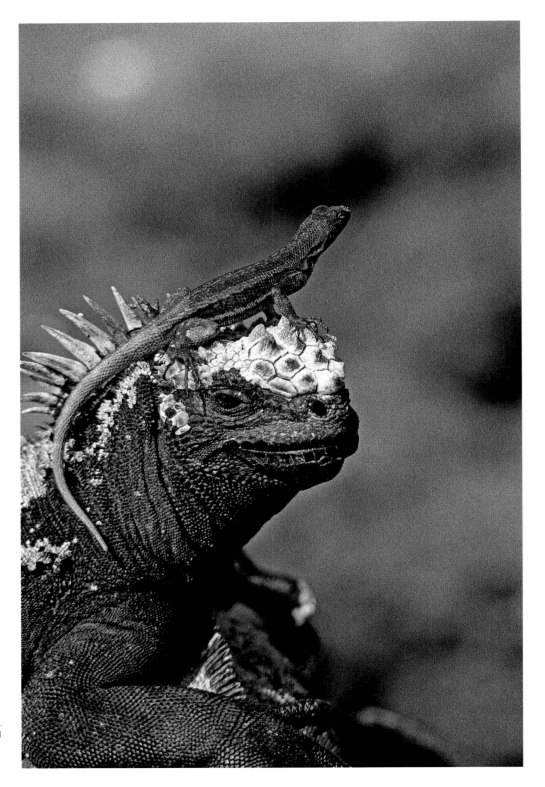

PLATE 14

Marine Iguana *Amblyrhynchus cristatus*, with Lava Lizard *Tropidurus s.*, catching insects attracted by the white frontal shield. Punta Espinosa, Isla Fernandina, Galápagos Islands, Ecuador.

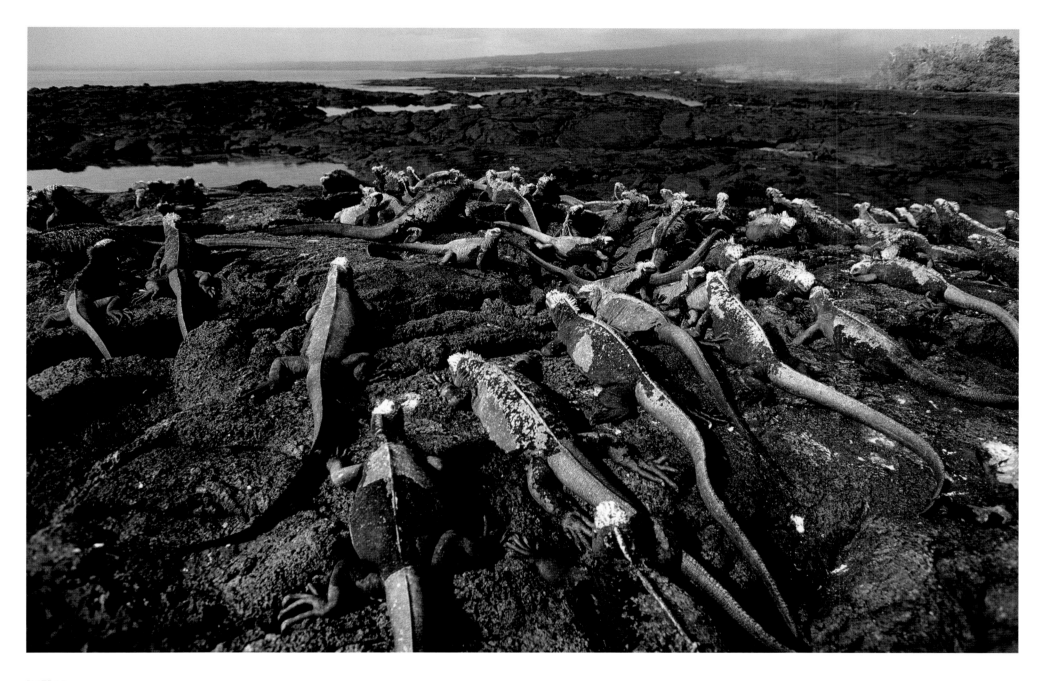

PLATE 15

Crowds of Marine Iguanas *Amblyrhynchus cristatus* cover the rocks above high tide at James Bay. British buccaneers used this bay as an anchorage during the 17th century as they found it an excellent area for firewood, water, salt and tortoises. Isla San Salvador, Galápagos Islands, Ecuador.

GALÁPAGOS | ISABELA

As we hove-to off Isabela Island in Elizabeth Bay, the chain rattled out as the anchor plunged into deep black water. There were no beaches in these parts, except for angry angular promontories of ragged lava enabling us to climb ashore to be entirely surrounded by a sea of shimmering stone. The uplifted lava desert on which we stood clearly joined the two volcanoes that once existed as individual islands. It was low lying, jet-black, and cooking hot. An occasional brachycereus cactus clustered into folds in the miraging rivers of pahoehoe lava, shelter for lava lizards or insects, tiny islands of life in a desolation of twisted rock.

The phenomenon we had come to see involved a swim, a long swim. Hidden in the floor of the lava flows were ingressions of the sea, natural canals of brilliant turquoise water between three and eight metres deep, penetrating inland for nearly a kilometre, forming a network of waterways that culminated in mysterious shallow pools. We jumped in with masks and snorkels and gazed down through shafts of sunlight into the depths. Below us was a veritable parade of pelagic species, a secret Noah's Ark of the sea. Sleek southern sea lions flew by chasing swarms of glittering sprats, rainbow parrotfish nibbled coral fronds and a curious and lugubrious large shining golden fish that

I recognised as a kind of grouper, drifted by and caught all our attention. We slowly swam on up the lava tubes into the warm pools that are the site of exquisite and gently erotic courtship displays of the green turtle, an ocean-going Cheloniidae, and master navigator, that returns here each year to meet, sea-dance and mate.

During the long shade-less walk back to the boat we chatted about all we'd seen. Among our company was a fish expert, Ian, who at some time in his life had been a world champion fish breeder. He knew the fish I'd seen as the golden grouper Mycteroperca. Excitedly, he told us of its scarcity, fables and its territorial habits and we learned over lunch on the boat that this fish may have twelve miles of ocean to itself, was capable of changing colour at will and that we'd had been very fortunate to observe it at close quarters like this.

We swam again during the afternoon along the outer lava edge. The tide had set in over exposed rocks displacing hundreds of marine iguanas into the sea. We duck dived down a few metres in amongst them to where they were now gripping the seabed with their strong claws and rasping away at the green algae on which they fed. These nearly-black reptiles have been described as utterly hideous with their thin spiny crests and long scaly tails, but they are not so to me, instead starkly beautiful in their natural setting.

Later, on board our small brigantine, appropriately named Beagle, dinner was served. The lounge below deck had a long dark oak table arranged with four solid ships chairs and a comfortable side bench. The galley door was pushed open by the captain's foot. He entered holding a large silver salver with both hands and, expressing a strange, almost shy, smile, placed the large weighty salver in the centre of the table. There was a momentary hush as he proudly lifted the silver dome, then a gasp across the table as our hands reached to avert our eyes. There, in splendid repose upon a deep bed of rice and prawns, lay our golden grouper! Oh dear! Our kindly Ecuadorian skipper Lenin had overheard our lunchtime enthusing and mistakenly fished for the grouper, imagining that we actually wanted to eat it!

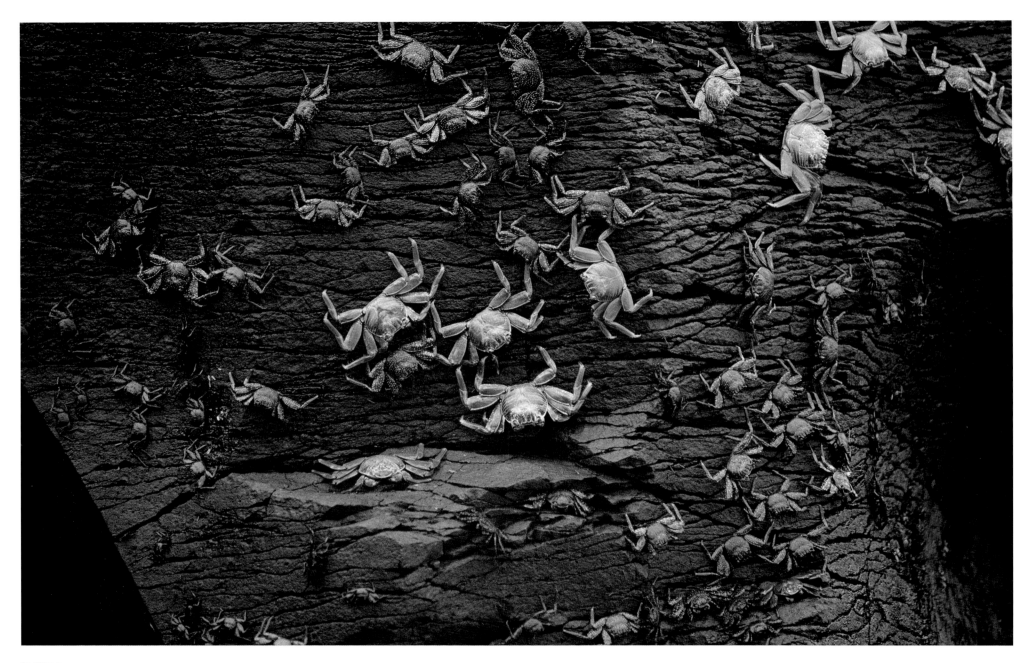

PLATE 16

The Sally Lightfoot Crab *Grapsus grapsus* is a quick moving and agile crab that lives amongst the lava rocks on turbulent and windy seashores of Galápagos, just above the limit of the sea spray. They feed on algae, plant matter and dead animals. Juveniles are dark and camouflaged, their carapaces becoming red and orange in adulthood.

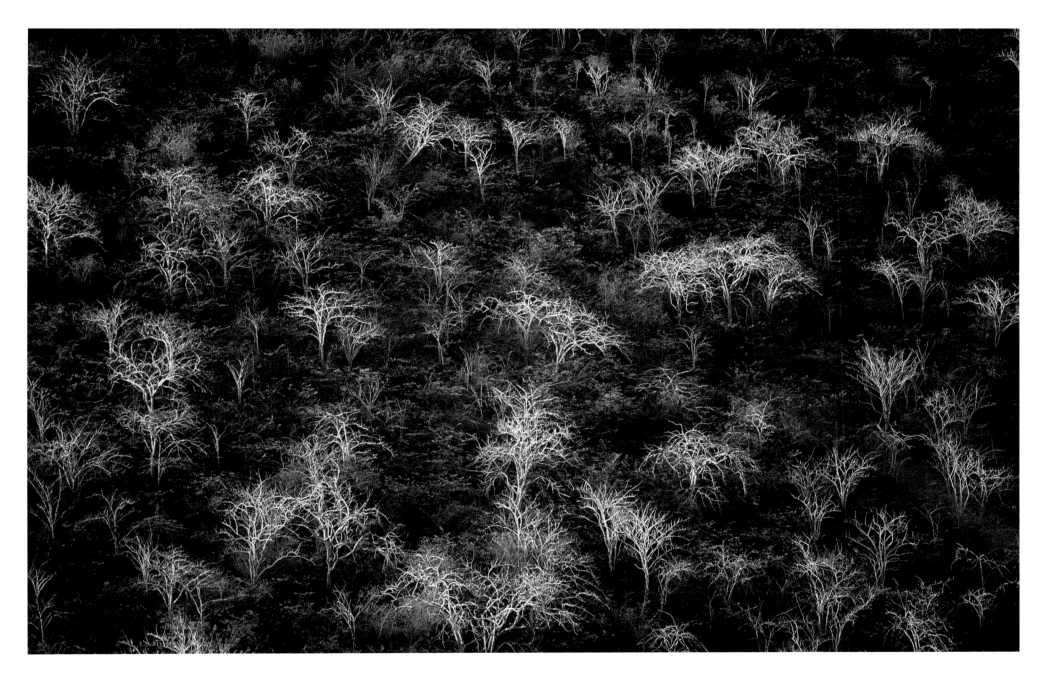

PLATE 17

The Palo Santo tree *Lignum vitae* (wood of life) grows in the Transition Zone,
higher than 60m above the sea on sheltered coasts of the Galápagos Islands.
This tree is valuable for the quality of aromatic oils in its bark. Tagus Cove,
Isla Isabela, Galápagos Islands, Ecuador.

GALÁPAGOS | ALCEDO

The final slopes to the summit of the volcanic crater of Alcedo consist of boot-filling dust-like nodules of pumice, a light airy gravel about a metre in depth. With midday temperatures well into the nineties and a shade-less wall of talus above, we scrambled upward knee and elbow deep in stones and bracken until the world around us transformed into a scene of primordial splendour.

The crater rim, a mere hundred metres wide, arced in a graceful curve perhaps eight kilometres in circumference. Behind and below us was a sparkling ocean of azure where our twin masted ketch lay at anchor and from where we had rowed ashore in the cool dawn before sunrise. Zephyrs of sea breeze were drafting the up slopes and condensing into wet clouds on the rim, bringing life to this mountain top in the form of dense Scalesia forest hanging with fronds of lichen, bearding every branch and twig. Already a catch of sulphur filled the air, belching from distant fumaroles a kilometre distant. Succulent birdsong drifted through the branches, a vermilion flycatcher, startlingly colourful, nervously sipped droplets from a leaf. A cool gust thinned the mist allowing sunlight to infuse some warmth, melting vapours into the air. There before me, in perfect quietness, was a spectacular creature grazing the steaming shrubs. A creature I had

longed to encounter in the wild, and one that as a boy I barely believed existed beyond the walls of a zoo. Its watery eyes gazed at me as if searching for meaning, its breath rasping and hollow. Streaks of green paste lined its hard beak-like mouth from hours of masticating leaves and grass. I carefully approached, its head retracted with a hiss as armored forelegs enclosed a face so ancient that Darwin himself may have witnessed this very beast. I crouched in its presence, listening in awe at the hydraulic exhalations of air from beneath its shell.

Relic species like these giant Galápagos tortoises have only survived in this location because of isolation from predation and competition. Once preyed upon for food by seafaring buccaneers and adventurers in search of fresh water in the islands, they now compete with the populations of feral goats that graze the same vegetation on the volcano's rim. A recent goat eradication scheme has thus far been successful ensuring, in the short term, continued survival for this strange iconic creature that, like the giant panda, carries with it the heavy import of being a representative of the 'last chance to see' mythical animals club.

Every journey to Galápagos has been a journey back in time. There is a visceral sense of belonging here, but why? Perhaps in recognition of our pelagic origins or because the atmospheres of salt and sea mist, unearthly animal encounters, desiccated rock, cacti, guarno and velvet starlight are an intoxicating mix for the senses, like being afloat amongst a thousand arching dolphins, and being carried to another world.

There is an ecstasy in nature here, a breathtaking sense of wildness… a world… a world away.

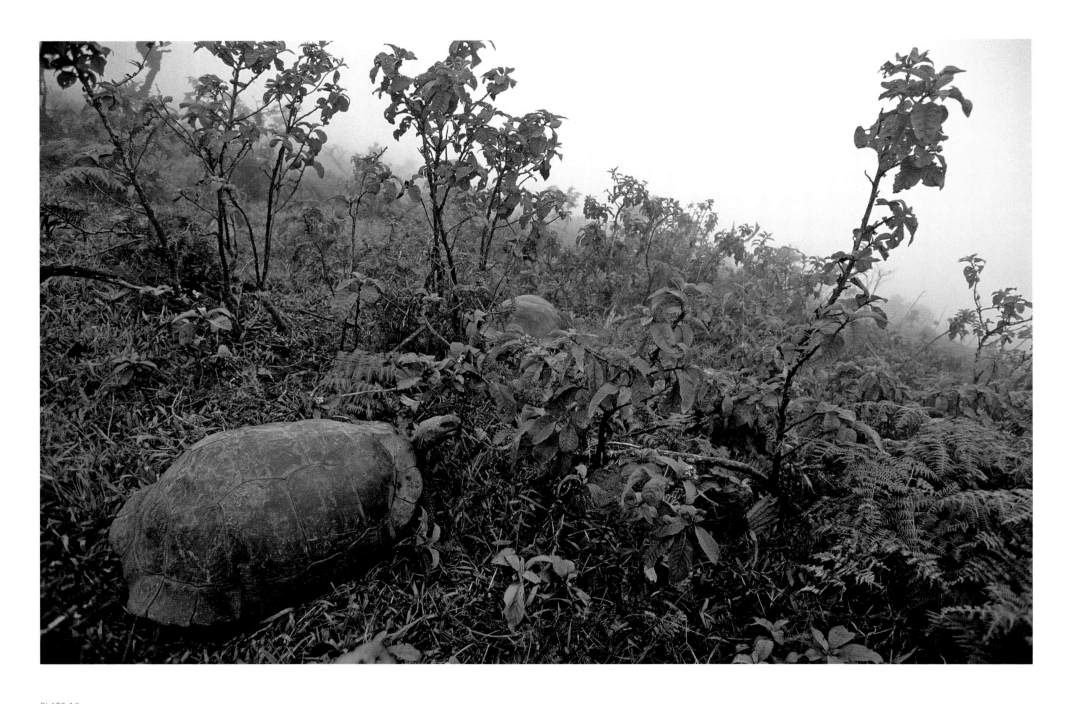

PLATE 18

Scalasia *Scalesia pedunculata* cloud forests provide food and shade for the Giant Galápagos Land Tortoises on the slopes of the Alcedo volcanic crater. Isla Isabela, Galápagos Islands, Ecuador.

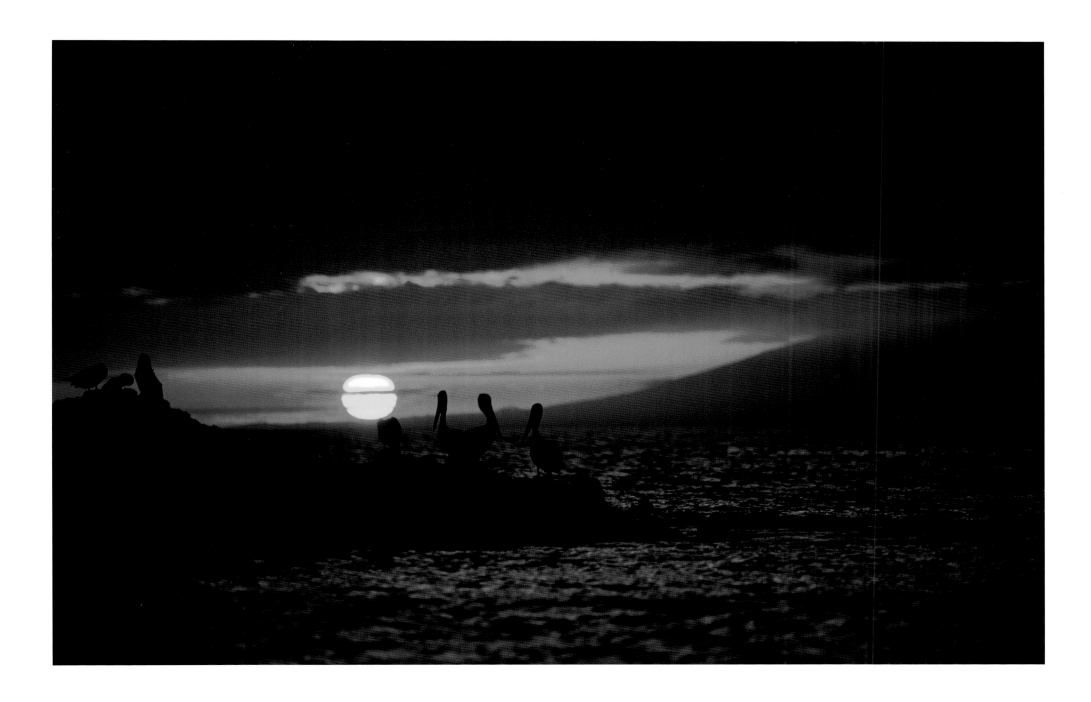

PLATE 19
Alcedo Crater at sunset, with pelagic birds – pelicans, boobies and southern gulls – on Isla Mariela in Uvina Bay, Isla Isabela, Galápagos Islands, Ecuador.

EASTER ISLAND – JOURNEY TO THE CENTRE OF THE WORLD

On Easter Sunday 1722, Dutch sea captain Jacob Roggeveen made land on the most remote inhabited island ever discovered in the South Pacific Ocean. He named it Easter Island, and it lies 3,600 kilometres from its nearest landmass, the coast of Chile, and 2,000 kilometres from its nearest neighbouring island, Pitcairn. But mystery and controversy still surrounds the historical accuracy of the demise of the original inhabitants of Easter Island.

It was most likely populated by wandering sea-faring Polynesians in canoes from the Marquesas and Society Islands, who became disorientated and were swept by prevailing currents. Indeed DNA from skeletal remains have been identified as dating from around AD 318, confirmed by reeds from the grave sites on the island which carbon dated similarly. At the time of their arrival, much of the island was forested and teeming with land birds, and was perhaps the most productive breeding site for seabirds in the Polynesia region. Because of the plentiful bird, fish and plant food sources, the human population grew and gave rise to a rich religious and artistic culture.

One school suggests that 'ecocide' took place after the early inhabitants had attained a level of social complexity that gave rise to one of the most advanced cultures and technological feats of Neolithic societies anywhere in the world.[3] The carving and erecting of huge stone statues took place between 1000 and 1650. A most extraordinary society developed, flourished and persisted for perhaps more than one thousand years, before it collapsed and became all but extinct. The considered view is apocryphal, that as the giant stone heads were required to be moved to the ritual sites, wooden rollers were made. Eventually all the trees were cut down, and the now unconsolidated natural soils blew away in the constant trade winds. Without soil to grow vegetables and fruits, the islanders survived by fishing, but without boats were only able to fish inshore waters from rocks. Hence the concept of cannibalism setting in, leading to eventual eradication of the entire civilisation. Other theories suggest that early explorers since 1800 inadvertently introduced diseases that brought the original civilisation to an abrupt end.[4]

(3) Jared M. Diamond, *Collapse: How Societies Choose to Fail or Survive* (Allan Lane, 2005). ISBN: 9780713992861. Diamond describes his theory of a self-inflicted environmental devastation, how its complex society collapsed, descending into civil war, cannibalism and self-destruction. His theory of ecocide has become almost paradigmatic in environmental circles. **(4)** An alternative theory by Benny Peiser, suggests that early European visitors around the eighteenth century brought degenerative diseases to Easter Island, sufficient to cause collapse of the existing small population. Benny Peiser, *From Genocide to Ecocide: The Rape of Rapa Nui*, Published in: Energy & Environment, Vol. 16, No. 3&4 (2005), pp. 513-539 <http://www.staff.livjm.ac.uk/spsbpeis/EE%2016-34_Peiser.pdf>

In the 1950s Norwegian explorer and erstwhile anthropologist Thor Heyerdahl popularised the view that early inhabitants had actually arrived by balsa rafts from the coast of South America. Recent linguistic, archaeological and ethnographic studies have categorically disproved this in favour of scientific tests on ancient site samples.[5]

Whatever the truth, Easter Island remains as perhaps the most famous yet least visited archaeological site in the world, also now recognised as a UNESCO World Heritage Site. Of the 887 giant stone statues – or Moai – 270 still stand erect on their massive ritual platforms called Ahu. Since early European visitors in the 1880s Rapa Nui became the familiar local name for Easter Island. However, the island's first probable Polynesian name was Te-Pito-o-Te-Henua, meaning '*the centre (or navel) of the world.*'

On a wild grey beach along the north eastern coast is a huge circular polished rock fifteen feet in diameter and domed to a metre high. In the centre is a perfectly smooth hole, revered by islanders as the epicentre, the navel itself. It was to this place, I first wished to visit.

Make-Make, the god of creation, is ever present across Easter Island. Petroglyphs depicting his image adorn many of the sacred rocks. So powerful was Make-Make to primitive communities that a ritual appeasement race took place each year that instated a new king to the island. From the two hundred metre high cliffs of Orongo, tiny islets are visible: Motu Iti and Motu Nui. The young men of the island would race down the cliffs, swim the dangerous channel to one of the islands and return by scaling the cliffs with the egg of a sooty tern, intact, in their mouth.

I gazed in wonder at the carvings of Tangata Manu, the bird-like man, in the searing midday sun atop the ancient city of Orongo, now merely a collection of turf roofed beehive dwellings dating to around AD 900. Below me on one side, the azure blue sea crashing the lava cliffs, to the other a vast plunge into the glittering pools of the volcanic crater Orongo, where the primitives once grew woodlands of fruit trees in the fertile soils. I imagined the lauded winner emerging from the cliffs and being nurtured into the incarceration of a dark stone house for his reign of one whole year, and the flurry of statue carving that always followed the annual race. >>

(5) Since the famous voyages of Kon-Tiki and Ra, Thor Heyerdahl wrote a popular adventure story about his travels and discoveries on Easter Island: *Aku-Aku* (Rand MacNally, 1958). ISBN: 9780528818103.

At the far end of the island, only twenty-six kilometres distant, is the extinct volcano of Rano Raraku where dozens of statues were either erected in situ on the hillside, or semi hewn from the volcanic tough lava quarries. Many heads stood over five metres tall and may have weighed fifteen to twenty tonnes, with a half quarried one I measured being over twenty metres long, lying down emerging from the lava cliff. Perhaps a hundred men may have been needed to move one statue on its tree trunk rollers. Then, just the hot ocean winds of a millennium, blowing away seeds of hope as the ground became a dying dustbowl. In desperation, the inhabitants fished from the rocks until there were no fish. Death came to this place quickly, perhaps in only fifty years of suffering.

Rapa Nui was alive with spirits as I wandered amongst the Moai. Tilted by time and raised in ritual over a thousand years ago, their eyes gaze from the stone ever outwards to the sea. Strangely comforted by the simplicity of intent, I began to imagine them saying '*I am here! I am here!*' Like our photographs of today, perhaps the great Moai are just simple representations of their ancient sculptors' transcendence of certain mortality.

PLATE 20

Ahu Tahai is a ceremonial complex of Moai (statues) near Hanga Roa on
Easter Island (Rapa Nui). These ancient monuments, protected by UNESCO
as a World Heritage Site, are on these remote islands in the Pacific Ocean
at the southern end of the 'Polynesian Triangle.'

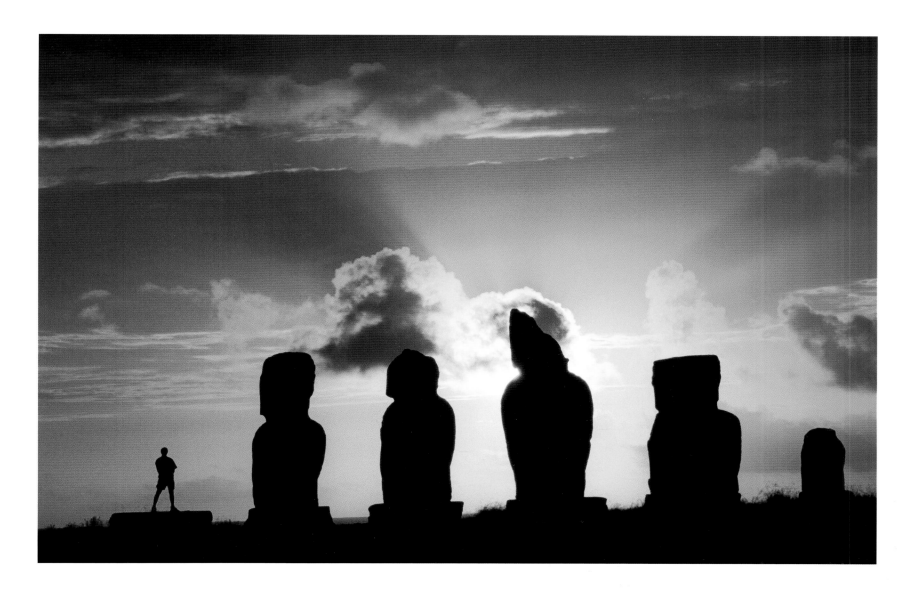

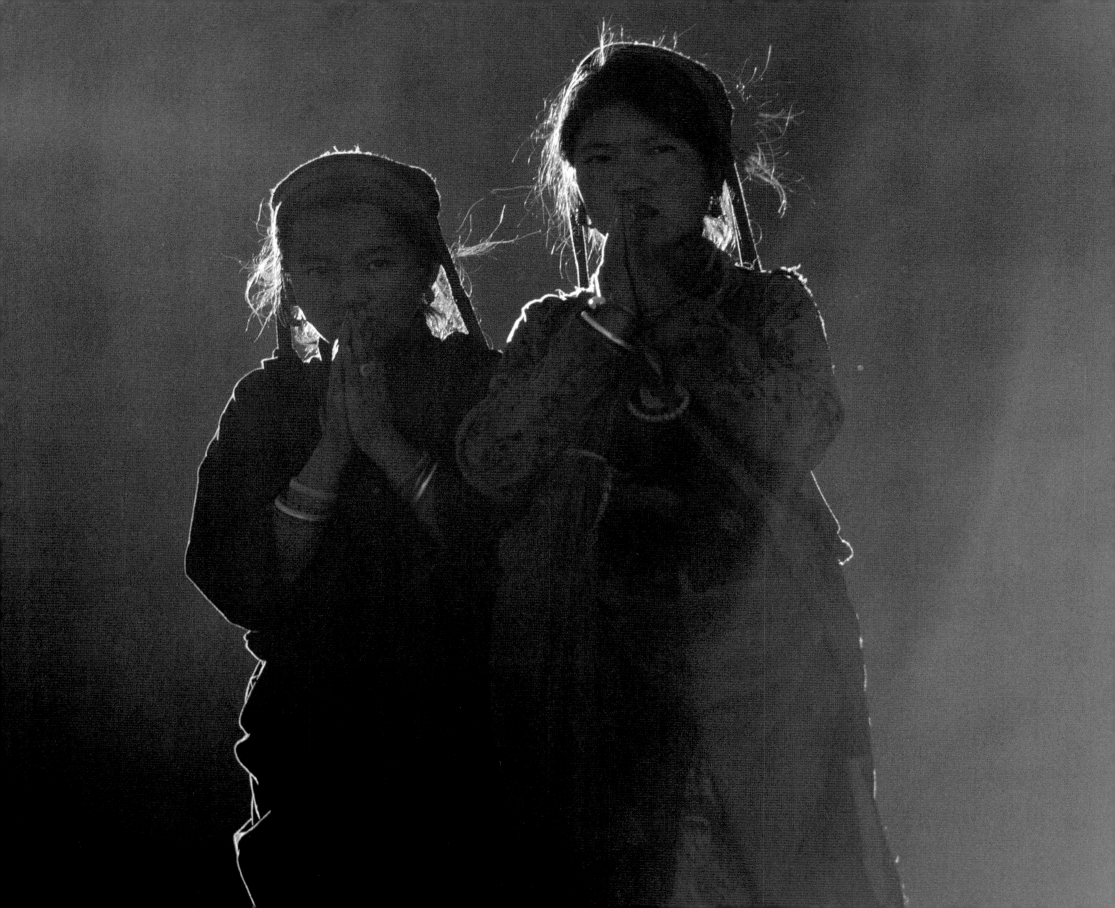

Himal

'Space, and the twelve clean winds are here;
And with them broods eternity—a swift,
white peace, a presence manifest.'

FROM *THE MOST-SACRED MOUNTAIN*
BY EUNICE TIETJENS (1884–1944)

PLATE 21

Girls from the Tamang Clan approaching with the customary salutation 'Namaste,'
literally meaning '*I honor the Spirit in you which is also in me.*' Trisuli Bazaar, Nepal.

There are several magic words in the English language, one of them is Himalaya and another is Everest. As a child I had a favourite book called *The Wonder Book of Adventure* that included most of the notable and adventurous human achievements of the preceding fifty years, such as the voyage of Kon Tiki, and the first ascent of Mount Everest. Along with my weekly comic, *The Hotspur*, I would read these tales of exploration and heroism wide-eyed as my imagination longed to have adventures like these.

The Himalaya is the world's greatest mountain range, and the only one that has peaks of 8,000 metres in height. There are fourteen mountains of this height and hundreds over 7,000 metres. The mountains stretch between Assam in the east, to western Pakistan – a distance of 2,700 kilometres. A huge shallow sea, the Tethys, existed where the Himalaya stands today. The submerged land masses located on top of tectonic plates began pushing towards each other forming the up-thrust of mountains, which are relatively young and continuing to rise at a rate of ten centimetres a year. The words 'abode of snows' and other phrases often associate it with eternal snows – Himachal, Himvat, Himadri. These snow-capped, frosted peaks have not only challenged adventurers but have inspired metaphysical and lyrical poetry with innumerable references to the soul. The poet sages in the *Rig Veda* praise the supreme deity; '*It is He to whom belong these celestial mountain ranges.*'[1] The epic Mahabharat and Ramayana describe the region as a place '*where the gods dwell,*' and it is beautifully evoked in the classical poetic works of Skanda Purana; '*As the sun dries the morning dew so does the mere sight of the Himalaya dissipate the sins of man.*'[2]

From early times there have been waves of population migration into the Himalaya. Pilgrims and adventurers arrived in search of fulfilment, whilst refugees from neighbouring countries established new lives here. These factors combined over a period of time to significantly change the ethnicity of the populace. For example, today the Bhotiyas of Bhutan have influenced the ethnic origins of Sikkim and the Sherpa people of Solu Khumbu in Nepal. Hindu castes like Brahmins and Chetris who speak Nepali, mixed with the Gurkha

(1) The Rig Veda is an ancient Indian collection of sacred Vedic Sanskrit hymns. Some of its verses are still recited as Hindu prayers, at religious functions and other occasions, putting these among the world's oldest religious texts in continued use. **(2)** Puranas – meaning 'ancient times' – are an important genre of religious Hindu, Jain and Buddhist texts, notably containing a narrative history of the universe from creation to destruction. The Skanda is the largest of the Mahapuranas, as recited by Skanda. The Skanda Purana is also known as the Scrap Purana – or scrapbook – because of the way it has been used by Indian authors over the ages; whenever the author wanted to explain a story that ought to be old but did not have a definite source, the author would claim, without any fear of contradiction, 'It's in the Skanda Purana'.

communities of Tamang and Gurung in the hill farming central regions of Nepal. In Kumaon and Garhwal in the central Himal, Khasas who arrived from west central Asia as nomadic tribes, spread through Kashmir to Assam.

The vast area covered by the mountain ranges of the Himal, along with some huge altitude gradients, has resulted in the tremendous biodiversity of flora and fauna in the whole region. Vegetation and wildlife both change according to the varying altitude and the resulting differences in climatic conditions. They range from the tropical deciduous forests in the foothills, to temperate forests in the middle altitudes, while, higher up, coniferous sub-alpine and alpine forests thrive. These finally give way to alpine grasslands and high altitude meadows, which are followed by scrublands which lead up to the permanent snowline. However, the floral wealth of the Himalaya has also been affected by people whom, over the centuries, have always been dependent on forests for a number of their needs. In earlier times, these needs were few, so the forests were able to replenish their resources, and the delicate natural balance was sustained. But over the years, the human population increased dramatically, and with it the number of industries that depended on forests. Extraordinary demands were made on them.

Forests were cut down for firewood, and to feed the growing number of forest-based industries. They were also cleared to accommodate the growing population. As a result, many species of tree that were very common even fifty years ago are now rare or have completely disappeared from certain areas. In many areas agricultural field terraces were constructed to hold both the soils and to retain irrigated water.

Like the plant kingdom, the fauna of the Himalaya also shows great diversity due to the wide range of habitats, from tropical to super alpine. Animals such as the wild yak have adapted to the conditions in the mountains where there is bitter cold, the lack or excess of rainfall in certain parts, or the increase in altitude. Some animals seasonally migrate in search of food and better living conditions. Many, such as the blue sheep – or bharal – and the ibex, travel from lower altitudes to higher elevations in summer in search of alpine grass. In winter, the animals tend to descend to lower altitudes to survive the bitterly cold winds. Some animals hibernate in winter while others resist the cold by having thick fur. One of these, the extremely rare snow leopard that survives at high elevations, usually follows the movements of its prey, the ibex and deer. Deforestation in Sikkim and other areas have reduced the habitat and range of the red panda, which is now extremely rare.

But in 2010 a remnant population of Bengal tigers, surviving at over 3,000 metres in the mountains of Bhutan, were discovered by a scientific research expedition, which may be crucial evidence in the ultimate survival of this spectacular and endangered species.

The Himalaya lie along the main migratory routes of birds flying into the subcontinent from the cold north to central Asia and back. Birds follow the valleys of the major rivers, which originate in the Tibetan plateau and have cut across the main Himalayan mountain wall. The cape barren goose and black-necked crane for example are known to fly to altitudes of 5,000 metres to cross high passes in migration. Raptors are common in the high mountains. Carrion feeders like the lammergeier and griffon vulture have entered local folklore, such is there mythical presence. Golden eagles, sparrowhawk and snow cocks range freely in the high valleys and mountain slopes. The high altitude lakes and marshes of Ladakh and Tibet provide an ideal habitat and breeding ground for wild ducks, geese and wading birds.

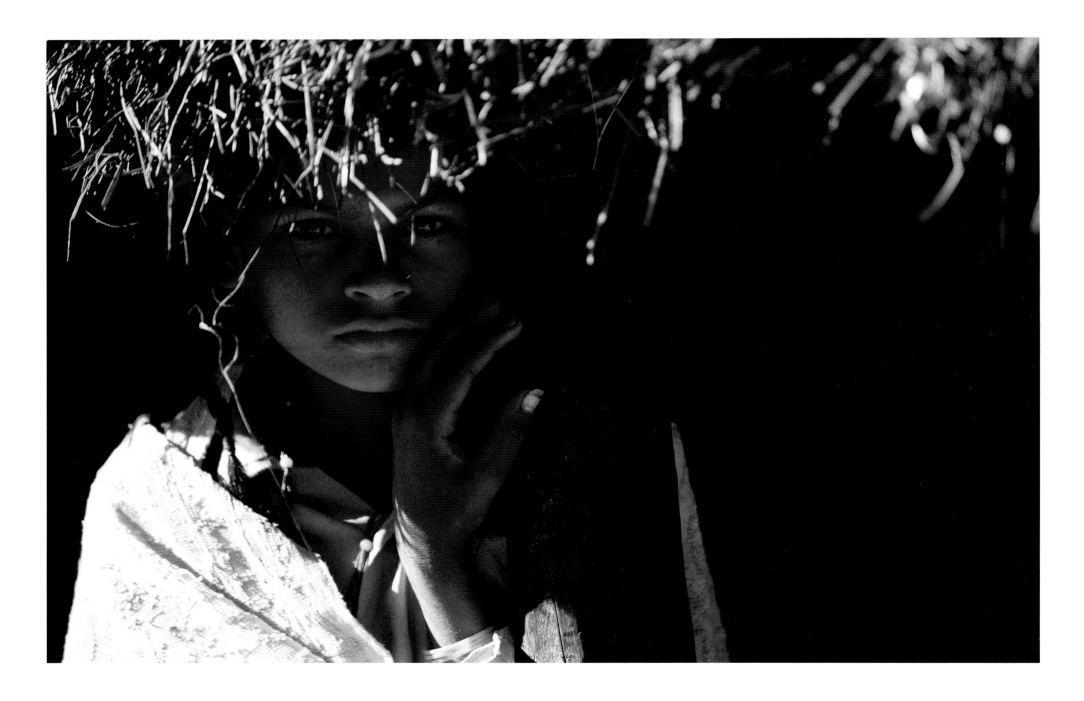

PLATE 22
Tamang girl beneath thatch-roofed home in Syabrubensi on the approach
to Langtang Valley. Dhunche, Nepal.

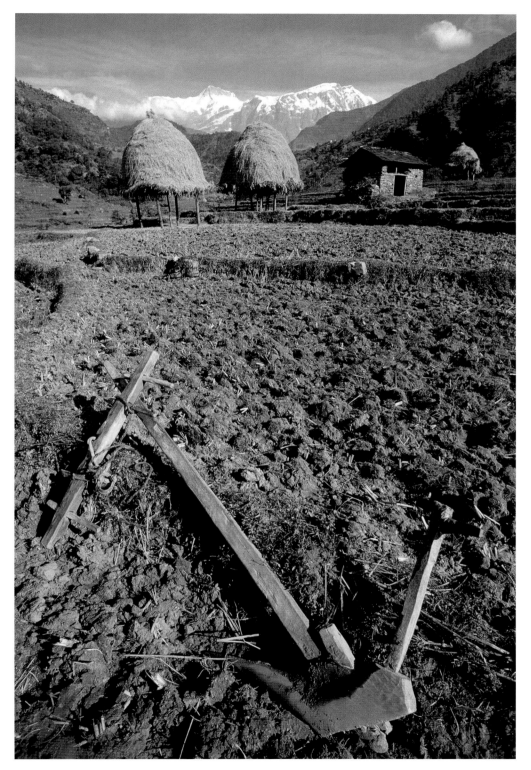

PLATE 23

Traditional ploughshares pulled by buffalo are used to till the millet fields below the village of Siklis near Pokhara. In the background, Annapurna III rises to 7,555m at the head of the Seti Kola. Central Nepalese Himal.

HIMACHAL, 1974

In 1974 as a young student, I was invited to join an expedition to the Dhauladhar Range of the Himachal Pradesh of Northern India by my friend from a local mountaineering club, a highly experienced expedition mountaineer called John Allen. The expedition would traverse on foot across the Great Divide of Himalayan mountains, climbing virgin peaks en route before descending into the mysterious and relatively remote Chandra Bhaga river valley on the very edge of the prohibited districts of Lahaul and Spiti. As a young guy of 23, and with no alpine experience, this was a very scary cherry to bite.

The four-day march up into the Chobia nullah in the late summer monsoon began at the end of all roads in the tiny village of Brahmaur. We walked with heavy loads for two days hoping to rendezvous with our porters higher up the valley. Then the rain began in earnest. That evening I wrote in my diary:

'Hollyhocks on the trackside, temple chants, incense and cowherds … a strange onset of night with thunder flashes, blackness, yellow sabres, silence and wonder … the morning broke crystal clear, nine porters arrived. We set off through beautiful pine forests and gorges, crumbling tracks above torrents and rickety bridges.' 2 August 1974

Incessant rain then fell for three days, and the nullah felt extremely remote as we crossed and re-crossed teetering logs over the glacial meltwater streams. Beneath an overhanging cliff we came upon a group of villagers flinging stones with slingshots up under the overhangs to dislodge bees nests. Broken off honeycombs were cascading down, the rock was dripping with amber honey. Most of the bounty was pressed into their jacket pockets, some was offered to us. Luckily I didn't eat it; those who did were violently ill for several hours! It was not the honey, more the hands that gave the gifts that did for them!

Deep, flower-filled alpine slopes above us bore signs of digging activity by the shy Himalayan moon bear that frequents these higher regions. The final nine-hundred metres to the upper glacier basin was a steep and loose scree slope leading to a knife-edge crest of soft snow that levelled into hollows and islands of rocks. Here above the ocean of monsoon clouds below us, the beauty of the high Himal was revealed at last. From our glacial moraine base camp on Chobia La at a height of 4,100 metres, peak upon peak, strung like a pearl necklace, floated on a cloud sea all around. Unfortunately, the blinding headaches that had begun at 3,400 metres, and which had left me without sleep for two nights, had become more severe, and tomorrow

I was to attempt my first climb. My diary records:

'Splitting headache for 14 hours, feeling like death
I crawl from the tent and attempt to eat … nauseating
… but out here a spectacular Himalayan dawn is
breaking, unearthly colours glowing on the horizon, the
moon is hanging like a wandering ship in a silver sea.
Today I must drag myself up a mountain.' 6 August 1974

Over the years I have experienced extraordinary
elation when living through moments of emerging
dawns; it is as if some primitive awakening is taking
place. Whatever it is, it empowers the spirit to be strong
and encourages one upward. Excited by some inner
energy, I left camp alone intent on exploring the higher
ridges. Looming for brief periods from the grey pall,
were shining mountain summits veiled and elusive.
At 5,350 metres, on a prominent peak along a summit
ridge of corniced snows in swirling mist, I decided that
my pounding headache was now too severe to dare to
continue. It was the end of the affair for me; I sat down
in the snow. My diary again:

'After four gruelling hours I emerged on a small summit,
probably a first ascent? … with a euphoria of limitless
extent. On this spot, I buried a stone and a leaf given by

my dear sister Pauline so many miles away, I read a letter
from her, and wept in joy of this solitude. … Thick cloud
driven up the mountain suddenly made my descent quite
dangerous … arrived base camp at 12.30 p.m., slept
fitfully all afternoon.' 6 August 1974

In heavy snow the next day we decided to crest
the pass of Chobia La – 5,020 metres – at a point
where a narrow slot cuts through the rocky ridgeline.
In the gash was a Hindu shrine to Shiva; a forked
trident, votive offerings, rupees and prayer flags and
a small pewter bell. How curious to see signs of life
up here. All around were animal droppings, in places
several centimetres thick. We roped up at the brink
of a vertical thirty metre drop and abseiled to the
glacier below. Presumably during the onset of winter
snows shepherds drive sheep and goats through this
snow drifted portal and cast them from the cliff to
the steep snowfields below. We pressed on, slithering
and sliding into a remote, wide glacier valley on the
north side of the range. This was the actual Himalayan
divide from where all drainage would change direction.
The water from the glaciers here would flood into
Tibet, whilst the waters from the south of the pass
would drain into the Yamuna Ganga and cross India.

>>

That night we bivouacked beneath a huge over-hanging boulder. Food was short; we ate nettles and sucked clean water from a mossy spring. Two days further down the valley, after struggling across miles of compacted moraines, we walked into a sleepy village called Triloknath, shaded by scented cedar groves and poplars, an oasis on a bench above the seasonal ravages of the tumbling glacier river below. The disputed border of Kashmir is very close at this part of the Chandra Bhaga valley, western parties were rare here, and it was preferable that we kept moving on our way. A lorry collected us and we drove east through the district of Lahaul, up over the misty heights of the Rohtang Pass into the Kulu Valley, and down through hillsides of marijuana into steaming India far below.

This first visit to India was crucial in my mountaineering life, giving me confidence in the hardships of travel, to experience unmapped mountainous terrain, and to engage for the first time with self-sufficient highland cultures. The high Himal had worked a spell on me; we had entered wild country and experienced a summer of raw nature.

PLATE 24

In 1974, as a young teacher, I was invited on my first expedition to the Himalaya.
In every village we were feted with great interest and amusement.
Brahmaur, near Chamba, Himachal Pradesh, India.

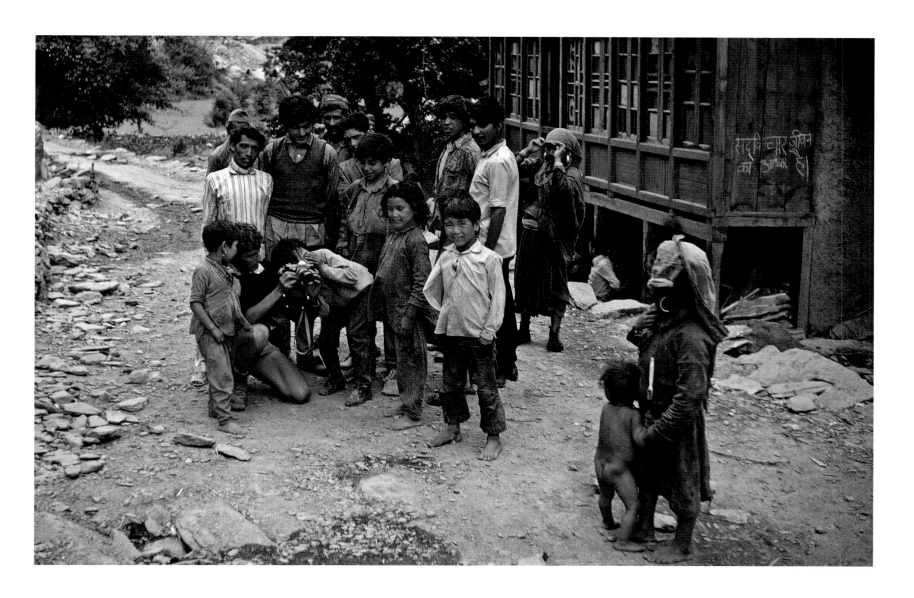

EVEREST

**Chomolungma, '*Mother Goddess of the Universe*,'
say the Tibetans of old Rongbuk, Sagarmatha,
'*Mother of the sky*,' say the Sherpas of Khumbu –
both names given to a vast bulk of rock and ice that
appeared to be considerably higher than its neighbours.**

The height of Peak XV was recorded in 1856,
and renamed by the British Surveyor General of India
– Andrew Waugh – in 1865 after his predecessor,
Sir George Everest. More recently, modern science
has verified its present height as 29,036 feet – or 8,850
metres – and the summit of Mount Everest is the
highest point of the earth's crust above sea level.

Since the first recorded ascent on 29 May 1953,
by Sherpa Tenzing Norgay and Sir Edmund Hillary,
over 2,400 people have climbed to the top.[3] Today
following the advent of escorted guided ascents, high
paying clients risk excessive dangers of high altitude
edemas, short-roped and breathless, in the hope of
attaining the summit and motivated often by the status
accrued from such agonies.

I remain curious but content to gaze at a distant
vista of its skyline as dusk descends, and to remember
how I felt about this mountain shining in my childhood
memories: an exotic faraway presence, a gravely dangerous
mountain whose careful reconnaissance and subsequent
early ascents were borne from a long series of bold
enterprises at the heart of true exploration.

(3) Edmund Hillary joined Everest reconnaissance expeditions in 1951 and again in 1952. These exploits brought Hillary to the attention of Sir John Hunt, leader of an expedition sponsored by the Joint Himalayan Committee of the Alpine Club of Great Britain and the Royal Geographic Society to make the successful assault on Everest in 1953. For reference: Sir Edmund Hillary, *View From The Summit* (London: Corgi, 1983). ISBN: 0552151041. Sherpa Tenzing Norgay was born in Thame, Nepal, and moved to Darjeeling as a child. Always intent on climbing the great peaks of the Himal, he eventually reached the summit of Everest with Edmund Hillary in 1953. At nineteen years old Tenzing landed a place on Eric Shipton's 1935 Everest Expedition. Then, with the reputation of having nearly climbed to Everest's summit in 1952 with the Swiss, Tenzing was invited to join John Hunt's successful British attempt in 1953. In later life, feted worldwide, he became the first Field Director of the newly established Himalayan Mountaineering Institute, a post that he held for twenty-two years, before his death in 1986. For reference: Ed Douglas, *Tenzing: Hero of Everest* (National Geographic Books, 2004). ISBN: 0792265572.

PLATE 25

Dawn breaks on one of the greatest mountain ranges on earth. Mount Everest, 8,850m (left), hides beneath banners of jet stream with Lhotse, 8,516m (middle), and Nuptse, 7,855m (right), high above the Khumbu Glacier. Nepal.

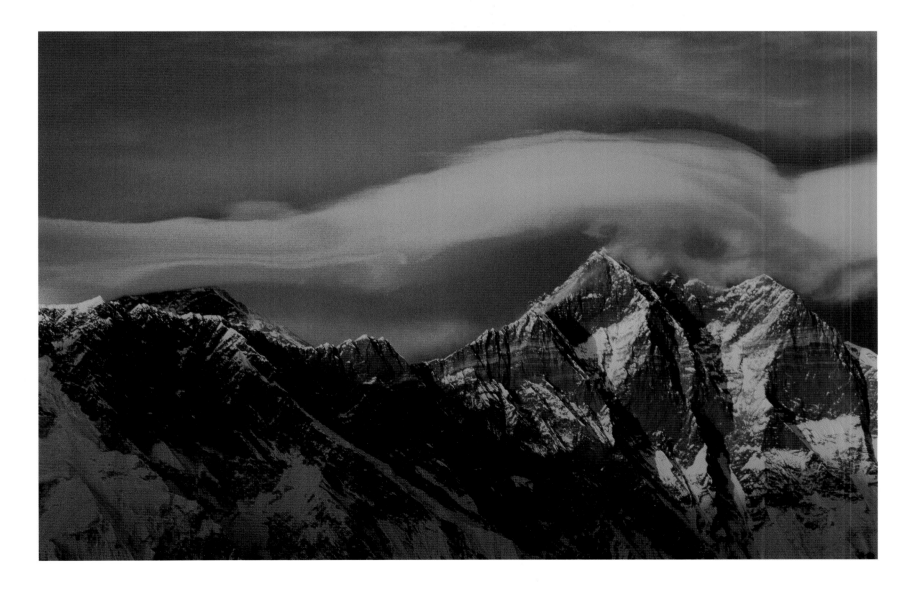

PLATE 26
Chorten stones and mani walls beyond the village boundary of Khumjung in the Khumbu Valley above Namche Bazaar. Nepal. *'The visual impact of the chorten on the observer brings a direct experience of inherent wakefulness and dignity. Stupas continue to be built because of their ability to liberate one simply upon seeing their structure.'* – Chögyam Trungpa Rinpoche

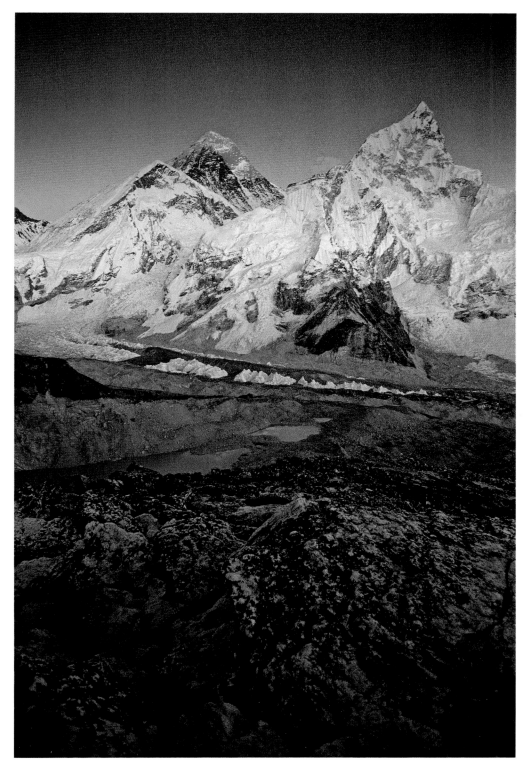

PLATE 27

Last rays of light on Mount Everest 8,850m (left), Lhotse 8,516m (centre), and Nuptse 7,855m (right), from the summit of Kala Pattar, 5,545m, above Gorak Shep, Khumbu, Nepal.

GATLANG AND TIPLING

The old narrow bridge crossing the kola at the approach to Syabrubesi was washed away in floods. A new bridge of steel, spanning a higher gorge, had only recently opened to traffic. The handcarts, piled with sweet smelling grasses, and winter fodder for yaks and mules, would soon be replaced with jeeps and buses from Dhunche and beyond. A plan to cut the road a further seventeen kilometres over the Tibetan border at Kyirong would soon be completed creating heavy traffic, trading lorries from Kathmandu and a swifter alternative route to Lhasa. The quiet magic of Langtang Himal would be changed as the ancient yak salt trains and leather traders from the north are displaced by lorries grinding along the valley sides. The tinkling bells and morning cockerels replaced by growling engines and trumpeting horns. The dusty little village of Syabrubesi lying close to the river beneath the pine and cedar forests of Langtang Lirung in the west and the wilds of Ganesh Himal to the east, was our starting point for a journey back in time to the high passes and remote villages of the Tiru Danda.

Stony pathways constructed hundreds of years ago thread their way across the steep ridges linking the remote communities in a complex landscape of ravines, forests and alpine meadows. Away from the bustling valley all was quiet. Time slows down walking these old trails.

I sensed change here. Wild, Tibetan-looking children tending goats greeted us with smiles, curious and eager to show our way up to the higher passes. A small group of women dressed in homemade felts were spinning their dangling handlooms, busily twisting sheep's wool into usable yarn. It was early autumn and the lower terraces were thronging with families harvesting millet and mustard. Sweeping sickles and wicker baskets are the age-old tools of the villagers who have adapted practices learned over generations of tough living.

In the cluster of wattle and daub houses of Gatlang, a ritual feast was being prepared. Three Tamang farmers had been swept to their deaths in a rockslide. Holy lamas arrived from the nearby Tamang community of Tipling to officiate and bless the clay effigies prepared to embody the spirits of the departed. Scores of butter lamps and rice balls were being prepared for the funeral feast, and presented in the village square bedecked with a thousand fluttering prayer flags. The cold winds of winter were expected soon. Wood was being gathered for fuel.[4] Mist shrouded the last lichenous trees before the rocky alpine heights emerged.

We rested for a day here, and wandered the crests looking always toward the glistening high snows of Ganesh, shining, and compelling us upward.[5] Ahead of us, beyond a dwarf juniper forest, we spied animal

tracks in an old snow patch. They were clearly feline and perfectly one behind the other. I imagined lynx or even snow leopard stalking these ridges, indications of our remoteness in this epic and undisturbed mountain place. But there were others too, and these footprints were extremely large. We crouched down to measure them; they too were in a singular line making a decisive turn towards cover. Was this yeti? It was so easy to envisage a gangling quadruped loping across the high snows, maybe islanded by human disturbance, a throwback entrapped by ecological changes. My companion was Alfred Gregory, who had been to Everest's South Col in 1953 with Hillary and Tenzing, and whom had known Eric Shipton during his heydays of intense exploration.[6] We were excited and amazed at the thought of such a beast, and entirely at ease with the possibility of a creature unknown to science surviving in these wild Himalayan heights.

(4) Woodcutting from local forests in the Himalaya is now a major environmental problem. Felled trees are unlikely to be replaced, leaving denuded hillsides from which soils are left exposed to weathering and subsidence. Use of kerosene is now an established domestic alternative for fuel in high villages. Micro hydroelectricity schemes are also being developed in many regions. (5) Ganesh is remembered as the God of knowledge and the remover of obstacles. He has four hands, an elephant's head and a big belly. His vehicle is a tiny mouse representing wisdom, intelligence, and presence of mind. (6) Eric Shipton (1907–1977) was the only veteran of all four 1930s Everest expeditions. It was Shipton who led the 1951 reconnaissance to the south side of Everest. Born in Ceylon, now Sri Lanka, but educated in England, Shipton established his climbing credentials in the European Alps. In 1928 he went to farm coffee in Kenya, where he met H.W. Tilman, his future expedition and mountaineering partner. Later he began a new phase of writing, lecturing, and exploration, mostly in South America where, in his mid-fifties, he traversed the Southern Patagonia Icecap. For reference: Eric Shipton, *The Six Mountain-Travel Books* (Seattle: Mountaineers, 1997). ISBN: 0898865395.

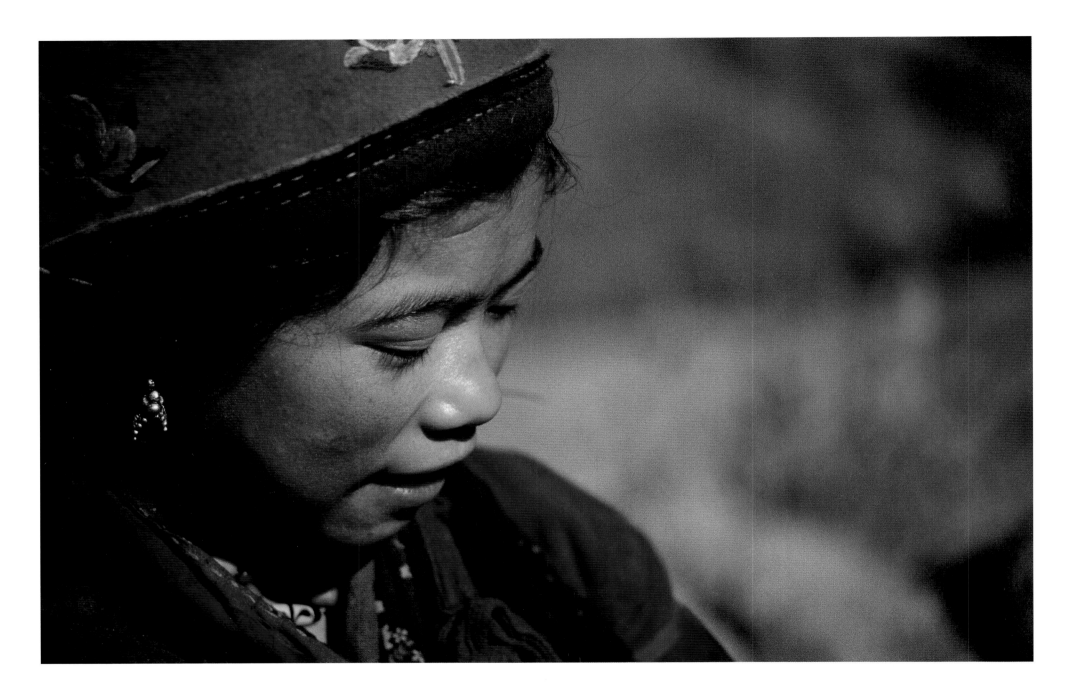

PLATE 28
Shepherd girl from Tamang clan village of Gatlang, 3,650m, on the Tiru Danda
Pass. These expert traditional weavers make their own felt clothing and
create simple tin jewellery. Ganesh Himal, Nepal.

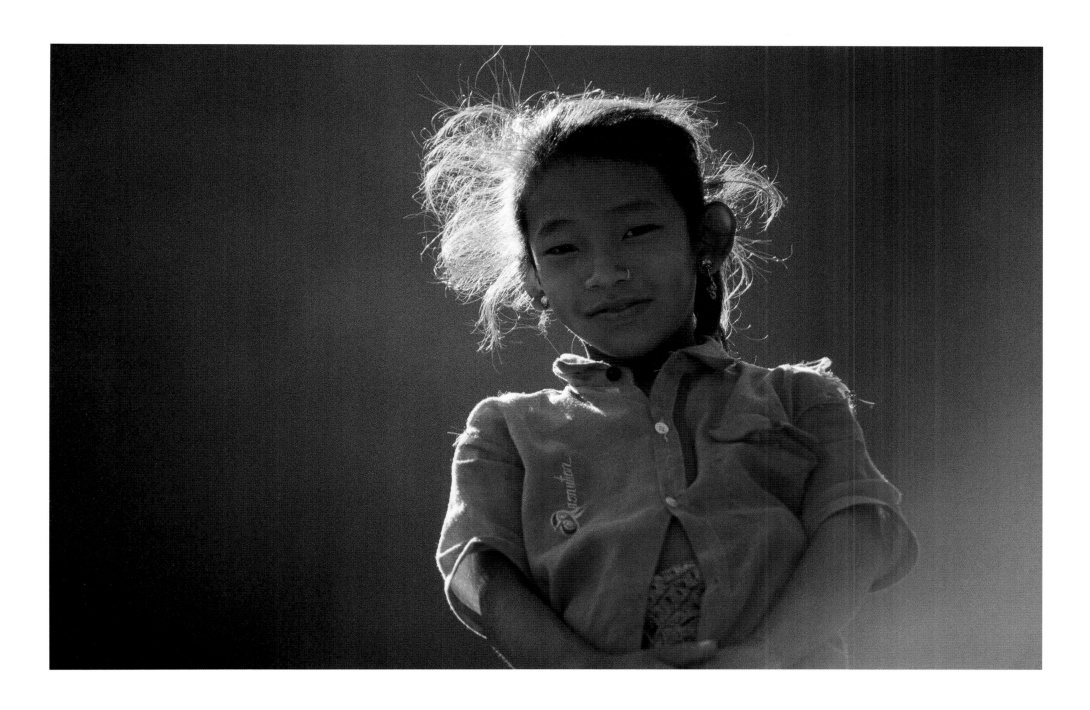

PLATE 29
Rinzen Sangmar, daughter of a passing Tibetan trader, watches our arrival
in Tipling, Ganesh Himal, Nepal.

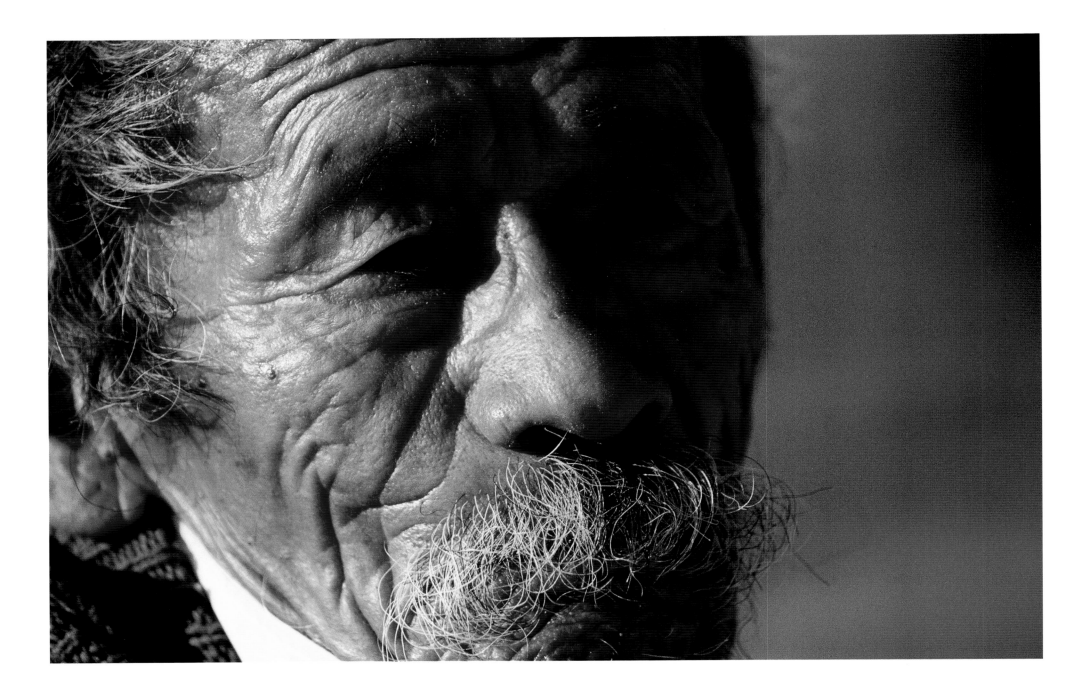

PLATE 30

Life expectancy in Nepal rarely exceeds 67 years of age. This Gurkha man was nearly 80 years old and working in the fields with his son.

PLATE 31

Om Mani Padme Hum. Mani stones are hand-carved Tibetan prayer stones whose inscriptions represent the embodiment of the Buddha's great compassion. The purpose of a Mani stone is to remove obstacles and purify the karma of the deceased. Siklis village below Machapuchare, 6,993m.

GOKYO

Trekking in the high valleys of Khumbu is to walk in one of nature's most astonishing amphitheatres. Even though it is a popular destination for trekkers, there is a very good reason; it is one of most spectacular places in the world.

High above the Ngozumba glacier is a small sherpa community called Gokyo, just a handful of simple dwellings and summer barns for yaks and shepherds. Today there is a small lodge for travellers and a first aid facility mainly for emergencies of altitude sickness. My diary entry from November 1989:

'Set alarm for 4.30 a.m. tea and porridge in Prem's tent. Left camp at 4.55 a.m., outside fierce cold and starlight. A heavy coating of frost and powder snow ... made good time with Kami sherpa toward Gokyo Ri ... Cholatse across the valley, inky black and jagged. Strange golden fiery cloud appeared with dawn near summit of Nuptse (like the golden tongue on the mandala in Thangboche monastery depicting the Himal as a dragon's body). The sun rose over Tibet, Cho Oyu out there in the cold sky ... and somewhere in the stony moraines, Shipton's old camp. And shining Menlungtse ... wow! ... rods of silver in the west. Descended quickly with stiff knees. In the boulders and dwarf juniper, Himalayan snow cocks running around, gliding low ... I stalked them for half an hour with my camera. Back to camp with prickling eyes ... too much photography I think. ... later same day crossed Ngozumba glacier toward Cho La ... scrambled over moraines into a different world, gloriously elemental, stone desert, ice, sand and silver pools ... glistening peaks on all sides ... and no one seemed to notice.

Cho La is high ... rocky col of 4,690m. It is the way through to the beautiful valley of Dzongla. This mountain scenery, breathtaking beyond words ... always Cholatse above like a huge ship's sail ... plunging ice couloirs into Chola Tsho Lake, a glittering turquoise jewel.' 1 November 1989

PLATE 32

Cholatse, 6,440m, above the Ngozumpa Glacier, Gokyo, Nepal. A tiny light
high on the face (upper right of photograph) indicates the bivouac site
of a mountaineering party.

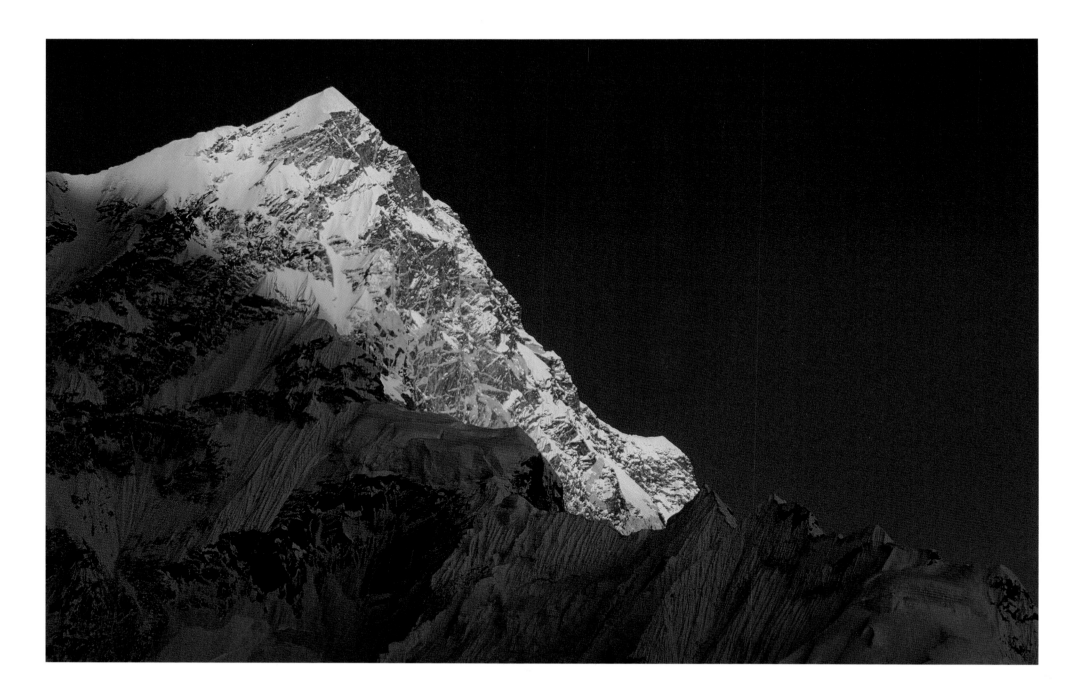

PLATE 33

Last light on Nuptse, 7,855m. First climbed 16 May 1961 by Dennis Davis
and Sherpa Tashi as part of a British expedition.

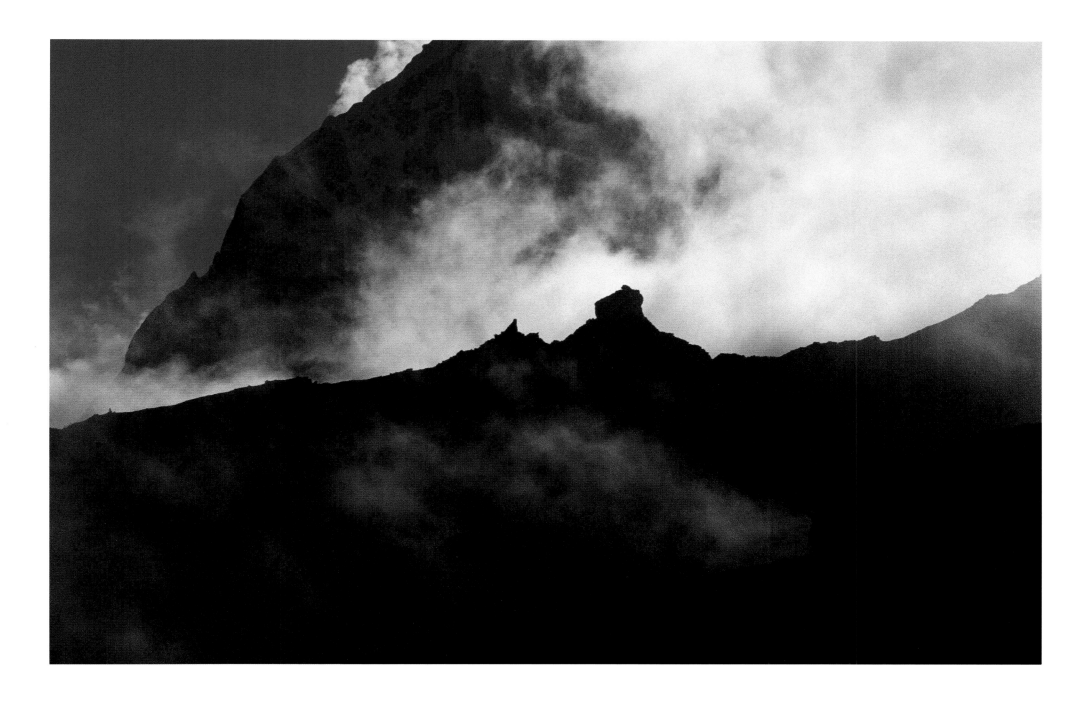

PLATE 34

Cholatse, 6,440m, emerges from the cold mists as the morning sunrise fills
the meadows of Dzongla. Pheriche, Solu Khumbu, Nepal.

GANGOTRI

As night fell, early planets quietly appeared in a darkening blue sky, and soon, a billion stars. Sparkling galaxies streamed overhead like celestial mist, an aura in the solar system, and to my comprehension. The only sound was from the river below; of tumbling waves over rocks. Ah Ganga, you mother of all rivers.[7] Here, at the river's birthplace, is a communion of space, a sublimation of wild energies flowing from ice crystal mountains into the soul of a continent.

The Bhagirathi and Yamuna rivers emerge from glaciers high in the Himalayan mountains, but only fifty kilometres from their sources they join together and flow down onto the Indian Plain as the Ganges, revered by millions as a symbol of purity, the 'nectar of immortality.' To walk to its source in the rarefied air of the Gangotri Glacier is a pilgrimage undertaken by thousands each year, who, through privations and fasting, will cleanse their sins by immersing in the River From Heaven at Gaumukh, the Cow's Mouth.

Rolling about in a tight sleeping bag when it's minus 15C is no fun. Especially when you already have a violent headache and slight delirium from ascending too quickly above 3,000 metres. Crazy images flowing through my mind were interrupted by a ghastly shriek

outside. It was 2 a.m. I awoke properly, in time for the bleating cries to die away into the silence and darkness. Morning couldn't come too soon. The Upper Gangotri valley is a cold, bleak place. The last trees of any size were cut down for firewood twenty years ago by pilgrims on their way to the source of the Ganges, just five kilometres further upstream. A recent replanting scheme is working well; a leafless copse of birch saplings at Bojwasa reminded us that late autumn heralds early snows and icy winds sinking down from the crystal ice peaks that surround this place.

The river tumbles by through bleached boulders carried by the receding glacier front. It is a favourite crossing point for the wild bahral – or blue sheep – of the Himal. Just two days before, we had seen a group of thirty crossing a distant high couloir. Clattering stone fall and a dust cloud shot through with slanting light marked their passage across the side stream. A big horned male stood momentarily on hind legs as if defying gravity on the exiguous crest of the loose moraine debris. The females followed in small groups; dancing, leaping, and balancing like genies on the walls of the steep collapsing chasm. By the river that morning were strong paw prints of a big cat, a snow leopard

(7) The Ganges river, personified as a goddess, is worshipped by Hindus, who believe that bathing in its waters causes the remission of sins and facilitates liberation from the cycle of life and death. Pilgrims travel long distances to immerse the ashes of their kin in the waters of the Ganga, so that their loved ones will pass on to heaven.

most probably, and I remembered again the night screams, the thrashing of dwarf azaleas and frosted berberis. The leopard had struck out at the herd.

The final walk to Gaumukh follows a twenty kilometre trail through golden autumnal woodland, crossing clear side streams and gaining height slowly in bare alpine scenery towards the spectacular rock and ice peaks of Shivling and Bhagirathi. We chose to hike up here late in the season, before the snows of winter and after the pilgrims had left, at the end of Diwali on the day of Yama Dwitiya, when the goddess Ganga is ritualistically carried on a palanquin down to her winter quarters at Mukhab near Harsil, where she will wait to return after the spring thaw. The village was icy cold and completely – and surprisingly – empty. Just a handful of sadhus remained, the jumbled stores and cafés shuttered and locked. Two off duty policemen, a temple cleaner and a very poorly French girl hiker crying out '*Je dois sortir d'ici, aidez moi?*' were the only people we encountered that day. The tiny passageways and twisting footpaths echoed with the granite thunder of the Saur Kund waterfall crashing through the gorge.

Across the world there are a number of special places where people visit to enrich their lives through pilgrimage. The experiences desired are often not easily identifiable, for while there, they might receive energy or insights uncommon in everyday life. It may be the configuration or topography of the land, it may be quietude or a perceived episode as if in the presence of a deity, but in whatever form, the hope is to return with a small found wisdom that remains with them for life. One may be wary of such imaginings, but there are always unexpected atmospheres in such places when wonder plays its part. Whether interested in Hindu philosophy or geologically spectacular landscape, the source of the Ganges at Gaumukh is a mighty place. >>

Beyond Bojwasa the valley widens out into a jumble of loose, stony moraines, residual and bleak from the recently accelerating glacial recession. Ahead of us the aspect of Bhagirathi Peaks I, II, and III, and the summit cone of Shivling come fully into view. Immense orange rock walls seer up into the sky, split by silver spears of ice and fluted snow. The histories of the first ascents lend redolence to the feel of the place.[8]

Beyond the final moraine, and about 500 metres before the secret ice caves of Gaumukh, the ground falls away in a series of giant clusters of polished boulders interspersed by white silica sandbanks glittering with flakes of mica. In this mountain desert, small tufts of golden reed grass, so fragile and brief, have gained a hold on the collapsed valley soils. Squabbling alpine choughs, ubiquitous scavengers of the high peaks, eek out a living from pilgrims' detritus.

The lammergeier vulture courses in the ether high above, searching for bones. A Hindu shrine dedicated to Lord Shiva, and dressed with effigies of Ganesh and Ganga herself, is bedecked with bells and fluttering prayer flags, creating a final dramatic gateway to the source. Thick lenses of ice swathe every river rock, as the sacred waters gain pace, liberated from the gaping, thundering blue mouth of Gaumukh.

We crouched by the calm pools encircled by the power of mountain gods, removed our boots, and washed our sins away.

(8) Shivling was first climbed by Indo-Tibetan Border Police in 1974, led by Hukam Singh. See *Shivling*, by Ed Douglas, in *World Mountaineering*, ed. Audrey Salkeld (Bulfinch Press, 1998) ISBN: 0821225022. Bhagirathi Peak III (the right hand curving yellow ridge) was first climbed by a British party up the steep South West Ridge in 1983 by Allen Fyfe and Bob Barton. Described by some as 'one of the world's finest rock climbs.' See: Andy Fanshawe and Stephen Venables, *Himalaya Alpine-Style*. (Hodder and Stoughton, 1995). ISBN: 0340649313.

PLATE 35

Bhagirathi Peaks I (6,856m), II (6,512m) and III (6,454m) rising above Gangotri
Valley, near the last birch woods of Bhojbasa.

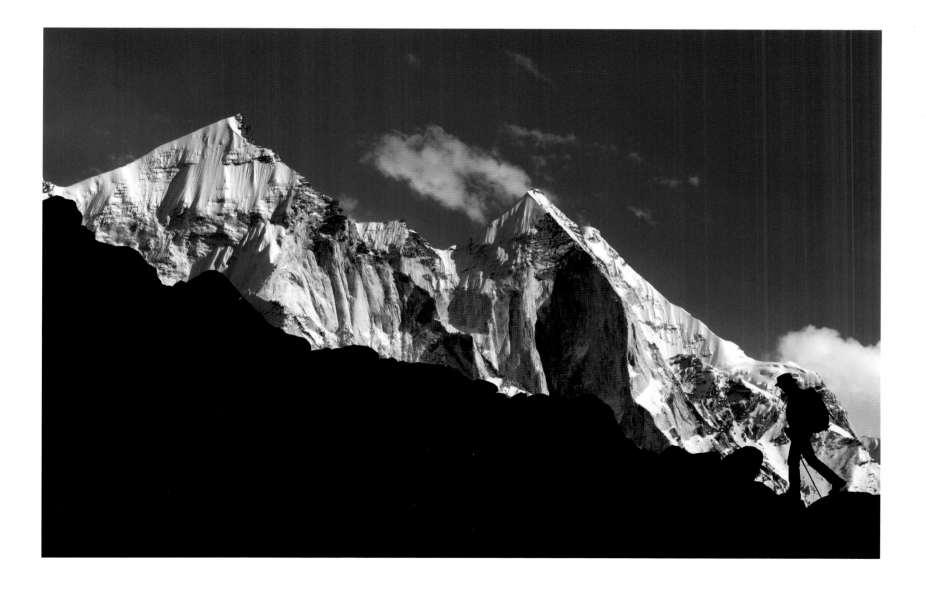

PLATE 36

Berberis *Berberis aristata*, a medicinal shrub of the high alpine valleys of
the Indian Himalaya. Its roots, stem, bark and fruits are used in many
ayurvedic preparations. Gangotri Valley, Utterakand, India.

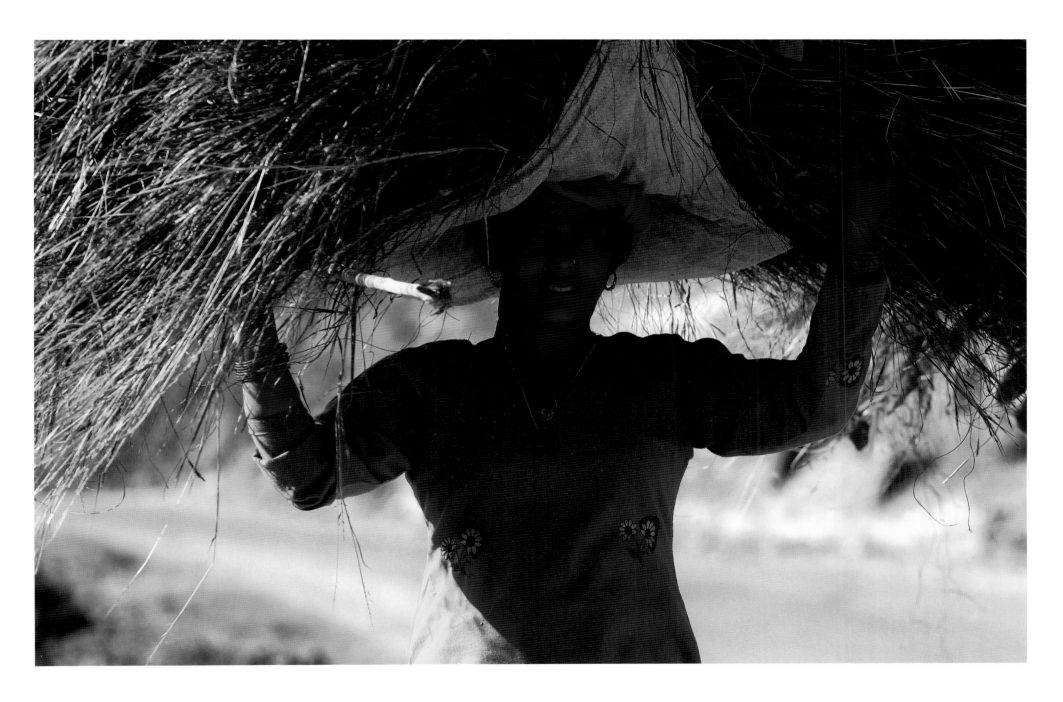

PLATE 37

The traditional method of carrying agricultural produce is by balancing the weight on the head using a conical 'turban' of wrappings, as in this example, for the large volume of grasses. Uttarkashi, Uttarakhand Province, India.

PLATE 38

Bharal or Himalayan Blue Sheep *Pseudois nayaur* are active throughout the day on grassy mountain slopes. Due to their excellent camouflage and the absence of cover in their environment, Bharal remain motionless when approached. Once they have been noticed, they run up the precipitous cliffs, where they once again 'melt' into the rock faces. Gangotri Valley, Uttarakhand, India.

PLATE 39
The upper reaches of the Ganges River, 10 kilometres from the sacred source at Gaumukh, where the water issues from a glacial ice cave.

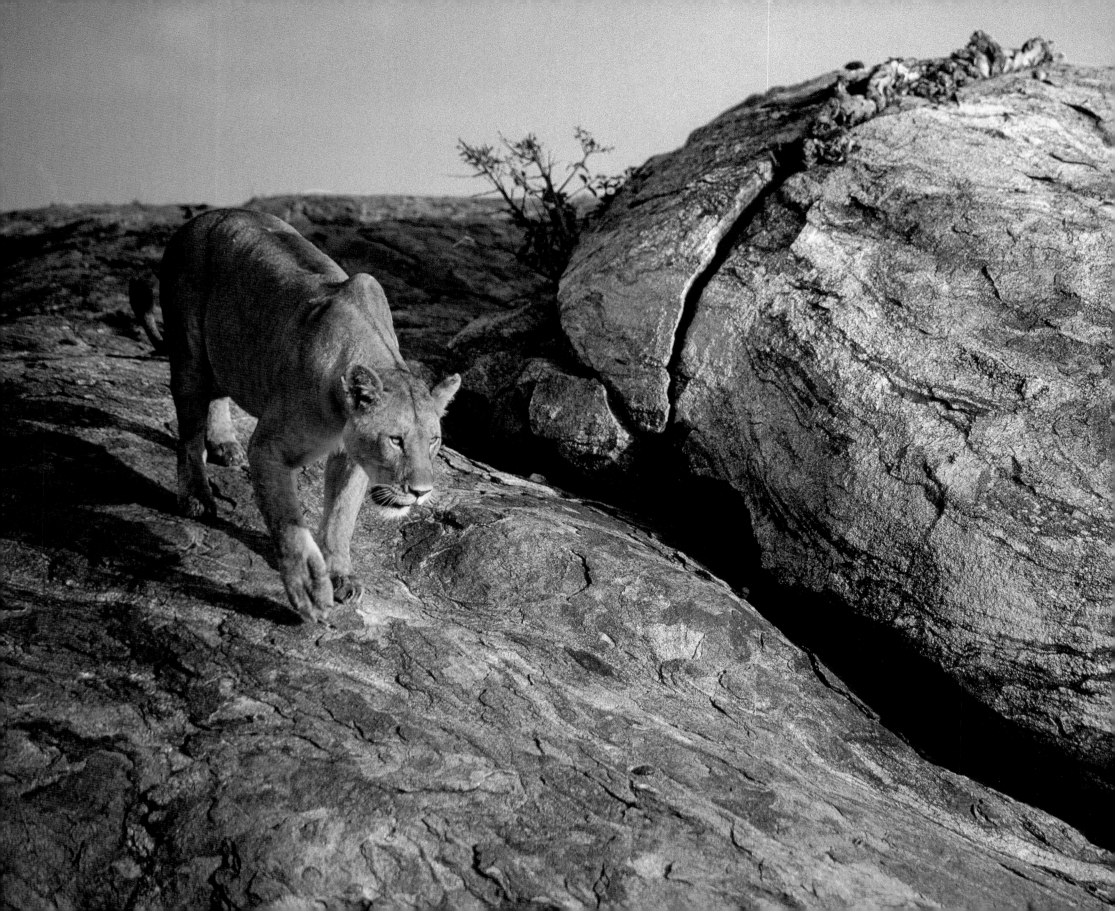

CHAPTER 3

Africa

'*…whence time ever art so still.*'

FROM *THE MYSTERY OF THE OKAVANGO*
BY KAGISO DUBLA SENTHUFHE

PLATE 40

African lioness *Panthera leo* at the Moru Kopjes of Southern Serengeti, Tanzania.
These residual granite tors scattered throughout the grasslands are miniature
ecosystems providing shade and water for animals and birds.

There is a curious sense of déjà vu in the African bush, a feeling that somewhere, or at some time in the primeval past, one belongs here. The fragrance of sage or the catch of animal musk, the waterfalls of birdsong or the constant perambulations of wild beasts, kindle a flame of knowledge that one cannot fully understand; a stripping away of artifice, an epic portal into some ancient desire of the heart. After all, it was from this crucible of fiery sands deep in the Rift Valley that humankind probably began.

Evidence of early hominids was first discovered in Olduvai Gorge in the Tanzanian Highlands by Dr Louis and Mary Leakey in 1959. Further paleontological discoveries – over six decades and three generations by the Leakey family, both in Tanzania and around the shores of Lake Turkana – concluded that modern homo sapiens likely evolved from their ancestors, the great apes, and thence migrated to all corners of the world, beginning around 40,000 years ago.[1]

In Roman times, the knowledge of the extent of the world was very limited. On the south coast of the Mediterranean Sea lay what was known as Africa Province, named after the tribal peoples, the Afri, native to the region we know as Tunisia. The story of the exploration of Africa cannot be told without reference to the fact that its discovery and eventual occupation, mostly by Europeans, was initially motivated by a desire to create trade with the Far East. The world map, by the Greeks, was extremely simplistic, and a landmass beyond the great sand sea was least expected. Prior to the second century, Greek geographers believed that the vast tracts of sand south of Libya and Algeria fetched up against a southern ocean. The Phoenicians explored southward along the west coast of North Africa, sending Hanno the Navigator in 425 BC, whom possibly reached as far as Sierra Leone or even Cameroon.[2] By 146 BC, the Romans had conquered the whole of the known extents of North Africa as far south as Mauritania and Ghana, calling it Africa Nova, which they occupied until the fifth century AD.

Curiosity, simple science and Christian proselytizing motivated these early explorations, but soon the discovery of mercantile goods like spices, silks and precious metals, trading through Venice and Genoa, created a feverish period of daring explorations down both the east and west coasts. The Islamic Provinces in the Middle Ages effectively blocked Asian trading

(1) V. Morell, *Ancestral Passions: The Leakey Family and the Quest for Humankind's Beginnings* (New York: Simon & Schuster, 1995). ISBN: 0684824701. (2) Kevin Shillington, *History of Africa* (Palgrave Macmillan, 2005). ISBN: 0333599578.

from European influence. The Genovese tried to circumnavigate their trading isolationism by seeking a sea route via the Atlantic Ocean to India.

In around 1440, during these early explorations, Portuguese navigators moved inland in Mauritania establishing a fort used for trading wheat and cloth for gold and slaves. The enslavement of tribal peoples for the next two centuries became a dark period in Africa's history. Eventually Vasco da Gama rounded the Cape of Good Hope in 1497 and effectively circumnavigated the Ottoman Empire's dominance of the north-east. Trading developed with Europe through Mozambique, Somalia and Madagascar during this time, when Portugal controlled the Indian Ocean. Portuguese colonisation of inland Africa was to have far-reaching consequences. By 1583 conquests were made in the Kongo (Congo) and Angola regions of West Africa. Catholic missionaries and merchants established colonies in Monomotapa (Zimbabwe); an illegitimate protectorate was created to secure the mineral wealth, but failed due to civil war among the miners.

By the seventeenth century the Dutch had begun exploring and colonising Africa, founding the West Indies Company, which assumed control of most of the slave trading markets from Portugal. At the Cape, the Dutch founded Cape Town as a useful port en route to the new and lucrative trading with Asia Minor. At the same time other European interests were developing outposts for slave trading. English merchant adventurers led by Francis Drake reached the Cape in 1581, but despite establishing colonies in Gambia and Senegal, the Portuguese vanquished most incomers during this period. The Napoleonic Wars, and especially the occupation of Egypt by the British around 1800, had a great influence on the future of the continent.[3] Distracted by the wars, the Portuguese colony at Cape Town acceded to the British crown in 1814. Protestant missionaries travelling inland from Zanzibar returned with reports of snow-capped mountains and a vast inland sea. These missionaries visited little known regions and peoples, and in many instances became explorers and pioneers of trade and empire. A new age of exploration was about to begin.

Even in ancient Greece, the source of the Nile was considered one of the earth's most compelling mysteries, as written about extensively by the historian Herodotus in 460 BC, who believed the river sprang from between two massive mountains. Later, the Emperor Nero ordered his Centurions to follow the Nile in search of this rumoured source, only to flounder in the swamps of the Sudd. Exploration of the Ethiopian Highlands (and the upper reaches of the Nile) was neglected until the nineteenth century due to the war-like behaviour of the Portuguese, who were protecting this isolated Ethiopian Christian kingdom founded by the legendary Prester John (although a Spanish missionary discovered Tisissat Falls on the upper Nile at this time.)

A Scottish explorer, James Bruce, set off from Cairo in 1768 to find the source of the River Nile. He arrived at Lake Tana in 1770, confirming that this lake was the origin of the Blue Nile, one of the tributaries of the Nile. In 1788 Joseph Banks, the botanist who had sailed across the Pacific Ocean with Captain James Cook, founded the African Association to promote the exploration of the interior of the continent.[4]

>>

(3) J.D. Fage and William Tordoff, *The History of Africa* (Routledge, 2002). ISBN: 0415252482. (4) Another Scotsman, Mungo Park, was hired by the African Association in 1795 to explore the River Niger. But, during a second expedition in 1805, Park's party was attacked by tribesmen at Bussa Falls, where he was drowned. In March 1827, Frenchman René Caillié made the first crossing of the Sahara from Timbuktu to Tangier with a caravan of 1,200 animals. Then, in 1855, Heinrich Barth, a German representing the British Government, made a double crossing from Tripoli to Lake Chad and back. However, it was a fascination for finding the source of the Nile that continued to excite this new age of exploration.

In 1841 a missionary doctor called David Livingstone was posted to a mission in the southern part of the Kalahari Desert. He became convinced of his task to reach remote tribes in the interior of Africa to introduce them to Christianity and to free them from slavery. In 1851 he travelled across the Kalahari for a second time and sighted the upper Zambezi River. In 1853 he began a four-year expedition to find a route from the upper Zambezi to the coast, and in 1855 he discovered the great waterfall, which he named 'Victoria Falls'. On reaching the mouth of the Zambezi on the Indian Ocean in May 1856, Livingstone became the first European to cross the width of southern Africa. The exploration to the source of the river Nile remained elusive, but Livingstone, convinced of success, set off lightweight with few bearers northward from Lake Nyasa (Malawi) in 1865. His four-year disappearance prompted a journalist from the New York Herald to travel to Africa and famously search for him with a well-armed expedition of 200 porters. On 10 November 1871 Henry Morton Stanley found Livingstone on the shores of Lake Tanganyika at Ujiji, and uttered the historic phrase '*Doctor Livingstone, I presume?*' to which Livingstone is said to have replied, '*You have brought me new life!*'

Unlike Stanley, who travelled for notoriety and fortune, Livingstone eschewed the chance to return to Europe with Stanley, but continued his quest, finally succumbing to disease in the swamps of Lake Banguela in 1873. Livingstone's heart and organs were buried on site; his body was carried to Zanzibar, thence returned to England for interment in Westminster Abbey. Stanley continued to travel in Africa, became sponsored by King Leopold (the second) of Belgium and navigated the entire length of the River Congo, reaching the sea in 1877.

The abolition of slave trading by Europeans led to a need for a new capitalism, developing from the acquisition of raw materials from Africa. Trade routes were planned, population centres identified and work forces were seconded. Plantations and cash crops of high value were the new 'Klondike' for colonial settlers. The massive scale of industrial farming of rubber, coffee, sugar, palm oil and timber became the African gold so desired four hundred years before.

When early human exploration took place across the continent the interior was seen as devastatingly hostile – physically and climatically – with its vast areas of tropical forest, hot desert and high plateaux. Today, few indigenous peoples survive intact, either in the forests or savannah. Hunter gatherers like the Ova-Himba of the Kaokoveld of Namibia are encouraged to practice pastoralism, while the San Bushmen

of the Kalahari have lost their land rights to farms and hunting concessions and are dispersing from their traditional lands.

The African landmass is very stable, being generally formed by one massive tectonic plate lying on an ancient Pre-Cambrian base. The only high mountains are volcanic extrusions on the plate, such as Mt Kilimanjaro and Mt Kenya, the Ruwenzori Mountains and the Ethiopian Highlands. Little folding has occurred in the stable strata except for that constituting the Atlas Mountains in Morocco and the Drakensburg in South Africa. The Rift Valley, stretching from the Red Sea to Mozambique, was probably formed by movements of the plate, and is a vast drainage system encompassing the River Nile and the Rift Valley Lakes of Malawi, Nyasa, Victoria, Tanganyika, Albert, and Turkana, most of which lie below sea level.

Despite colonisation and agriculture across Africa, great tracts of bush remain pristine and support thriving masses of wildlife, probably the greatest concentration of wild animals on earth. Many of these places are designated as preserved areas with National Park status and represent a new understanding of the value of tourism.[5]

The dusty shale hills of Olduvai Gorge were unremarkable, scattered with ragged acacias broken by elephants and grazed to death by throngs of passing animals. But as I walked down expectantly into the stony hollows where the Leakey's had dedicated their lives to archaeology, there was an overwhelming sense of the long and quiet passage of time. The spirits of ancestors had clearly left this place, it was dust and stone now… just dust and stone. I crouched down and placed my palm on the ground as if divining for a sense of meaning. The rock I picked up was strangely weighty. Upon close inspection it was like a fossil of some kind, stippled and pitted like bone. One side was smoothly curved and cupped, the other sheared off into minute, splintered spears of stone. What fragment was this? Was it of hominid origins, or ossified remnants of a lion kill five thousand years ago? The layered mounds amongst which I walked had yielded secrets of the universe to Louis and Mary Leakey; had altered the voices of science, and revealed our connection to the tree of evolution. On a nearby knoll a stand of fever trees afforded respite from the desiccating afternoon heat. I searched the

shimmering horizon. Far out there to the north, Serengeti glowed yellow in the dying sun, an ocean of waving grasslands, and home to the most astonishing wildlife spectacle on earth.

(5) A recent survey by scientists from the Zoological Society of London and Cambridge University created an index of change in population abundance of species in 78 protected areas throughout Africa. The index revealed an average decline of almost sixty per cent in the population abundance of sixty-nine key species – including lion, wildebeest, giraffe, buffalo and zebra – between 1970 and 2005 in the national parks visited by millions of tourists each year. There is great variation by region, with populations increasing in southern Africa, declining by more than half in East Africa, and declining by eighty-five per cent in West Africa. The massive declines in West Africa are likely due to the lack of financial and personnel resources, high rates of habitat degradation and the growing bushmeat trade. Despite the severe losses, the rate of decline has slowed over time, indicating that management of the areas has been gradually improving.

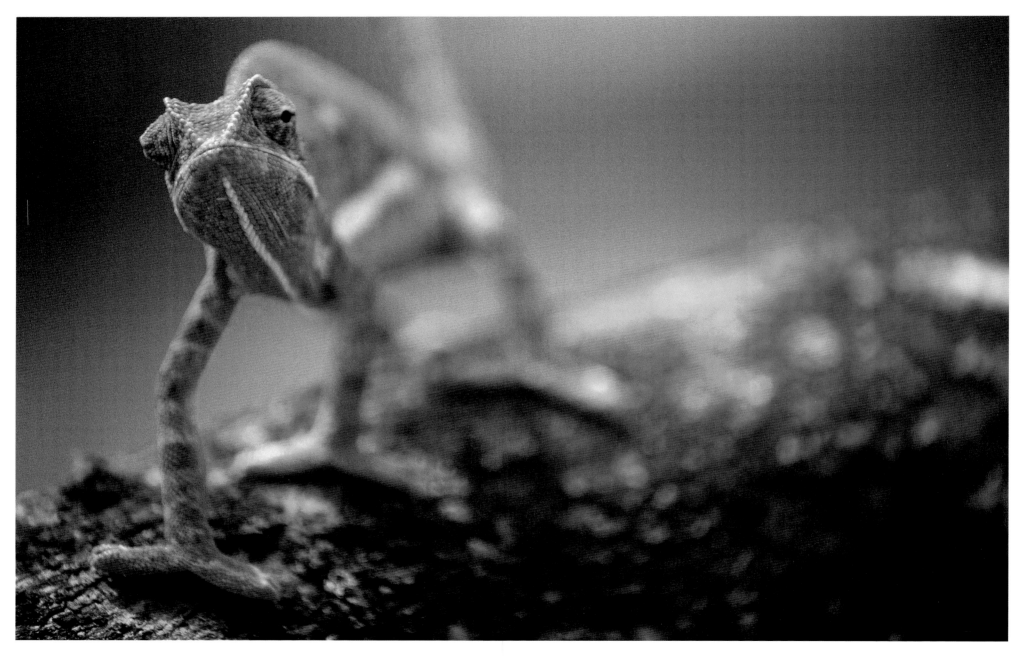

PLATE 41

The Flap-necked Chameleon *Chamaeleo dilepis* is usually found amongst the branches of trees and bushes, but will occasionally descend to the ground in order to seek out new feeding grounds or a mate. Like other chameleon species, it has a number of special adaptations for hunting: independently moving eyes, and a remarkable, extensile tongue. Ndutu, Serengeti, Tanzania.

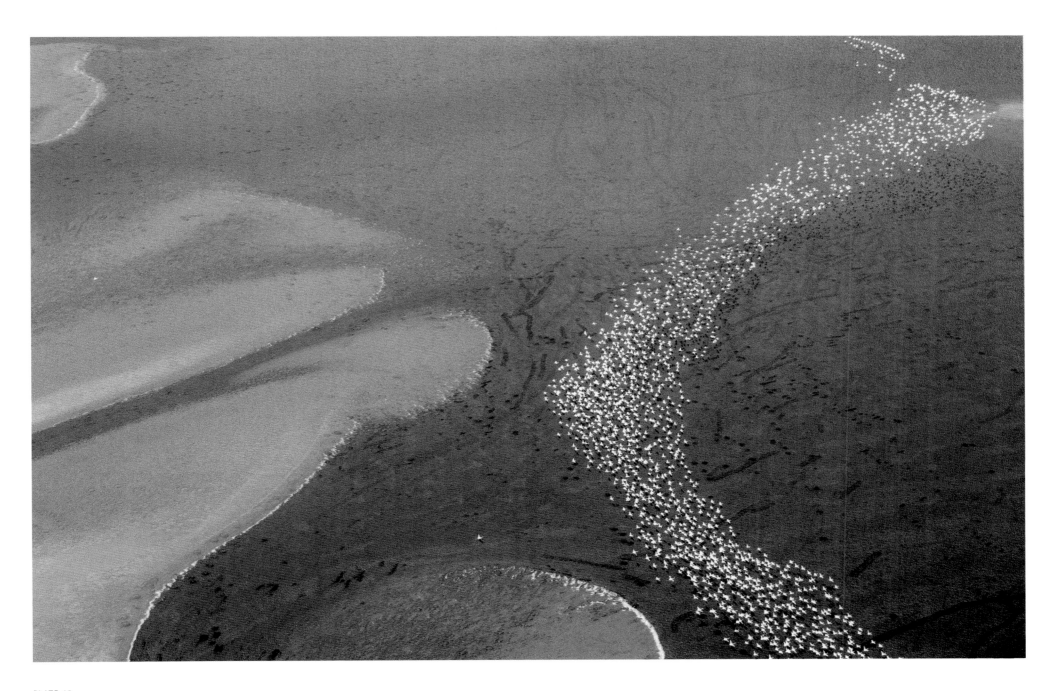

PLATE 42

Greater Flamingo *Phoenicopterus roseus* at Sandwich Harbour, a large natural tidal lagoon on the Skeleton Coast of Namibia. The lagoon is fed by freshwater springs draining from the surrounding dunes, which enhance the feeding habitat for its large population of bird life.

PLATE 43

The Nile Crocodile *Crocodylus niloticus* is one of the most ancient animals on earth, largely unchanged by evolution since the late Triassic period 200 million years ago. Jack's Pool, Okavango Delta, Botswana.

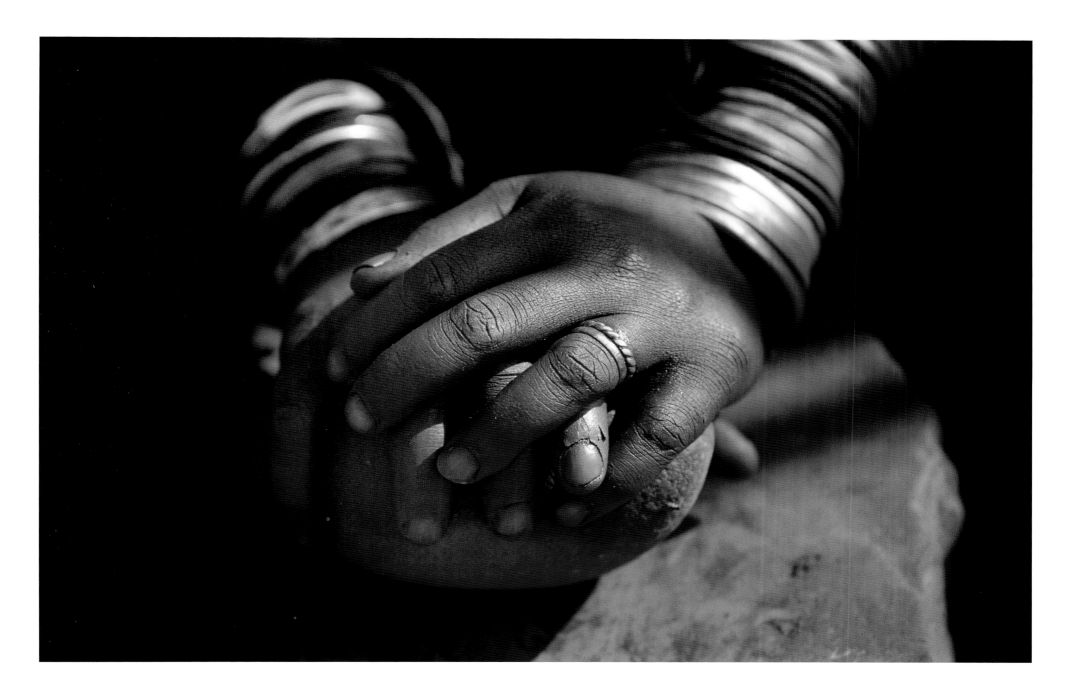

PLATE 44
Ova Himba indigenous tribes of the Kaokoveld of Northern Namibia grind ochre rock into powder mixed with goat fat to adorn their bodies with a red clay called *otjize*. Epupa Falls, Namibia.

SERENGETI – THE GREAT MIGRATION

Just two tracks in the hard earth led through mile upon mile of short tawny grass. The trundling jeep halted with a judder, allowing the sounds of the land to emerge: a gentle soughing breeze over the sweet grasses, a sizzling of crickets and a lizard rustling nearby in the tinder-dry leaves of the midday sun.

We waded through waist deep brush to a small outcrop of wind-sculptured granite surrounded by a cluster of dense euphorbias.[6] Scrambling to a ledge about ten metres up the rock we found what we'd come to see. Balanced on the wide ledge were two large angular detached flakes of rock, leaning against one another. Curiously, the largest was pitted with cup and ring indentations. We belted it hard with a stray stone. Resonating out into the space, after the initial metallic clack, was a whooping hum that seemed to vibrate and hang in the air. This was Gong Rock, an ancient Maasai ritual platform used for millennia as a means of summoning herdsmen and warriors from across the plains. Behind us, sheltered in the shade of an overhang, were exquisitely coloured rock paintings, depicting elephants, humans and shields: the white and yellow came from clays, the black from the ash of a wild caper

and the red was clay mixed with juice from the wild nightshade. There was no need to step back in time here, the past had become the present.

That night around the glowing ash of our fire-ring, dappled in pools of moonlight, we watched baboons and hyraxes moving along the crests before a velvet black sky, and imagined the green eyes of leopards in the shadows and their silent padding paws across the warm granite.

Dawn strikes swiftly in Africa, sun-up brings a bubbling cacophony of birdsong, none more gentle than the fluttering, rhythmical – almost breathing – song of the morning doves, whose incessant 'croo-crooing' rises with the heat of the day. If Africa were a sound, it would be this. We drove up a short rise facing the rising sun to a broad col between kopjes. Beyond was a scene so elemental, so painterly, it was as if we were entering a Pleistocene world. Several kopjes stretched away into the dawn mist like fairy islands in a sea of grass.[7] Thin strands of wildebeest flowed like ants across the plains, grunting, munching, hustling, always moving inexorably along. We halted; I jumped out and could feel the vibration of beasts through the ground, and a catch of animal breath on the air.

(6) Heaped, seemingly randomly along a north-south axis of southern Serengeti, these unusual clusters of granite – called the Moru Kopjes – are a vital feature of the ecosystem as they catch water in the impervious hollows and cracks of their structure which in turn supports the germination of the seeds of trees, which provide essential shade and protection for a multitude of species. **(7)** A.R.E. Sinclair and M. Norton-Griffiths eds., *Serengeti: Dynamics of an Ecosystem* (Chicago: University of Chicago Press, 1984). ISBN: 0226760294.

Losing height, and the panorama of the plains,
we drove down into a flowing river of animals. We crossed
one line of thundering hooves, then criss-crossed a
dozen more, making our way slowly through procession
after procession of wild beasts. Running with the
wildebeest were zebras and Thomson's gazelle – the
eyes and ears of the herds, for wildebeest have poor
sight and become blinkered by their instinctual urges.[8]
As if in slow motion, giraffes glided through the
commotion with such elegance and grace, lending
an unearthly presence to the scene. We pulled up in
a kopje to shelter from the dust and the tide of energy
surging by.[9] A lioness stretching out on a warm slab
lazily wandered into the shade and was greeted by heaps
of cubs jumping, pawing, playing her into submission
with twitching tails and endless mutual licking.
Observing such intimacy and indifference to our
presence disabled conversation among us. Contact
with wild creatures sometimes seems strangely painful
to me, as if a mirror is reflecting shadows in ones soul.
Awe and wonderment are at play here, challenging the
senses and helping us to step out of our lives.

>>

(8) A.R.E. Sinclair and M. Norton-Griffiths eds., *Serengeti II: Dynamics, Management, and Conservation of an Ecosystem* (Chicago: University of Chicago Press, 1995). ISBN: 0226760324. (9) George Schaller, *Golden Shadows, Flying Hooves* (London: Collins, 1974). ISBN: 0002162644.

Nowhere in the world is there such a conflagration of urgent life and death massed in one place. Over one million wildebeest, and many other herbivores, gather in the southern Serengeti short-grass plains during the long rainy season, to give birth to over 400,000 calves. Lions and hyenas, leopards, cheetahs, wild dogs and vultures become satiated and languid, such are the lavish takings of these winter months. For weeks the wildebeest have waited in the wooded eastern corridor of Lobo and Loliondo, waiting for the darkening skies and thunder that will bring the rains to the south. Almost immediately the animals begin to walk towards the newly sprouting fresh grasses germinating on the rich volcanic soils blown out from Ol Doinyo Lengai. [10] Birthing is rapid, and the massive herds graze the shoots back to dust. Soon nutrients are insufficient and the herds head north into the western regions of Serengeti along the natural corridor of Mbalageti and Grumeti Rivers at the height of the new rut. In the fast flowing currents and tangled branches, crocodiles await, reaping further death on the incessant travellers.

The constant search for fresh grazing on this habitual migratory circuit has become part of the natural balance of the ecosystem in Serengeti and a grand theatre to witness the great flowing biomass at its most raw and powerful. After all, it was from this very place in Olduvai and Laetoli 3.6 million years ago, that primitive hominids first stood upright and migrated northwards into the rest of the world.

(10) Located on the southern edge of Serengeti, on the rim of the Rift Valley, Ol Doinyo Lengai ('Mountain of God') is a recent active volcano in the chain of Tanzanian Highlands and the most holy mountain revered by Maasai peoples.

PLATE 45

Burchell's Zebra *Equus quagga burchellii* have unique individual patterning. Zebras have acute senses of sight, smell and hearing and warn other species of approaching predators during the annual game migration across the Serengeti. Tanzania.

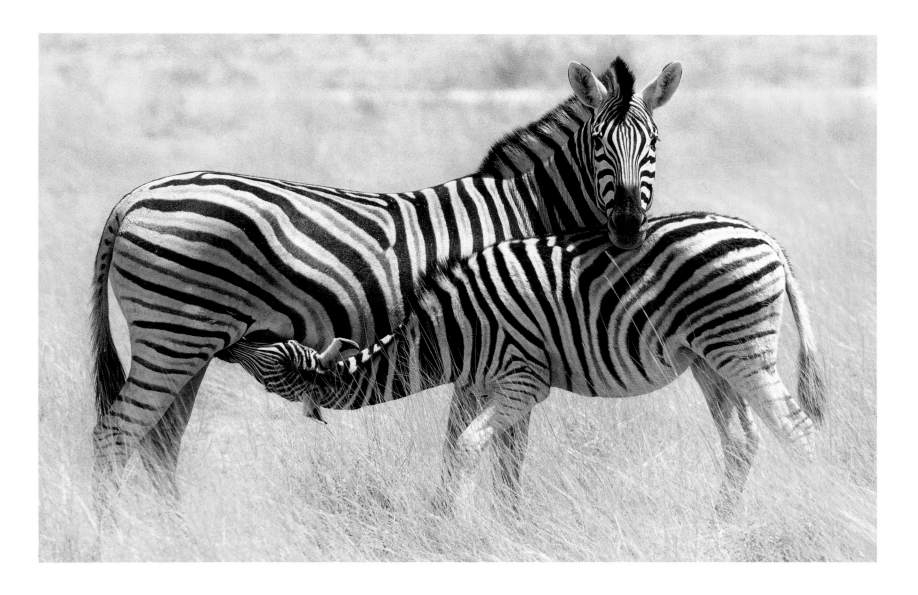

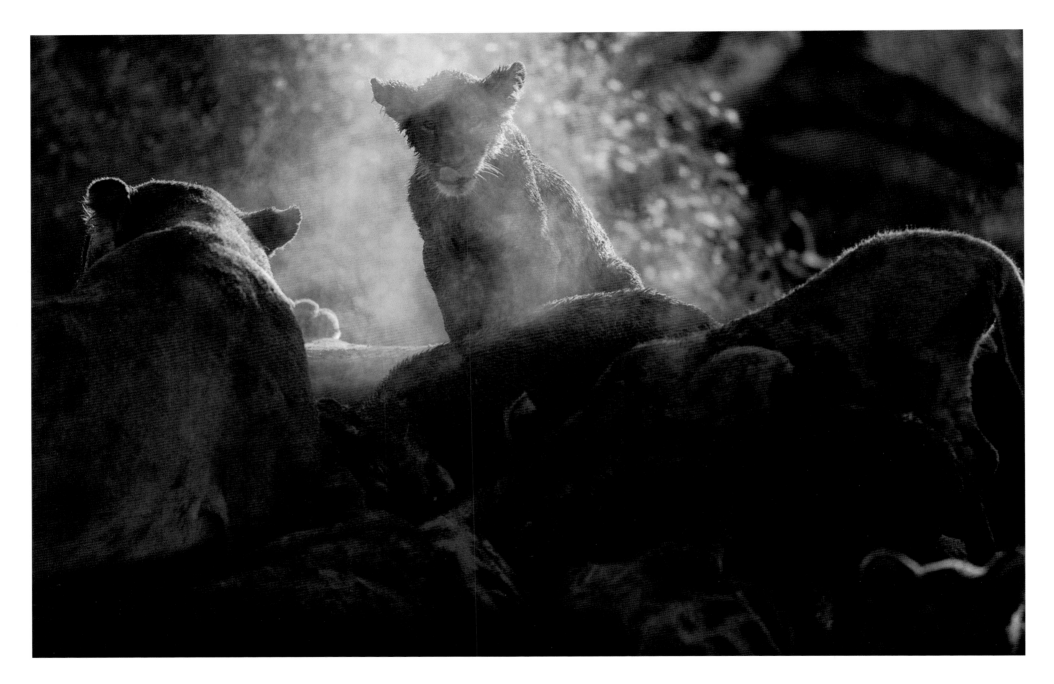

PLATE 46

Dawn reveals a primeval scene on the Savuti Plains of Botswana. Two prides
of Lions *Panthera leo*, including eight cubs, feed on a newly killed Reticulated
Giraffe *Giraffa camelopardalis*. A pride of lions usually consists of related
females and offspring, and a small number of adult males.

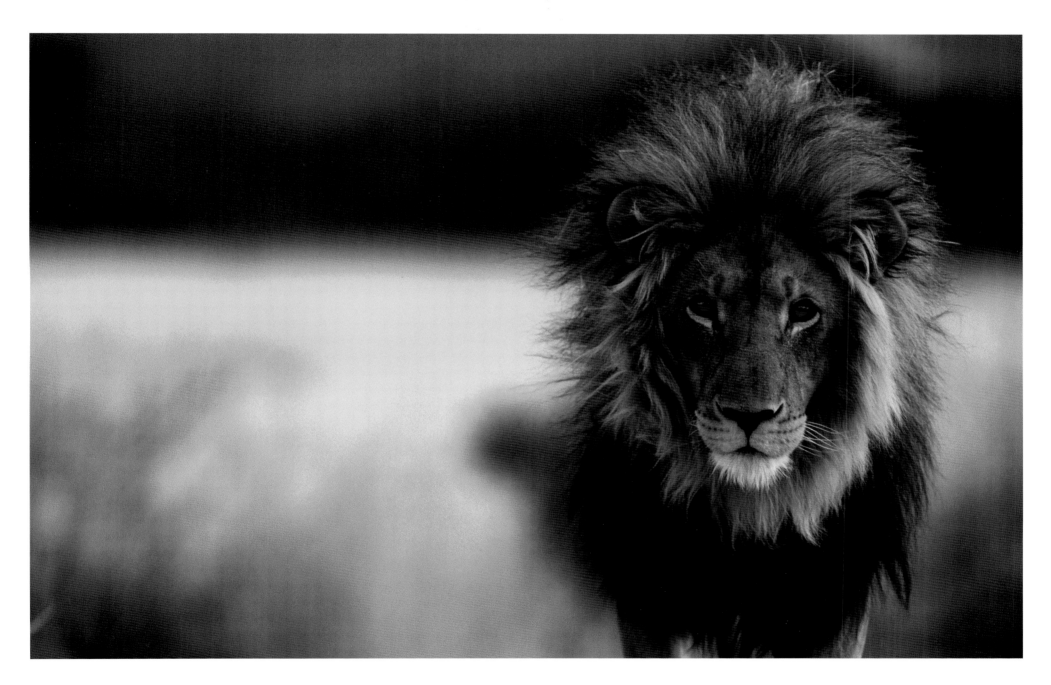

PLATE 47

One of the most widely recognised animal symbols in human culture, the male African Lion *Panthera leo*. In the wild, males seldom live longer than ten years, as injuries sustained from continual fighting with rival males greatly reduce their longevity. Moru, Serengeti, Tanzania.

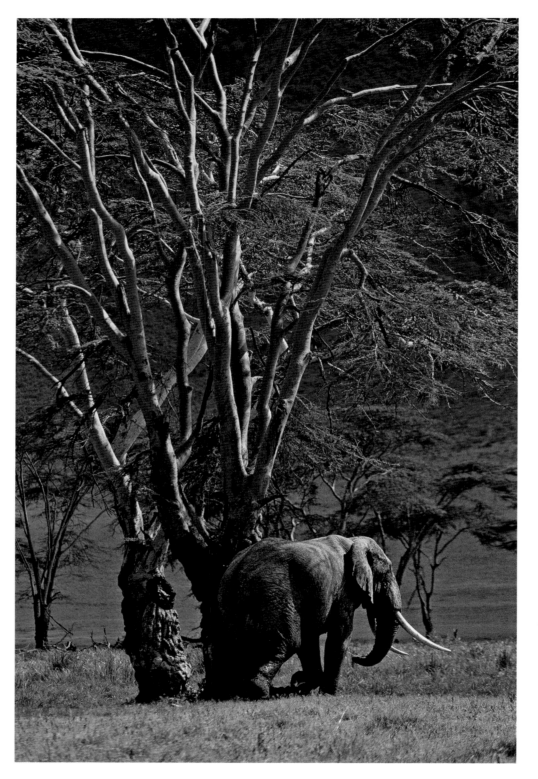

PLATE 48

African Elephant *Loxodonta Africana* resting in the shade of a Fever tree *Acacia xanthophloea*. Their tusks are the second incisor teeth, used for digging for roots and stripping the bark off trees for food, for fighting each other during mating season, and for defending themselves against predators. Ngorongoro Crater, Tanzania.

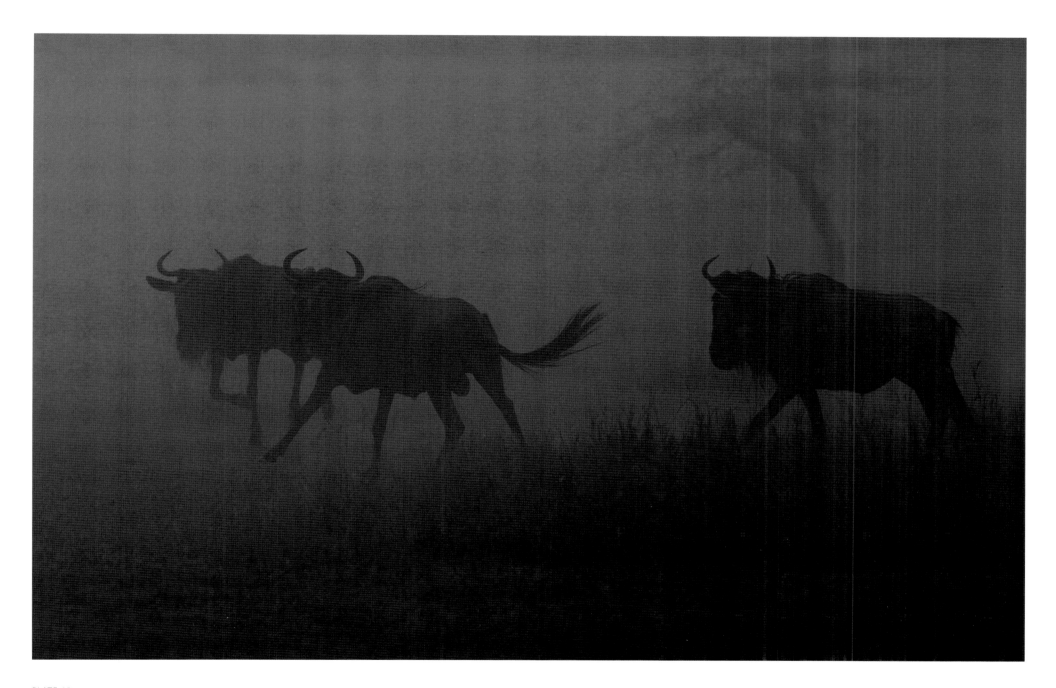

PLATE 49

Blue Wildebeest or Gnu *Connochaetes taurinus*. The vast Serengeti herds, sometimes numbering one million, are purely migratory; perambulating in succession around the plains after the rainy season has ended to seek higher grasses in wetter areas. Grumeti River, Serengeti, Tanzania.

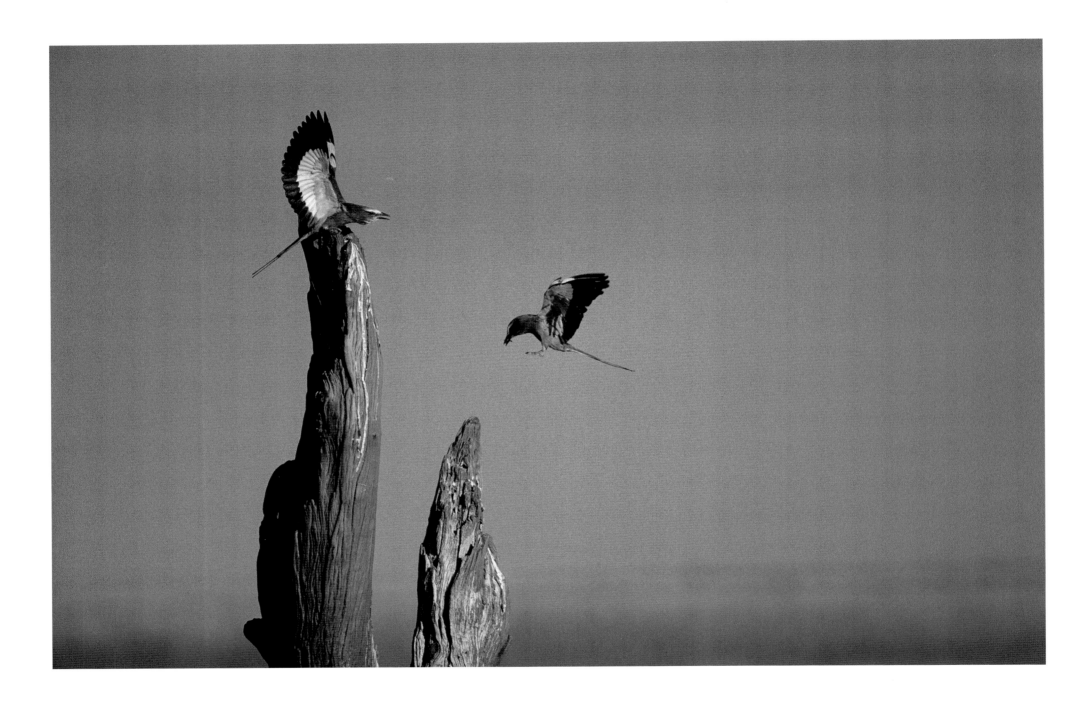

PLATE 50

Lilac-breasted Rollers *Coracias caudatus* in nuptial courtship. The male (right)
offers the displaying female fresh caterpillars. Savuti Plains, Botswana.

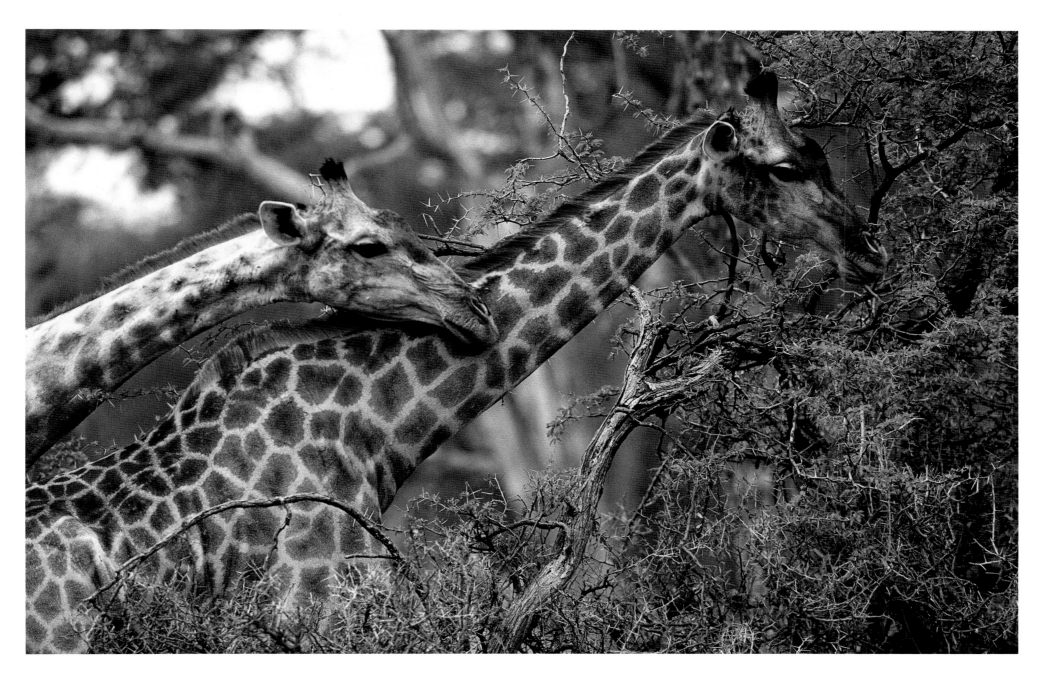

PLATE 51

The Giraffe *Giraffa camelopardalis* is the tallest land-mammal on earth. With its long neck the giraffe reaches high into the branches of trees to feed, carefully wrapping its long black prehensile tongue around the tender leaves, delicately removing them from between the spines. Savuti Marsh, Botswana.

DEADVLEI AND THE KAOKOVELD – THE NAMIB DAYS

The haunting backgrounds of many of Salvador Dali's surreal paintings often include empty desert scenery in which sculptured boulders and twisted trees melt into infinity. For years I imagined where this place might be. I found it in the mid 1990s in the Namib Naukluft desert of central Namibia, south of the Kuiseb River and ninety kilometres west of a tiny petrol station called Solitaire.

Deadvlei is a hidden place, a dead place, a small basin of alkaline clays secreted deep within one of the world's most labyrinthine and inaccessible oceans of sand. To reach the great dunes of Sossusvlei we drove down an endless dirt trail from the high desert plateau into an unearthly landscape of wide valleys of sandy gravel, where ridge upon ridge reaches away to the west, fetching up at the cold misty shore of the Skeleton Coast. Here are jagged yellow escarpments, arid gorges carved by lost rivers, stunted acacias hanging with pendulous nests of the buffalo weaver, and delicate exposures of ochre red earth dotted with soft green euphorbia and spiky love-grasses. By the trail, sunbirds whirred from flower to flower; a lonely ostrich marched by, legs burnished by constant stinging of windblown sands; and a shovel-snouted gecko lay flattened out on a stone in ecstatic comfort. It was 41C, and climbing.

The Namib Naukluft desert, one of the world's oldest at around eighty million years, extends for 2,000 kilometres, from Angola to the western border of South Africa. It is made of a variety of habitats, from high rocky peaks, extensive sand dunes and scrubby gravel plains to marshy reed beds and desiccated salt pans. A cold Benguela current flows from the southern ocean up the Namib coast, meeting hot outblowing desert winds, which condense into thick fogs. While this has been an age-old hazard to coastal shipping, it is the lifeline to most of the flora and fauna of the Namib. The tok-tokkie beetle, or tenebrionid, for example, climbs the dunes before sunrise to receive condensed moisture on its carapace. When droplets form it extends its long back legs for the water to trickle over its mouth parts for ingestion. Bat-eared foxes have highly vascular ears for dispersing heat in the blood. The oryx, or gemsbok, survive life in the scorching desert by way of a mechanism in their domed nose parts that cools their blood temperature, indeed they can sense water beneath dry courses and will dig for it. Many invertebrates and small mammals survive on the wind blown detritus in the lee of the dune crests. Nature and evolution has adapted the life forms in the Namib to survive the extremes of the climate. The inland mountains of Waterberg and

Brandberg produce a small seasonal watershed sufficient on occasions to channel down the courses of the Ugab, Huab and Kuiseb basins. Most often the water table is below the land surface, yet high enough to create riverine vegetation that supports a huge variety of life. Many plants and animals are endemic, occurring nowhere else in the world, like the strange welwitschia plant that lives for over 1,000 years.

The cold silver bead of dawn rose in the grey dunes but, as the shadows dispersed beneath the climbing sun, colours began to emanate across the face of the sand. Pastel salmon pink, saffron and chimney-orange light glowed from the dunes. We walked out into the ground rift soughing over the sand, each carrying compass and water, heading toward the Deadvlei, an hour to the west. Cold sand is easy to walk in, it holds its friction in the grains, but hot sand is slippery, treacherous and exhausting. The dunes around us grew ever higher, indeed these are some of the highest sand dunes on earth at around 500 metres. Climbing over the dune crests demanded care, as mini sand avalanches swept away below our floundering ascents. Beetle trails cut fabulous patterns across the perfect wind cupped surfaces; I was heartened by signs of other life. The constant wind high on the dunes flared with banners of flying sand, reminding me of their constant migration, moving along inexorably in a different time world. On a high ridge I halted above a cirque of shapes. Shadows and light in triangular wedges plunged down into a deep, shadowy depression. We tumbled and fell down into the silent and windless basin below. As if in a theatre before a show, light at once followed us over a crest, flooding the bare earth with heat and colour. Before us were anguished tree forms, ancient and dead, scattered randomly over a cracked pan of grey alkaline mud. There was no sound but the echoing croak of two pied corvids stabbing at lizard prey. In the presence of natural wonders such as this, quietude overtook our exuberance, as if we were listening for connections to another world. We had found the Deadvlei: Dali's unholy Eden, an elemental place ruled by reptiles and crows.

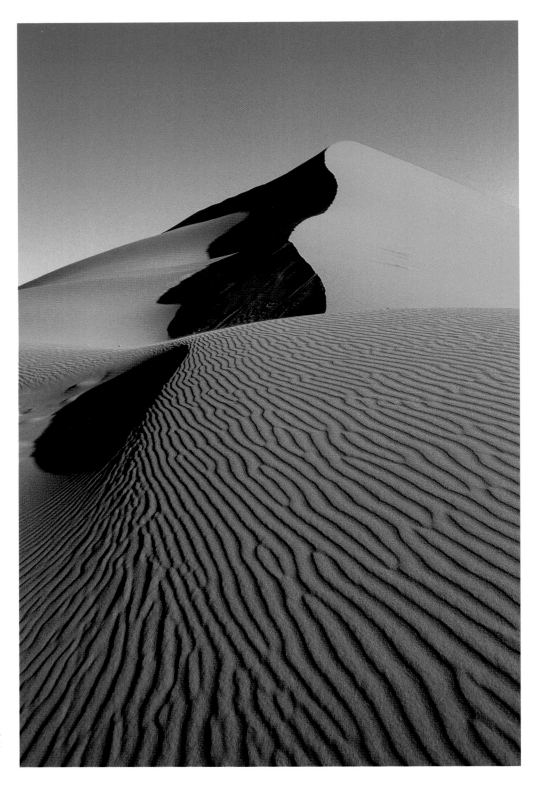

PLATE 52

The great sand dunes of Sossusvlei in the Namib Naukluft desert of Namibia are some of the highest and most active dunes in the world.

PLATE 53

The Tenobrionid or Tok-tokkie Beetle *Stenocara gracilipes*, survives in the arid
conditions of the Namib desert by collecting condensed water droplets
from the air onto its wing covers and feeds on windblown debris
in the lee of dune crests. Sossusvlei, Namibia.

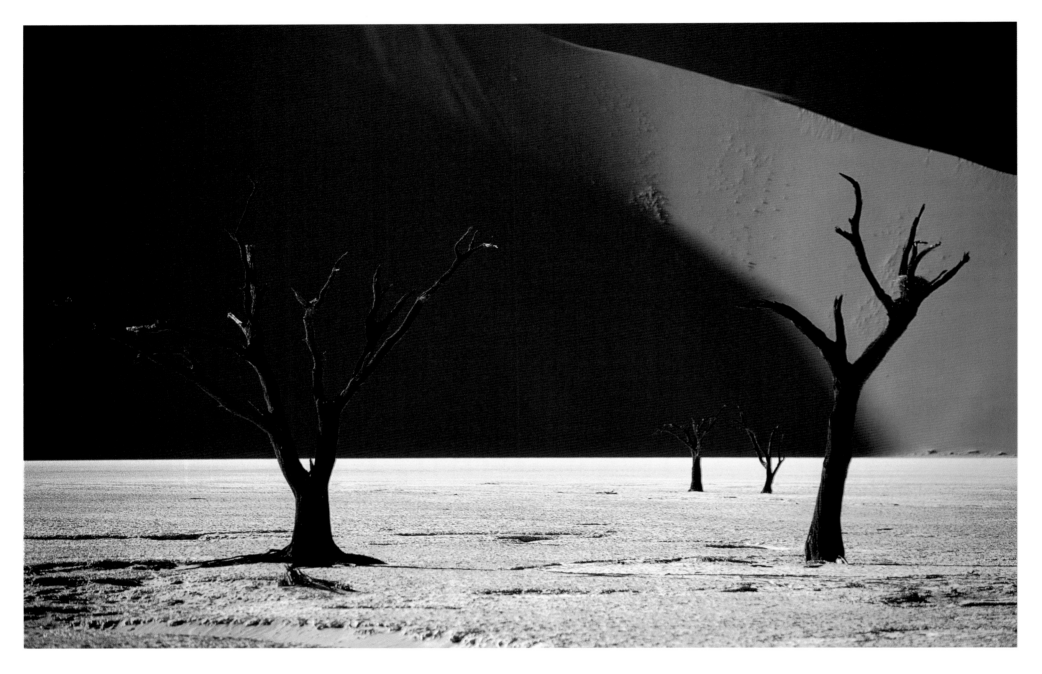

PLATE 54

The so-called 'Deadvlei,' was once a green marsh supporting a few trees.
When the climate changed, drought hit the area and sand dunes encroached
on the pan, blocking the river from the area, and drying the pan into an arid
basin. Sossusvlei, Namib Naukluft desert, Namibia.

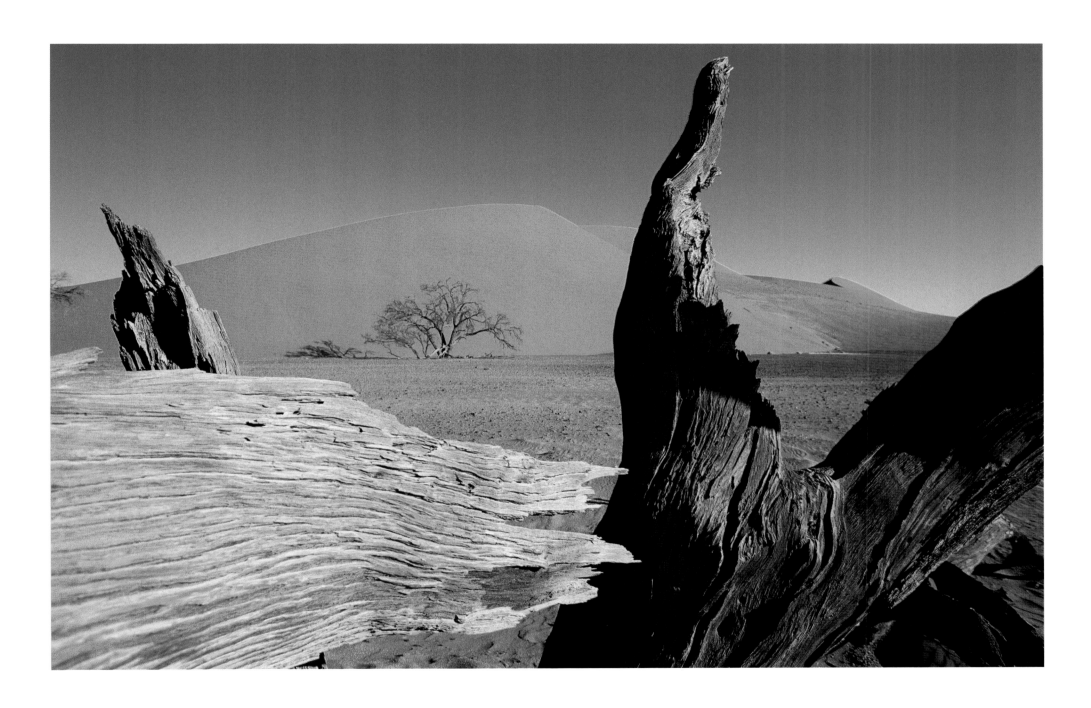

PLATE 55

Camel Thorn trees *Acacia erioloba*, stark survivors of the rare and seasonal rains
in the Tsauchaub River basin of Sossusvlei, Namibia.

ETENDEKA

The Kaokoland north of the Huab River is one of the last remote wilderness regions on earth. First described by Swedish explorer Charles Andersson in 1858 as '*the finest and most peculiar hill country I have seen*', the mountainous Kaokoveld is home to many plants and animals found nowhere else. In this exquisite landscape, hyenas and leopards wander, while desert-adapted elephants and the last free roaming stronghold of black rhino in Africa survive in the lonely dry hills of Damaraland.

The land is populated by the semi-nomadic pastoralists, the Ova-Himba peoples, who adorn their bodies with spectacular jewellery of shells, leather and metal bracelets, and who daub themselves with a paste of goat fat and red ochre dust. On the several journeys I have made to visit them in the desert, I have returned home determined to simplify my life, such is the level of gentleness and humility I encountered. But the story I'd like to relate is an incident with animals that happened quite suddenly and surprisingly, and whose outcome I remain bereft of scientific validity. It was, quite simply, unusual!

The red mountains of Etendeka in Damaraland are extremely remote, turreted peaks of complex geology. Their steep terraced sides, dropping into a maze of small ravines, reminded me of the mesas and buttes of the Colorado Plateau. Strange moringa 'ghost' trees cling to the broken escarpments, their swollen trunks and roots supporting tentacle-like branches. The ground is strewn with crystals and geodes as big as footballs. Once I found a lion skeleton here, with its lower jaw in repose on its front feet, gazing through hollow eyes across beautiful evening mountains. The Himba shepherds won't graze their goats or cattle in this wild place.

One of the animal rarities here is the Hartmann's Mountain Zebra, a subspecies of its plains neighbour that has adapted to the harshness of the elevated rocky habitat of these Grootberg mountains. Rangers had spied zebras the previous day on a particular stoney hillside and took me to the spot. I climbed out of the Land Rover at a place where I could see the flanks of two mountains that met at a low col, a gap in the hills that looked mysterious and inviting. Heading out alone and on foot, I made for the pass with a knapsack, containing water, binoculars and a camera. It was 3 p.m., and very hot.

Between the mountains at the highest point, a goat track led me through to the rim of a deep rocky ravine. In front of me crowding the track appeared a troupe of at least forty baboons. One or two baboons is safe enough, but en masse in mixed family groups, they can

become aggressive and unpredictable. I remained of a calm disposition and quietly waited by a rock, minimising eye contact with the mob. Some playful scuffles broke out in the ranks, but soon all the animals melted away, barking and screeching into the ravine.

I proceeded on my way until I was halted by an extraordinary find. Across the track was a large mound of crystals that I identified as quartz. But crowning the cairn was a sun bleached baboon skull that appeared to have been carefully placed. The thoughts running through my mind questioned 'who, how, why?' in this utterly desolate place. I looked up as if to scan the horizon for an answer. Along the trail from where I'd passed through the mountains, the baboons had quietly re-assembled. They were clearly agitated and were looking my way. Was this cairn of significance to them? Had I trespassed their territory in some strange way? The only way back was back, but the path was now blockaded by an increasingly angry hoard. The baboons were shrieking out, clapping wildly and jumping irrationally about in the dirt. My pulse rose as I tried to calculate my options. To run? No! To walk towards them? No thank you! To sit down and wait a while? Maybe!

Simultaneous to these crazy thoughts, high on a skyline ridge above the track, I saw a very large lone male baboon. I don't quite know why I did what I did,

but I slowly raised my arm in a gesture of greeting to it. To my utter astonishment it mimicked my gesture and raised its arm to me! I caught my breath. Within a minute the bedlam amongst the baboons subsided and they dashed away out of sight back into the ravine, as if under instruction from their leader.

With safe passage apparently secured, I walked hurriedly back along the narrow trail with a pounding heart, to rejoin the waiting vehicle some two kilometres distant. The events I experienced remain inexplicable to me to this day. Had I stumbled on a territorial site of ritual? Had the animals spoken to me? I cannot offer any explanation, except on that trail – on that day – I had understood a little more about the land.

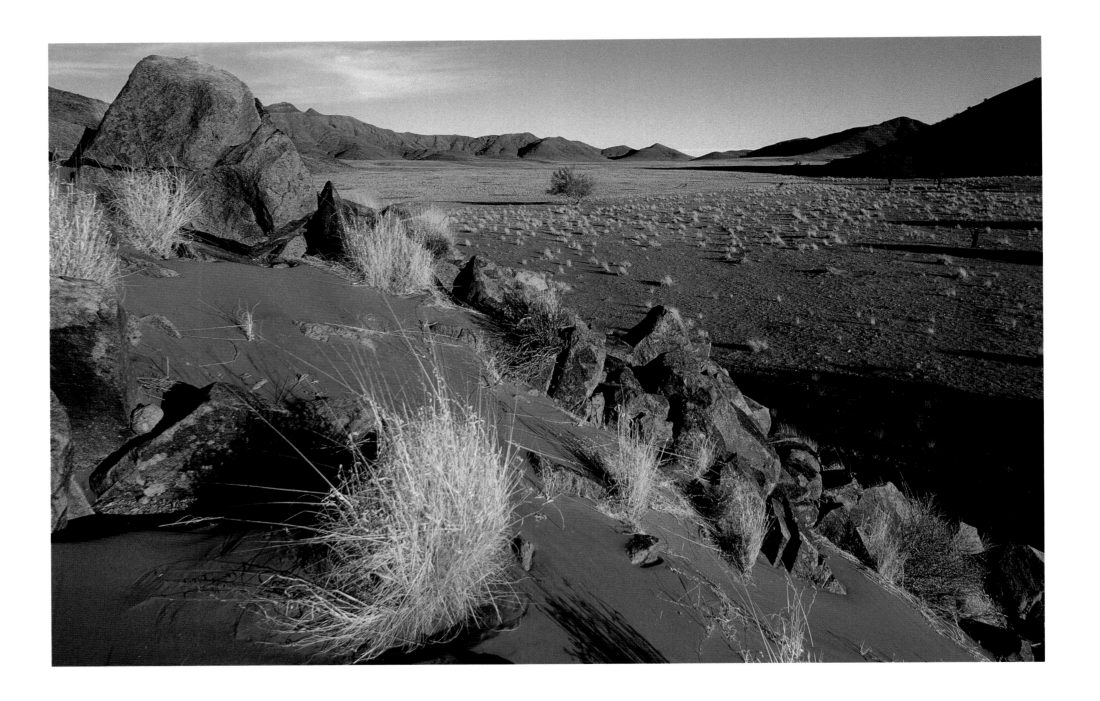

PLATE 56
Desert scenery near Wolwedans in the NamibRand Nature Reserve.

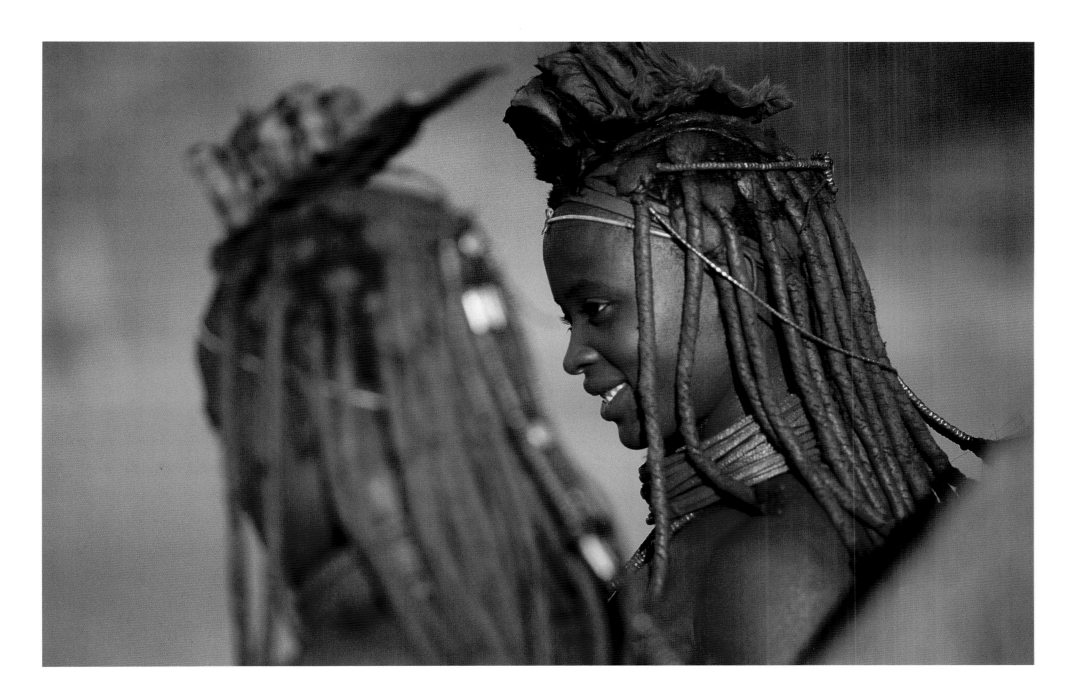

PLATE 57

The Ova Himba peoples of Northern Namibia wear little clothing, but the women are famous for covering themselves with *otjize*, a mixture of butter fat and ochre to protect themselves from the sun. Epupa Falls, Kunene, Namibia.

DOWN IN THE FLOOD – THE OKAVANGO DELTA

Through the side window of the Cessna, glittering water stretched below me to the horizon, a dendritic network of channels and pools, islands and inundated trees. Occasional tiny boats flashed and glinted in the midday sun. The outspread wings of large water birds glided below, hinting at the multitude of life that congregates in this region. Inland water on this massive scale is exceptionally rare in Africa. It was flood season in the Okavango Delta.

The seasonal rains that fall in the highlands of Angola from November until March initially flow inland via tributaries, behaving like a normal river. In fact the Okavango River is one of the largest in Africa, but, as the land levels out, it forms a delta, which initially floods the land from June to September and then disappears without trace by percolating away through the permeable strata of the Kalahari sands. Unlike most tropical water, which is muddy and warm, the Delta's waterways are cool and clear with huge oxbow lakes and lagoons filled with the purest water in Africa, if not the world. This is an enchanted oasis set in the heart of the tinder dry bush land of central Botswana. It is a geological and hydrological wonder of the world, attracting a huge variety of fish, birds, mammals and insects, with some of them well adapted to life in, and close to, water. The Hambukushu chiefs

are the rainmakers of the Okavango, and have long experience of the rains. All who live here, Bantu and Bushman, have been connected to the waters for centuries; to its rhythm and cycle, its inhabitants, its life-giving and life-taking flow.

In the breeding season vast numbers of birds arrive in the Delta to nest. Along the channels, which are often densely lined by tall, emerald green papyrus and choked with flowering water lilies, are secret lagoons amidst the tangle. Here, mud collects and forms floating islands of dense vegetation that harbours large colonies of nesting birds. We floated silently between the enclosing reed stems, as the reptile crests and slit eyes of crocodiles hung motionless in the shallows. A pygmy goose paddled deeper into the swamp, alarming a tiny jewel-like malachite kingfisher perched high on the reeds. Jacanas ran across the lilipads, stepping stones beneath their elongated toes. A clamour ahead gave notice of our proximity to a large colony of yellow-billed storks. We drifted into the island of flooded shrubs. I slid over the side of the aluminium skiff into water that looked about thirty centimetres deep. It wasn't shallow, and I sank through suspended mud entrapping my legs in the underwater root system. Momentarily panicking, splashing wildly and gasping for air, I made it to the surface and grabbed

the gunwale of the boat. This time I scrambled over the bow and climbed into the bushes establishing a safe position to wait comfortably amongst the colony to take photographs of the nest sites. Nervously, birds returned to feed the young. Huge wings glided over the pools in gathering dusk and landed close by, rustling vegetation, swishing, flapping and clacking bills, settling in to roost for the night. We retreated and poled our way to the shores of a dry island.

Dragging the skiff ashore we sat on the bank beneath a grove of great ebony trees and listened to the night. The air was filled with the delicate wind-chime clinks of bell frogs. Hippos grunted and sloshed around the edges of the lagoon. We lit a small fire, and laid out our bedrolls and nets beneath a blanket of stars. The shadows of the night moved across the clearing as the moon travelled by. Somewhere out in the darkness the rhythmical roaring of lions gave way to ghastly hyena yelps. In the torch beam a hundred eyes were watching; scorpions, hawk moths, leaf mantids, geckos, bush babies and – suddenly – huge shapes, silent and sentinel, became apparent by the tall termite mounds nearby: elephants!

Their shapes, like textured darkness, stood perfectly still, caught in the light beam, as if dark rounded boulders had moved around our campfire with phantom footfalls. Not a sound could be detected of their presence, only the light, leathery swish of ears, and a resonant rumble from the bowels of an ancient earth.

Dawn breaks the silence of the cool early hours. A fish eagle sweeps low over the water, deftly plucking a silver fish from the lagoon. Her mate joins in, and they perch together on a drowned tree calling in unison, the most beautiful and evocative sound of the Okavango. From the long reeds a curious antelope appears, a sitatunga, preferring to quietly wade around in the marshy fringe on floating mats of weed. As the heat of the day rises, the insect world emerges with a surging tinnitus-like presence. We take to the water again and drift past an earth bank peppered with nest burrows of spectacular carmine bee-eaters. Hundreds of crimson beauties twittering and flitting in and out of the bank in the golden morning. On a high stump, lilac-breasted rollers display electrifying colours of blue in gentle attentive courtship. A commotion of red lechwe antelopes dash through the shallows, leaping and bounding in flight.

I have rediscovered something here in Africa, not so much with my eyes or ears, but something resonating from deeper in my heart. Perhaps like Van der Post's 'far-off place,' it is hard to leave from where I feel I might belong.

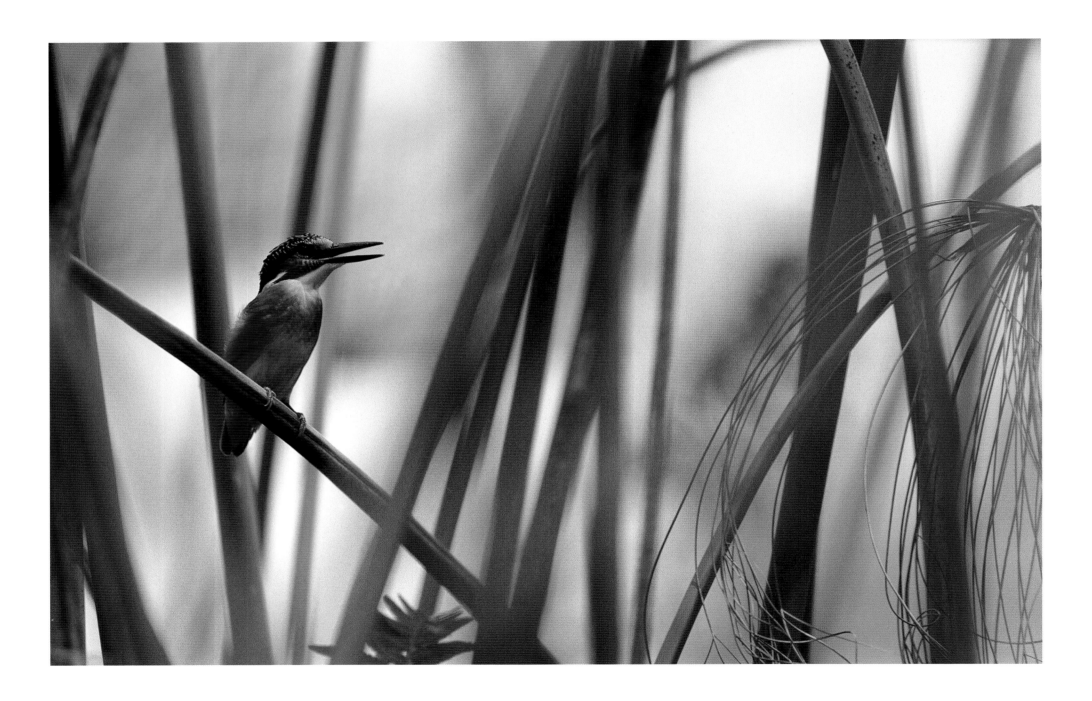

PLATE 58
Malachite Kingfisher *Alcedo christata* in Papyrus reeds *Cyperus papyrus*.
Chief's Island, Okavango Delta, Botswana.

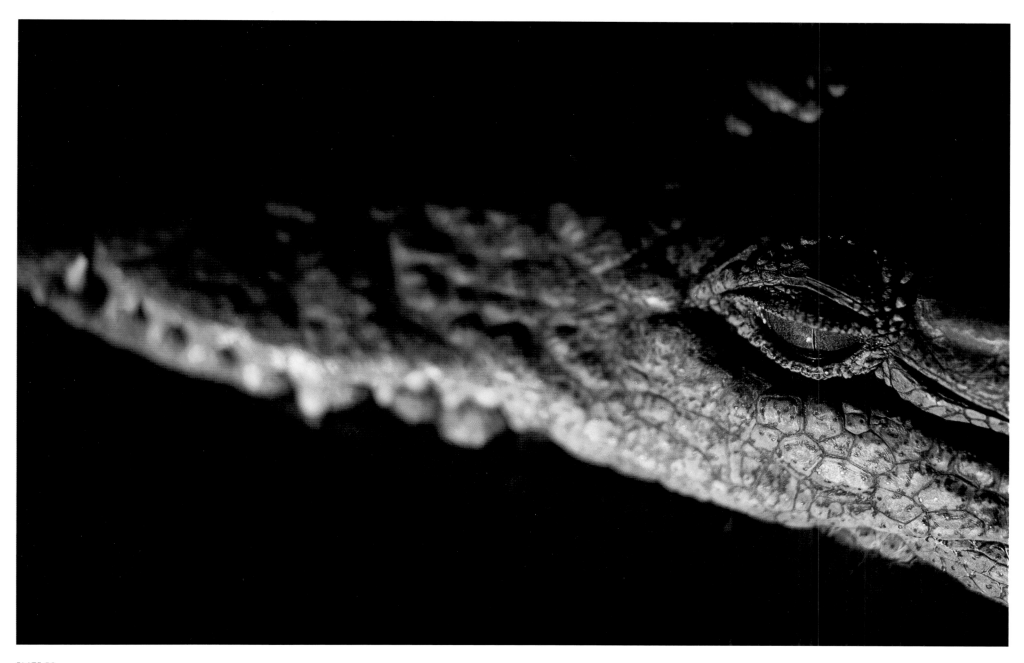

PLATE 59

Nile Crocodiles *Crocodylus niloticus* are common within the Okavango Delta, spending most of their time semi-immersed in water channels and pools. They normally dive for only two minutes, but will stay underwater for up to thirty minutes if threatened. If they remain inactive they can hold their breath for up to two hours. Mombo District, Botswana.

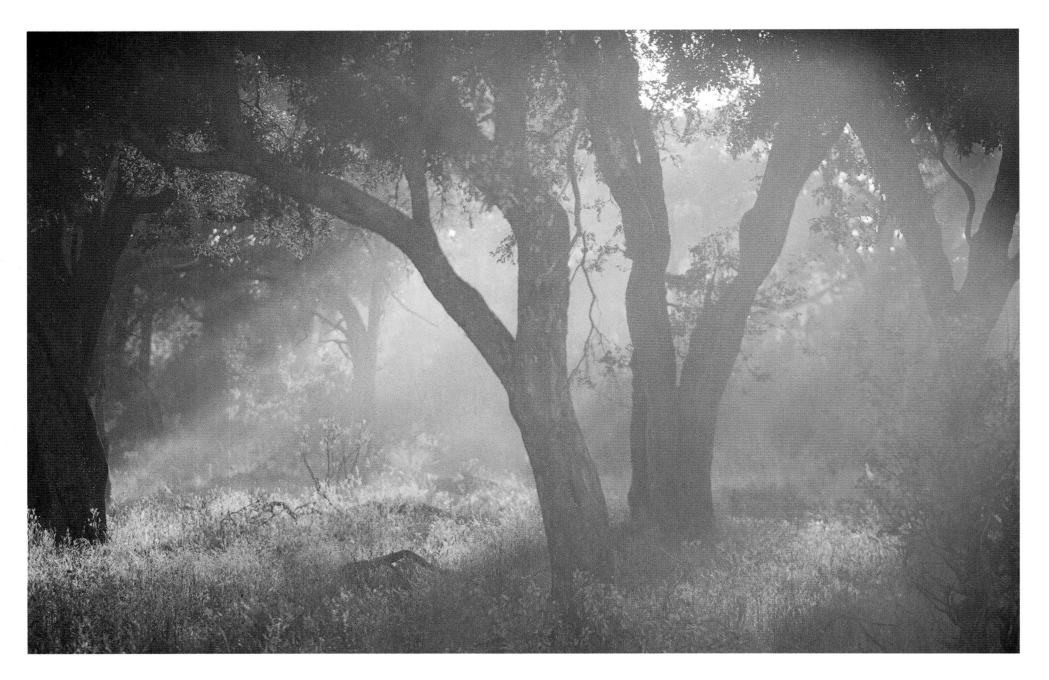

PLATE 60

Mopane forest *Colophospermum Mopane*. The trees themselves are an important source of food for game, as the leaves have a high nutritional value, rich in protein and phosphorus, which is favoured by browsers and is retained even after they have fallen from the trees. Chief's Island, Moremi, Botswana.

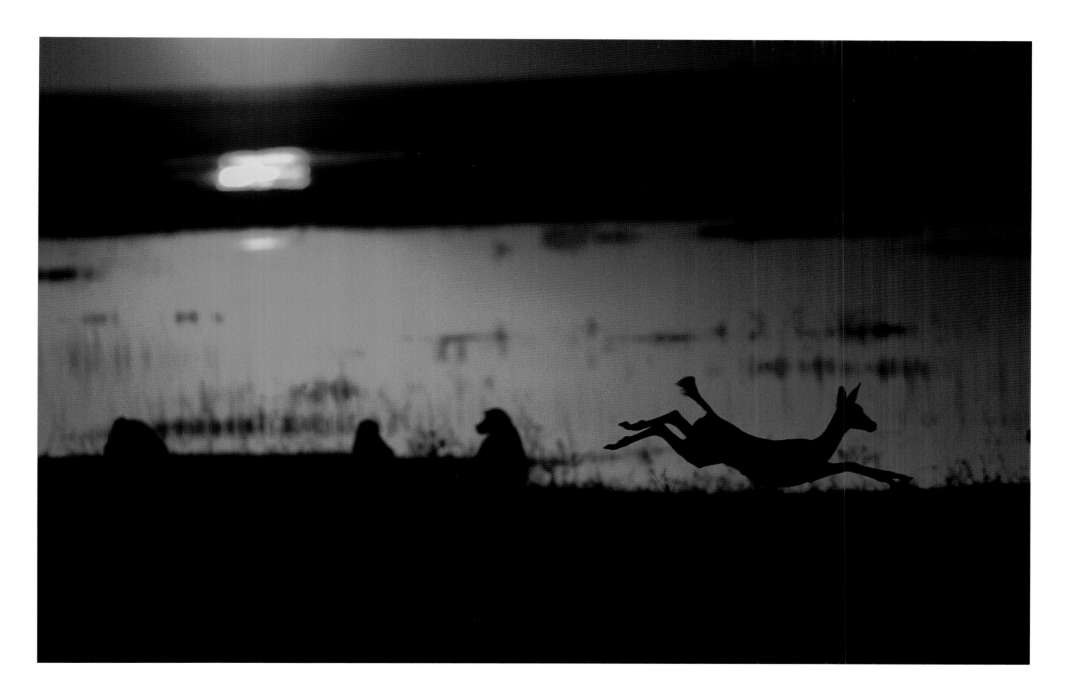

PLATE 61

Sunset on the Chobe River. The floodplains of the river drain the eastern Okavango corridor and are an excellent habitat for animals with mixed patches of open grassland, thickets of bush and riverine forest.

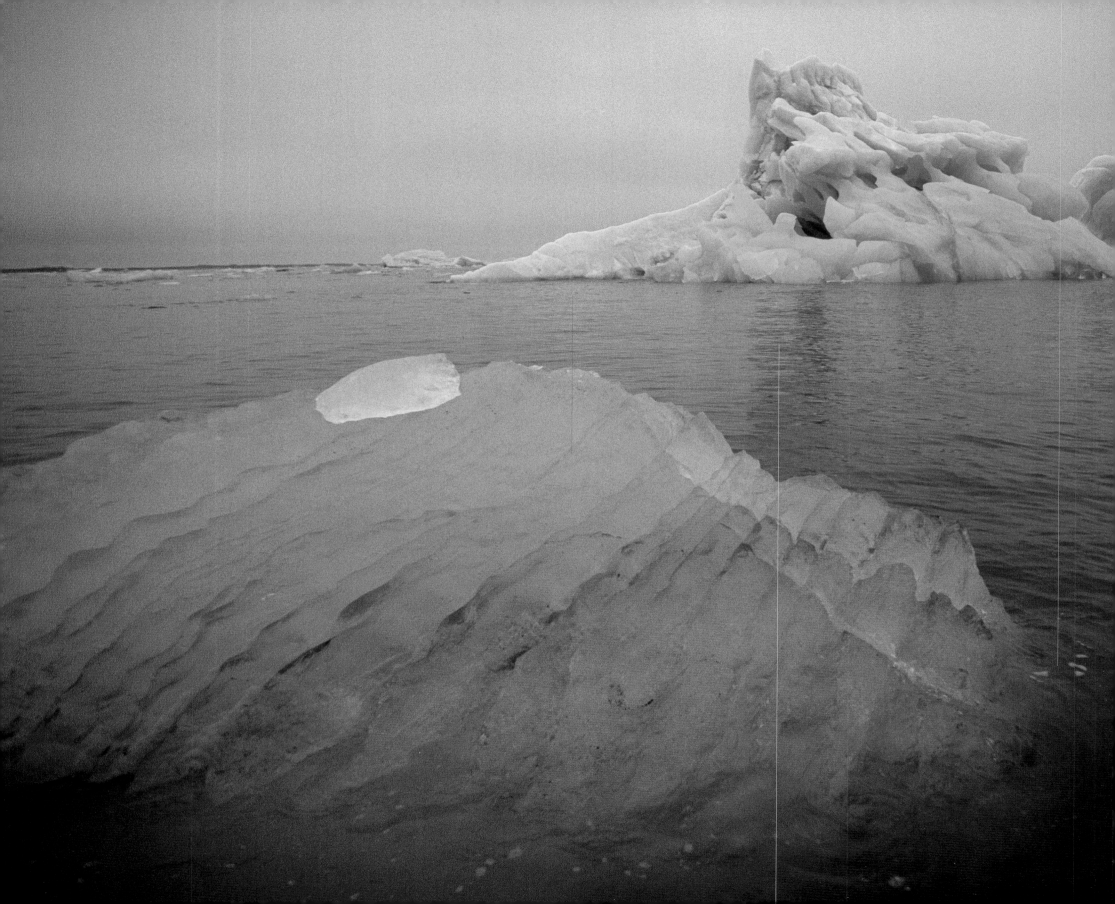

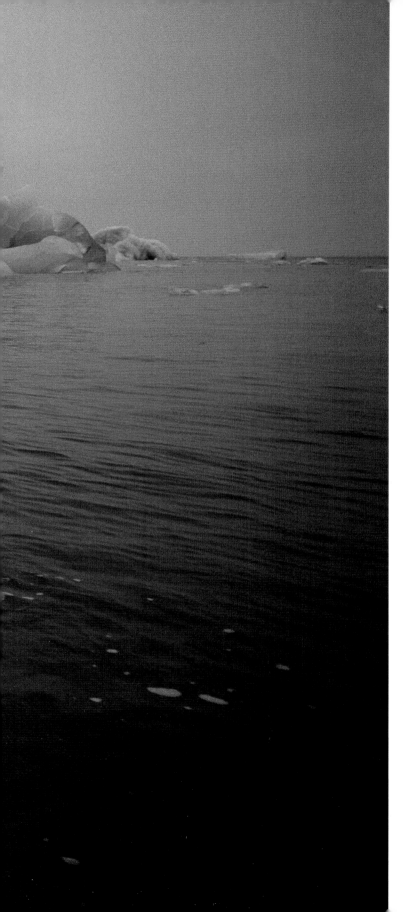

The High Arctic

*'Nowhere has knowledge been purchased at
greater cost of privation or suffering.'*
FRIDTJOF NANSEN (1861–1930)

PLATE 62

Blue icebergs are very old, possibly thousands of years old, and very dense.
They have had most of the air compressed out and cannot reflect white light.
Recent studies have shown that the water surrounding icebergs teems with
plankton, fish and other sea life.

When Pytheas sailed with a hundred oarsmen in 325 BC, he first reached Scotland and eventually Iceland, which he named _Thule, The End of the Earth_. Few followed for centuries except the Norsemen, whose heritage of seafaring and struggle inured them to great feats of exploration in search of new lands, and who settled in Iceland in 874 and Greenland in 984. It is likely that Leif Ericsson was the first European to make land in Newfoundland in the ninth century.

Why voyage north into the unknown? Did the hope of mineral wealth on some far off unknown shore drive the ambition of imperialist nations? Was it to discover a northerly sea route to the reported riches of Cathay after the 1453 fall of Constantinople? In Elizabethan times, epic voyages were sponsored mainly from England, one of which enabled Martin Frobisher to enter the arctic region midway up Baffin Island in 1576 and return with quantities of black ore, which he suspected contained gold. His hopes proved fruitless, though rumours of mineral wealth in the region created a flurry of excitement by 1578.

The Danes and Norwegians, who were discovering 'new' worlds to the north and west, slowly penetrated what we know today as Lancaster Sound. These early successes were likely due to their understanding and appreciation of the methods and skills of the indigenous peoples of the north, like their own Sami of Lapland. Yet Scandinavian colonisation of the High Arctic was slow and largely short lived since the visitors preferred to insist on poor yield agricultural produce over an easily acquired diet of fish and sea mammal meat, as practised by all Arctic peoples, such as the Inuit, Inupiat and Yupik of Far Eastern Russia and Alaska, alike. In 1610, Englishman Henry Hudson followed, sailing under a Dutch flag. But, while exploring his newly discovered Hudson Bay, he suffered a mutiny amongst his crew led by his navigator Robert Bylot, who set a handful of loyal souls adrift in a small craft whom were never to be seen again. Soon enough, an obsession developed among the British Navy for finding a navigable sea route through the treacherous pack ice of the Northwest Passage, exemplified by the voyages of Royal Navy sea captains John Ross and William Parry in the early nineteenth century.

The most major advance of exploration of the High Arctic was made in the early nineteenth century by Sir John Franklin, who made four daring sea and overland explorations along the north Canadian coast in the region of the Coppermine River and the now infamously oil-rich Prudhoe Bay on the Beaufort Sea. His disappearance somewhere in the Canadian Arctic archipelago in 1845 led to the biggest search and rescue

attempt ever undertaken. Over a period of fourteen years a multitude of expeditions mapped extensive areas of wild arctic coasts, largely proving in the course of their journeys that a sea passage could indeed be made across the top of the Americas, but which brought no solace or answers to the mystery of Franklin's demise. Only in 1854 did Dr John Rae return with rumours purported by an Inuk that claimed he had heard about white men camping at the mouth of his nearby river. With this thin narrative of evidence, a final expedition in 1857 sponsored by Lady Jane Franklin was sent out under the command of Francis Leopold McClintock. On a small cairn out on the bleak shores of King William Island a note was indeed found, dated 25 May 1848. It told of the ghastly tragedy that had taken place: of ships crushed in ice; of men perished from starvation, exhaustion and tuberculosis; and of a team that had headed south with sledges in the vain hope of reaching help.

In 1905, a Norwegian, Roald Amundsen, eschewing the prosaic tactics of former expeditions and favouring the methods of the Inuit peoples, succeeded in traversing the Northwest Passage in a small forty-eight ton sloop, the Gjoa. This event, and the borrowing of Inuit method, inspired the American Robert Parry to venture north out across the wastes of frozen Arctic Ocean in an attempt to reach the North Pole itself. His final position in 1909,

and his claim to success at reaching a most northerly point, though plausible, is still a matter of historic conjecture to this day.

Whatever treasures were sought in the High Arctic or beyond, they were well protected by natures forces, shipwrecking seas, extensive coastal mountains, heaving and grinding ice sheets, total winter darkness, frightful cold, extreme remoteness and, for most, suffered for at a grave expense.

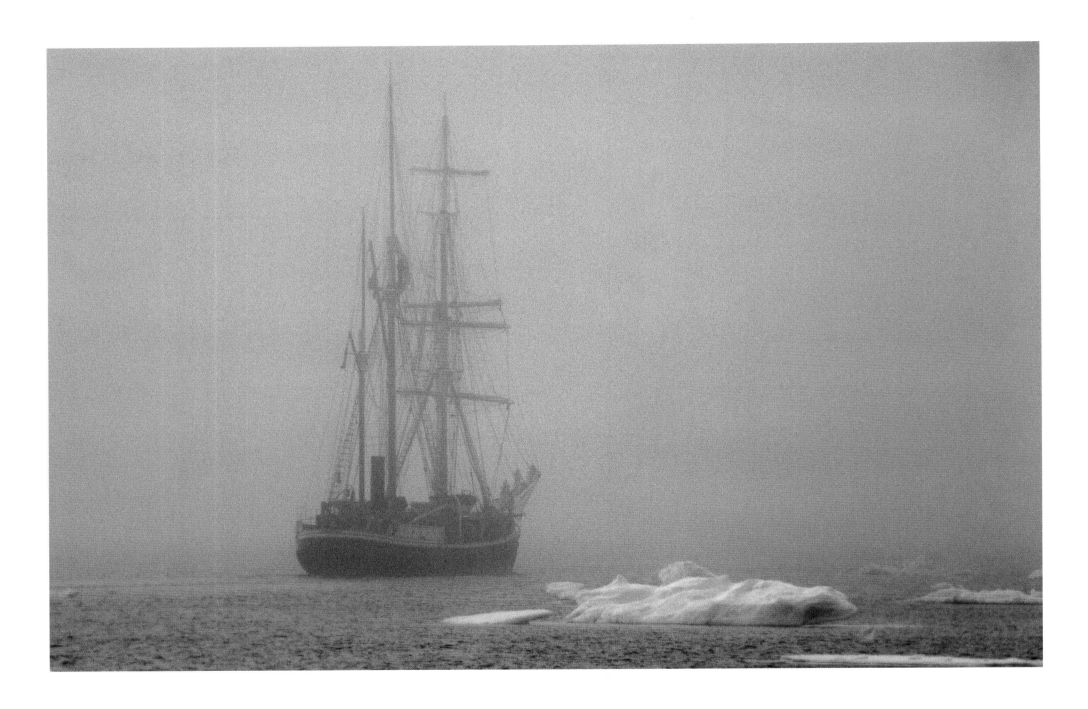

PLATE 63
Replica of Sir Ernest Shackleton's expedition ship HMS Endurance.
Photographed off the east coast of Greenland, 1982.

PLATE 64

Remains of Caribou *Rangifer tarandus* after passing migration. Somerset Island, Northern Territories, Arctic Canada.

BELUGAS

The pilot reached under the Twin Otter's seat for a spanner and grips. The door lifted off easily and I climbed in to the cockpit, sitting sideways, belted in, leaning out with my feet pushing down hard on the wheel strut. We rumbled and bounced on tundra tyres to a flattened terrace where the littered glacial rocks and stones had been picked clear, and an avenue of painted rocks marked a hard, dusty take-off strip. The brakes were released and we surged forward. Beneath my boots the wheel flailed and spun on the loose shingle. Airborne, the icy slipstream battered my knees as I leaned away from the blast. We circled the rugged coastline to gain height then swung out over the turquoise sea, blotched with the brash of melted icebergs.

'Belugas!' shouted Steve through the headset, as he cranked the plane over in a tight, sinking turn. There they were at last, swarming in the shallows of a gravel bank, curved like commas, these primeval and white soft forms, like the unborn. Our elevation of four hundred metres was high enough not to disturb the vast numbers of white beluga whales massing below us on their summer migration. Each year they make long journeys, navigating through the open water leads in the summer pack ice along the coasts of the Beaufort Sea and the Lancaster Sound west of Baffin, to arrive here in this sheltered bay of Cunningham Inlet to congregate, mate and slough off their winter skin in the shallow estuary of glacial run-off. This unearthly spectacle of cetaceans, set in the harshest and bleakest arctic haven, overwhelmed me at once, such are the mysteries and wonder of the north lands. To witness this fragile beauty was also to fear for its capacity to support such intense and specialised ecology in the future, despite it having survived the ebb and flow of a changeable climate since prehistoric times.

PLATE 65

Beluga Whales *Delphinapterus leucas* congregate in Cunningham Inlet on Somerset Island each year in mid July. They migrate in groups from around Lancaster Sound and gather in these shallow waters to slough parasites from their skin. Northern Territories, Arctic Canada.

FURY BAY

The air was cold and still. I sat outside my tent in the grey polar evening, gazing at the mute colours of the inlet – the tawny-shell browns, streaked with yellow-flecked ochre and interspersed with the curvaceous aquamarine of the glacial river channels that swung past me through the gravel strands. A small caribou migration had recently passed: antlers and bones were scattered on the tundra, dung trails pressed into lichen would provide nutrients for years to come.

A distant engine droned out of a grey arctic sky and descended toward me and, with a fluttering and a squeak of tyres on the shingle, slithered to a halt by my tent. Three men jumped out and strode over, one of them with a heavy bound ledger under his arm. I opened the canvas flap and offered them tea. They were archae-ologists from Winnipeg University calling by in their Twin Otter en route across Somerset Island in search of the legendary arctic beach of Fury Bay. The time was 1 a.m., the light dim and pearlescent in the overcast sky, yet tea and laughter produced the desired result: I was invited to join them. Little did I know that this experience would number as one of the most fascinating and eventually dangerous adventures of my life.

Between 1820 and 1825 Sir William Edward Parry, a British sea captain fresh from the office of navigator on Spitzbergen guarding the whaling fleet, made three attempts to discover a Northwest Passage to Cathay over the Canadian Arctic. His success, though partial, was crucial in understanding the geography of the archipelago of icebound fragments of land west of Lancaster Sound.[1] In 1824, on his third voyage in the two naval ships of HMS Hecla and HMS Fury (both of which had sailed into northern ice on his previous expeditions), Fury became fast in ice on the remote east coast of Somerset Island. Not wanting to remain for a further winter, Parry doubled his crew into HMS Hecla and forced a retreat through the pack ice escaping into the Bering Strait and home to England. HMS Fury was left to disintegrate in the pressure of winter ice, but not before Parry had emptied all stores, longboats and furnishings ashore on what he had named Fury Bay. These stores proved to be a life saving cache as they provided sustenance to future expeditions, including the famous escape of Sir John Ross after he lost HMS Victory in the same bay in 1834. While contemplating the possibility of entering yet another arctic winter, the Ross party made for the haven of

(1) William Edward Parry, *Journal of a voyage for the discovery of a north-west passage from the Atlantic to the Pacific* (London: John Murray, 1821).

supplies even then known to be ashore on this remote and inhospitable coast. In a documentary commentary from his book *Fury Beach*, Ray Edinger described the scene thus:

'Despite the great odds, their goal was eventually reached, and against all hope the stores at Fury Beach were largely intact, and the crew were elated; even Light admitted that they "could not have felt much happier, had they set foot on their native land." A capacious tent was soon erected, and the men warmed themselves by the stoves as they contemplated what they hoped would be their soon relief. The summer thaw was not far away, and the boats were quickly prepared, only for their crews to meet the most crushing disappointment, as the lone lead in the ice closed about them, leaving them no recourse but to retreat to Fury Beach for another interminable winter.' [2]

We fired up the Twin Otter's engines and took to the air in a pre-dawn dash to find Fury Bay, over a hundred miles to the south-west. Below me, the reticulated patterns of hexagonal frost heave were delineated by late snow-melt lying in the troughs around the polygonal shapes. The patchwork in the drab, brown tundra was

cleft with deep, post-glacial river valleys gouged by super rivers when the ice sheet retreated. The droning and vibrating of the engine was soporific in combination with the elevation in the un-pressurised cabin. We began to lose height and search for signs of human activity along the bare coast. Perhaps we might spy the foundations of an old Inuit hunting hut, or a discarded barrel hoop from McClintock's 1857 expedition during his final search for Franklin along this wild shore?

The big tyres hit the ground hard as we bounced on a gravel terrace above the sea, and, in a final surge of engine power, the pilot turned the plane around in a tight circle in readiness for take-off. The side door was pushed open and we scrambled out onto a flat stoney beach twenty metres above the calmly lapping sea. At the back of the beach a low cliff of loose conglomerate guarded access to the plateau beyond. The sky was a strange deep amethyst in the greying dawn, above a mercury sea littered with flat, luminous icebergs. We stood enraptured in silence broken only by a passing right whale breathing deeply far offshore. Peter, who was carrying the ledger, opened it with slow and deliberate drama proclaiming with due gravity, 'We are here,' before pointing to broken fragments of planks >>

(2) Ray Edinger, *Fury Beach: The Four-Year Odyssey of Captain John Ross and the Victory* (Berkley, 2003). ISBN: 9780425188453.

and debris of rusted food tins – remnants of winter survival from almost two centuries ago. McClintock had been here, and Dr John Rae, Sir John Ross and cousin James Clark Ross had waited patiently in this loneliest of places, wondering if they might ever return to the world so far away. Down by the sea a huge pile of barnacled chain heaped at the water's edge confirmed our location was indeed the legendary Fury Bay. I imagined the exhausted crew mates heaving the chain ashore, wondering if they would ever return to their loved ones, or if they would die of fearful cold and starvation, unable to summon rescue nor effect safe retreat. The pressing weight of arctic history fell across us like a heavy pall.

Surveys, measurements and photographs were taken and we prepared to leave. The pilot paced out the maximum length of usable beach and declared it was too short. We dragged the Otter backwards until its tail wheel was resting on the last possible boulder before a deep trench. The pilot did not speak but gesticulated for us to climb aboard and lock the doors. His eyes focused on the near horizon, we tightened our seatbelts to the last buckle. He pushed all accelerators in the flight cabin to maximum, against the stops. The engines screamed at maximum revs, vibrating the fuselage into a hideous convulsion. He held it on the brakes for agonising seconds and then threw the levers off. In the same instant that the plane lurched forwards, he snatched the flaps back to lift us with a powerful jump into the air, perhaps only five metres high. At the same time we plunged off the edge of the gravel terrace and sank towards the sea's surface, only fifty metres below. The Otter screamed with wind pressure in a ghastly stall, only making airspeed as we wave hopped and lurched along the very surface of the water, slowly, so slowly gathering speed and lift like a crow with a full belly. Fifty, one hundred, one hundred and fifty. We rose high into the air from what had felt like certain oblivion. Every one of us had held our breath, and we now burst out in relief, shouting, cheering and punching the air. We subsided and stared out at the new morning's silvery sea, thinking about HMS Fury lying on the seabed below. Each in our own thoughts, we remained in silence all the way back to camp.[3]

(3) In the year of 1826, Sir William Edward Parry obtained the sanction of the Admiralty for an attempt on the North Pole from the northern shores of Spitzbergen at Seven Islands. In 1827 he reached 82°45'N, which remained for 49 years the highest latitude attained. He published an account of this journey under the title of *Narrative of the Attempt to reach the North Pole* (London: John Murray, 1828).

PLATE 66
Lower jaw and molar grinding teeth of Caribou *Rangifer tarandus*. Bathurst Inlet,
Nunavut, Arctic Canada.

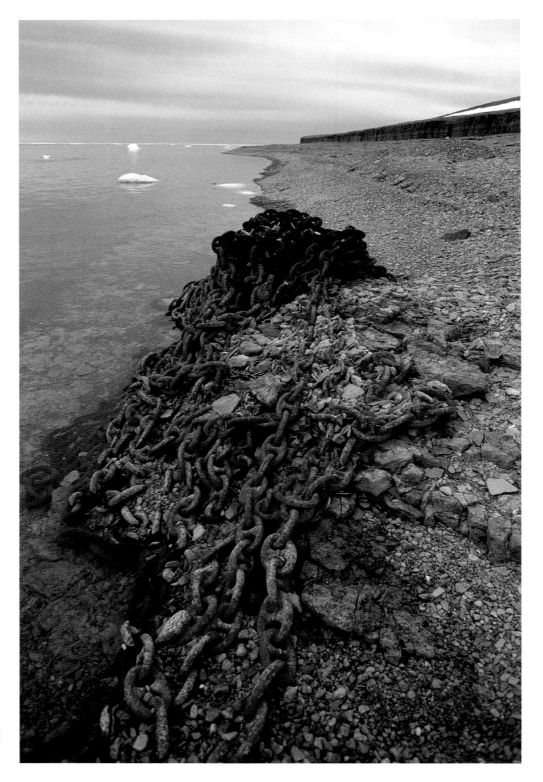

PLATE 67

Ships chain on Fury Beach, King William Island. Sir William Edward Parry abandoned his vessel HMS Fury here in 1824, while searching for the Northwest Passage.

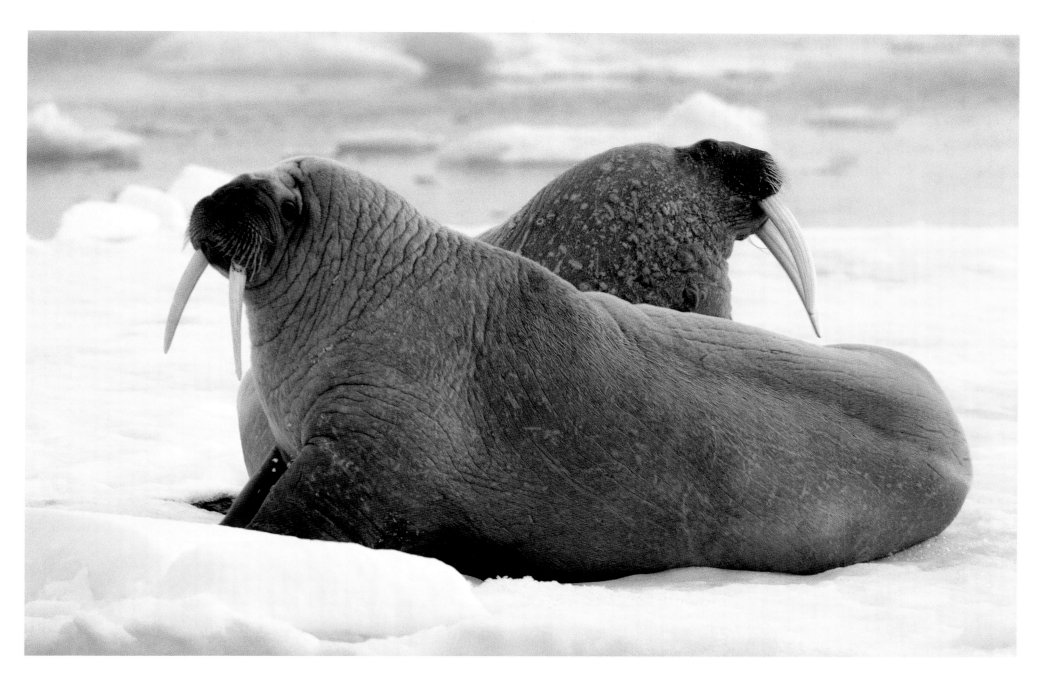

PLATE 68

Walrus *Odobenus rosmarus*. Walruses were once very abundant in the Svalbard archipelago, however they were hunted virtually to extinction here after three and a half centuries of heavy exploitation. Ivory was a valuable trade item and walrus haul-out sites were very easily exploited.

CROSSING GREENLAND, 1982

The water was boiling in the pan, balanced on top of the tiny paraffin stove. I unzipped my wind suit and crouched to retrieve the pan lid that had been dislodged by the head of steam. At last the tent was warming up. The midday sun, low on the horizon, barely helped the temperature rise from minus 15C. I heard an unusual sound outside. It was a high-pitched 'seep-seep-seep' sort of sound. Unusual because we were in a vast ice desert and had been man-hauling sledges across the Greenland icecap.

It was day thirty-three, we were about seventy miles from land and near the end of an amazing journey. I looked out around the tent flap. Hopping around the snow valence of the tent door was a small bird, a male snow bunting replete with white head and breast, and flecked tawny brown rump and tail. Before our expedition I had read the account of the first crossing of Greenland by the Norwegian biologist, Fridtjof Nansen, from the expedition of 1888. His successful pioneering exploration was close to journey's end when they too were visited by a small flock of snow buntings. He described this encounter and noted how cheered his party were. My heart soared; we too must be close to the edge of the ice.

Around us now was a deltaic labyrinth of summer meltwater, flowing along in ice blue channels and often blocking our straight line navigation. Rivers blasted down into caves beneath the ice making forward progress interminably slow. Some days in this area, we only made three kilometres, daring ourselves to either tiptoe across fragile snow bridges, or rope down into the water, before wading across and ice climbing up the opposing vertical walls. Eventually, there was little choice but to abandon our sledges and backpack all our survival kit and remaining food and make a dash for the mountainous west coast. It felt strange to be nearing the end of this life-testing journey, an inner journey in many ways, and set in the heart of extreme nature.

We had endured forty-four days of violent winds and penetrating coldness across the ice. At 3,000 metres – the highest part of the central plateau – the temperature dropped to minus 53C. Here the surface was hugged by a bank of ice crystal mist through which the weak midnight sun refracted unearthly colours of burnt orange, rose pink and vermillion yellow. Columns of silver light seared the sky, profoundly beautiful parhelia swelled up like wraiths in the chill, early hours of dawn. We marched on in this ethereal frost kingdom, lost from the world without means of rescue; like astronauts floating in deepest space.

The end was not a mountain summit, but a simple

stride off the ice edge onto living land beneath our boots. The scent of sweet grasses overwhelmed me as I buried my hands into a green bank of moss. Ptarmigans whirred round us, a white gyrfalcon flashed over a granite bluff, bog cottons danced in the late summer breeze and we gorged on bitter bilberries. Even the pebbles and lichens seemed vibrant and new. All this life and colour was overwhelming, a kaleidoscope of sensory wonders.

For two days we walked in a daze through the coastal mountains toward the American Air Station of Sondre Stromfjord, stopping frequently to marvel at our release from the ice, to gaze backward at our captor, from where we had engaged in a profound physical and mental battle. Ahead of us, we knew adjustments must be made to re-enter the worlds of our complicated lives, and the thought of sinking into the first hot bath for fifty days!

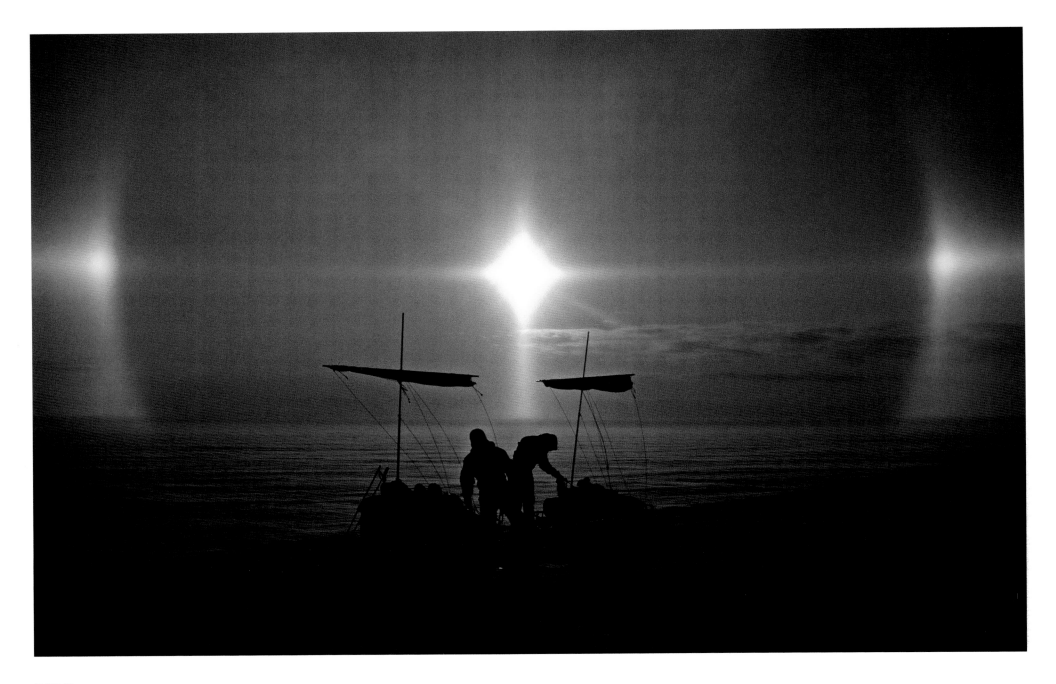

PLATE 69

During the expedition to man-haul sledges across the Greenland Icecap in 1982, we experienced the meteorological phenomenon of *parhelia*, when the midnight sun rising through freezing ground mist refracts the sun's rays. Inuit refer to them as *sun dogs*.

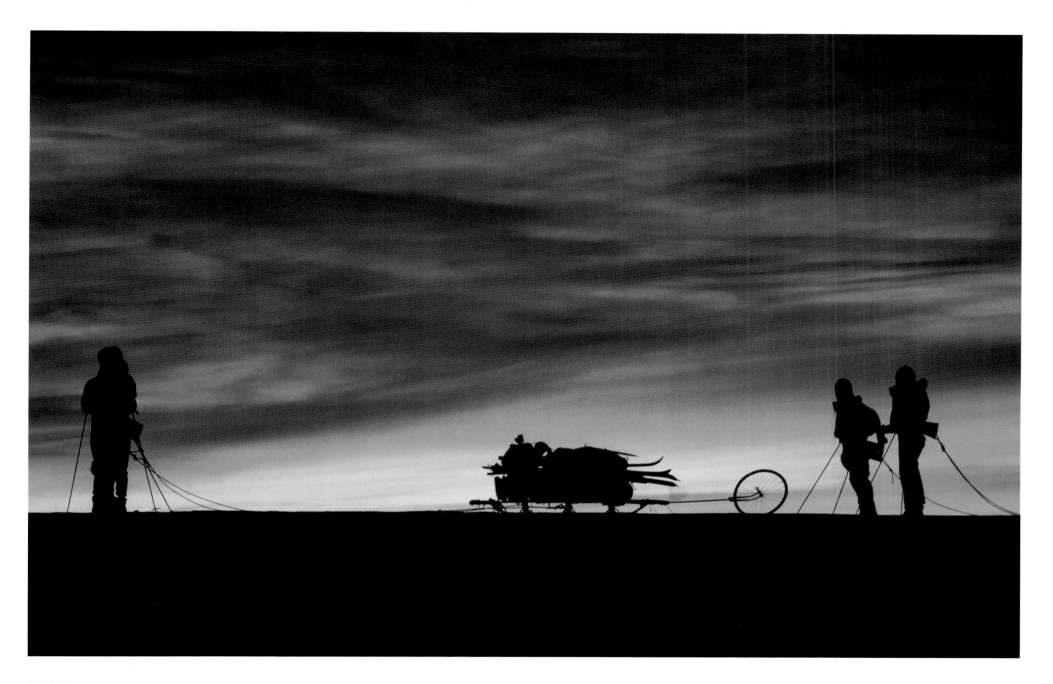

PLATE 70

The expedition to sledge across Greenland in 1982, from Angmagssalik on the east coast to Sondre Stromfjord on the west coast, covered a distance of 580 kilometres and was achieved in 44 days. Most travelling took place between the hours of midnight and midday.

WIND FOSSILS IN SVALBARD

The hot cylinder head of my snowmobile was the perfect place to defrost the sandwiches that had frozen solid while inside my windsuit. The wilds of Svalbard in late winter are very severe. Permanent twilight throughout March, and constant temperatures of minus 40C, ensures that one is attentive to safety, and that includes eating food. I suppose gherkins and cheese are not the most efficient fillings for an expedition sandwich, but this was a long and strange expedition.

The emergence of daylight after the leaden darkness of the arctic winter is the signal for polar bears to emerge from hibernation. Often the she bear has cubs to feed, and more often than not the winter sea ice has not melted, resulting in no seals and hungry bears. Sometimes they travel inland away from the sea in search of food, hoping perhaps to ambush a reindeer or even raid the garbage of a human settlement.[4]

After my experiences in Antarctica in 1981 as a general field assistant for the British Antarctic Survey, I was invited to work as a field safety officer for a geological survey company in Svalbard in the high arctic of the Barents Sea. The largest island of the archipelago, Spitzbergen, is 1,800 kilometres north of Norway and only 1,200 kilometres from the Pole. Sixty per cent of the islands are glaciated and mountainous with permanent icecaps. Along the coast the North Atlantic Drift breaks out the winter ice in the estuaries and fjords, providing excellent nesting and feeding habitats for hundreds of thousands of migrating seabirds, geese and sea mammals.[5] Part of my work involved travelling by snowmobile and on foot across hundreds of kilometres of spectacular glaciated scenery.

The arrival of daylight is like a yearly rebirth, transforming life in polar places. Through January the dim winter sky occasionally reveals pillars of stray light from beneath the horizon, with beautiful solar flairs and colours of jasmine and orange reflecting under the cloud. Each day's daylight is actually twenty minutes longer than the day before. A curious phenomenon of the sun in high latitudes is its appearance above the horizon in mid February: its arc traverses almost horizontally creating luminous and unearthly colours, as if the delights of sunrise and sunset last for over a month. By the end of March the transformation is complete, and daylight is continuous across Svalbard until September. Indeed the largest township in Svalbard is called Longyearbyen.

(4) In Churchill, Manitoba, a great problem exists with polar bears habituating to easy pickings from the local trash dumps. Recalcitrants are trapped and shipped far away into the backcountry for their own protection. **(5)** The North Atlantic Drift, or Gulf Stream, is a warm ocean current originating in the western Atlantic near the Equator and flowing in a north-easterly direction ensuring moderate winter temperatures in Britain, and an ice-free summer coastline for Arctic Norway.

One bleak cold morning I travelled by snowmobile high into the mountains of Heerland above the basin of Agardhbukta. The entire landscape was inundated in snow to a great depth. All signs of rock were erased beneath a mantle of ice. It was a land of simple shapes. Smooth parabolic curves edged every ridge line as if sculptured by Gaudi. Banners of spindrift flew from the crests, the grey sky muted the snow into a dull satin wasteland. We arrived on a pass between three small peaks. The wind had abated to an uneasy calm, the temperature was rising. We cut the motors on the snowmobiles and opened the frozen sandwiches, thawing them on the cylinders.

Peak upon nameless peak surrounded us as far as we could see. Distant glaciers like silent rivers wound in energetic curves, dividing the mountains into clusters. No human history, I thought, no creatures or life or anything. One can quite suddenly be overwhelmed by loneliness. Just bleak arctic vistas penetrating the mind. I began to study the patterns on the snow. The sastrugi ground textures described the prevailing winds like frozen compass needles. But just a hundred metres away we spotted unusual shapes. They were the huge footprints of a polar bear and cub. Instead of being depressed into the snow surface, they stood proud to a height of nine or ten centimetres. The ground-drifting winds through

the night hours had scoured the soft surface, scarifying every grain of loose snow into natural art. The bear prints, originally compressed by its own body weight into the surface, now remained as transient wind fossils for us to wonder and imagine about its life, awoken by the light of spring. Once released from their icy den, they will wander the arctic wastes together before the catch of salt air draws them inexorably to the bounty of the summer seas.

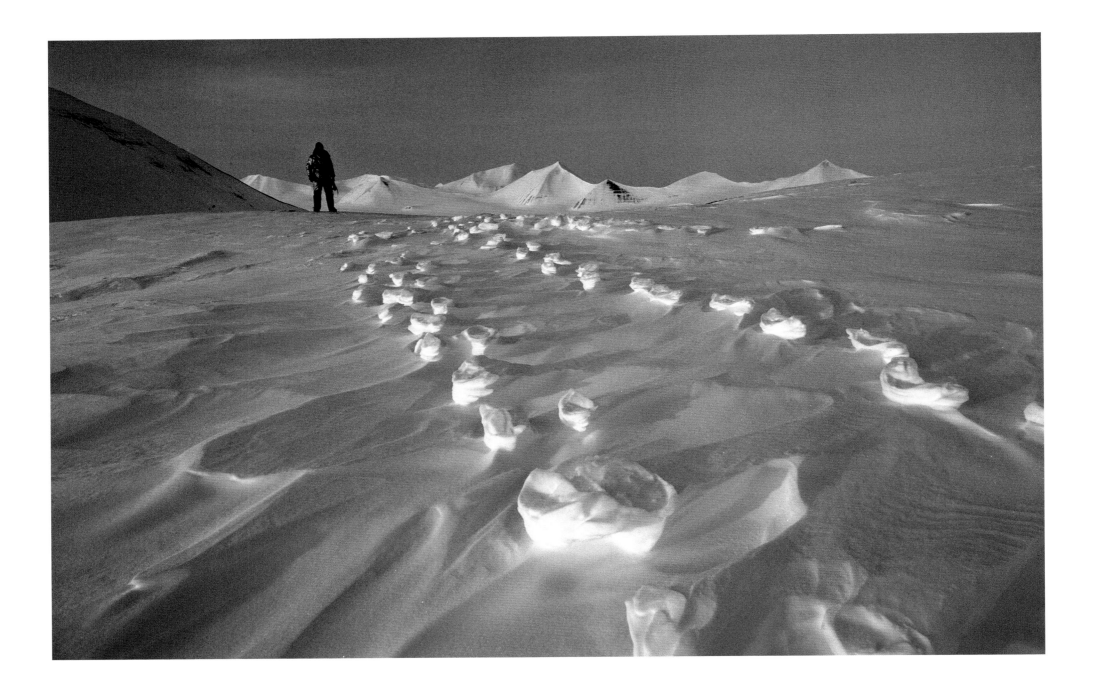

PLATE 71

Raised wind-scoured paw prints of Polar Bear *Ursus maritimus* sow and cub.
Heerland, Spitzbergen, Arctic Norway.

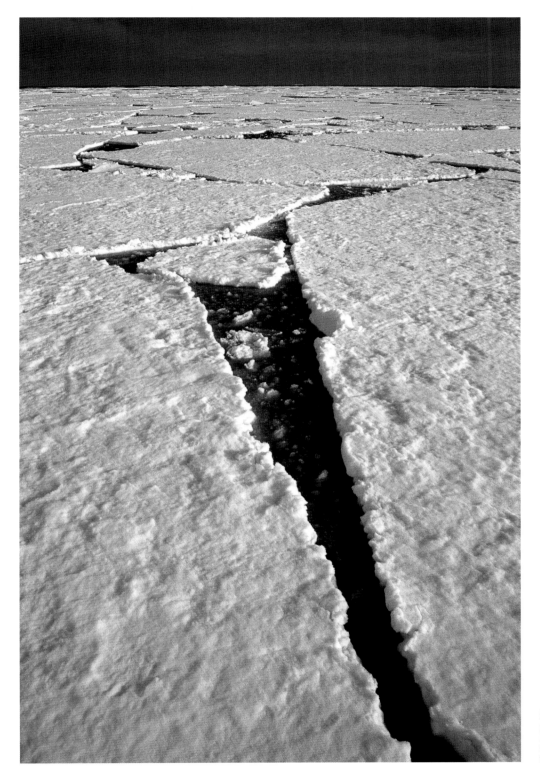

PLATE 72

Pack ice along the coast of Svalbard begins to break during late May and June, influenced by movements in the Gulf Stream and atmospheric temperatures. Migratory birds flock to Svalbard at this time for feeding in the rich waters.

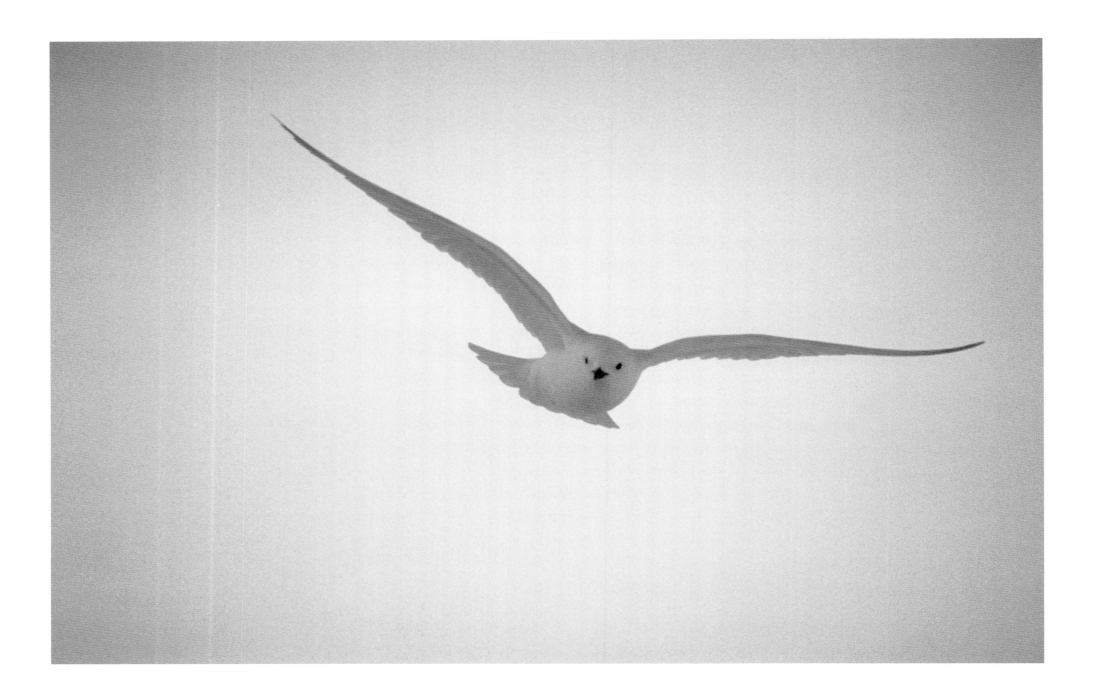

PLATE 73
The Ivory Gull *Pagophila eburnea* is the most northerly breeding bird of the Arctic.
Ny- Ålesund, Spitzbergen.

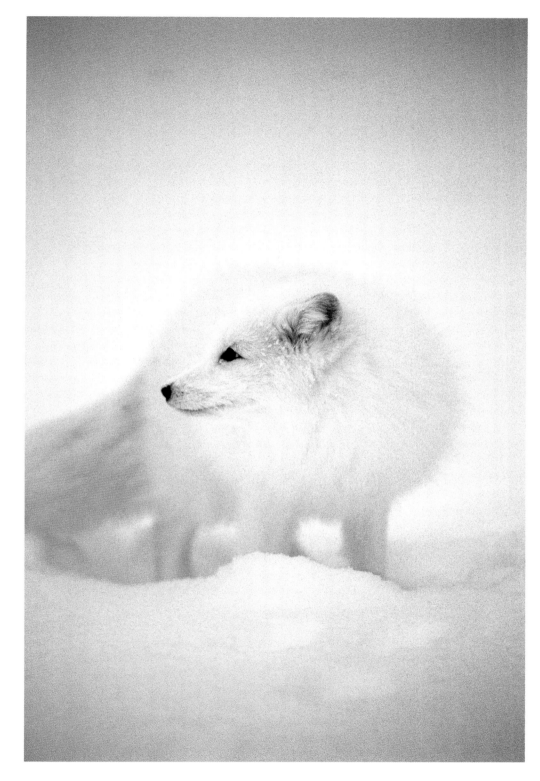

PLATE 74

Arctic Fox *Alopex lagopus* in winter pelage. In summer months the arctic fox feeds on seabird chicks, lemmings and other small prey. Sveagruva, Van Mijenfjord, Spitzbergen.

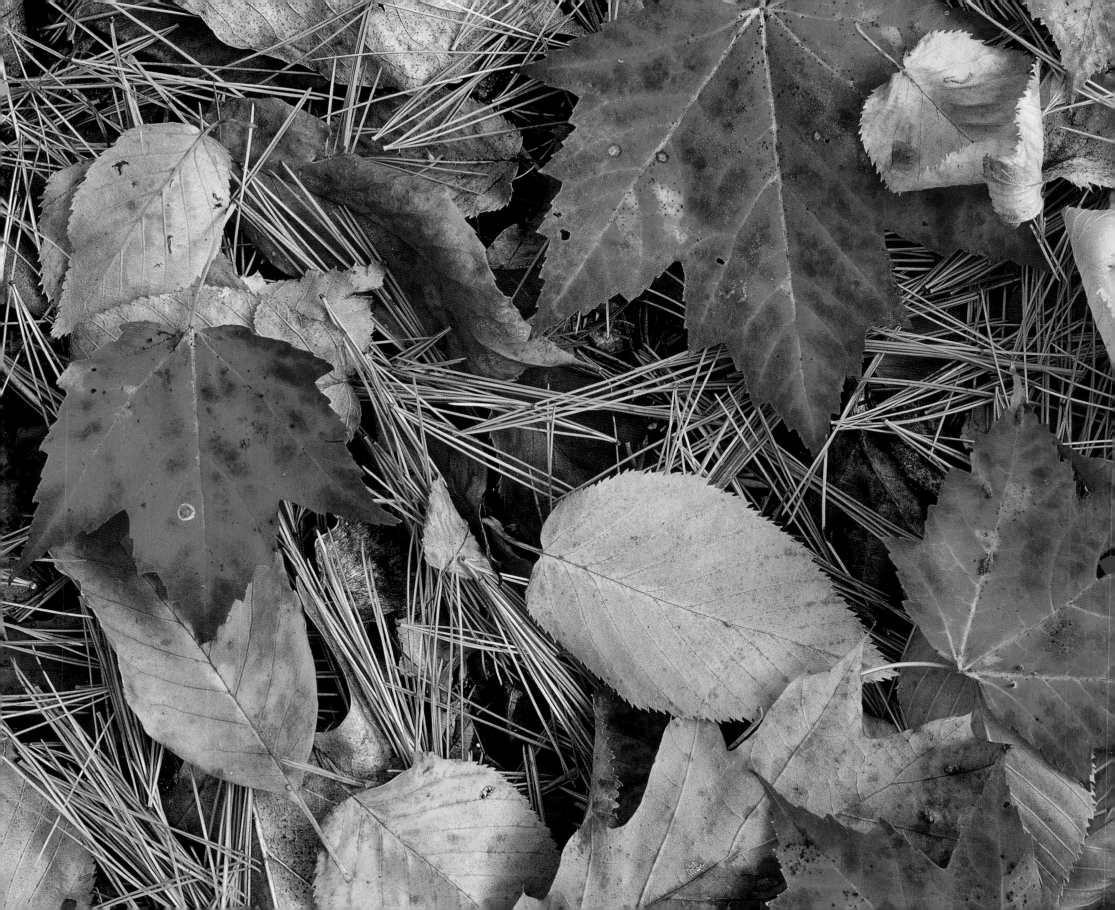

Northern Forests

'The unrecorded past is none other than our
old friend, the tree in the primeval forest
which fell without being heard.'

BARBARA TUCHMAN (1912–1989)

PLATE 75

Woodland leaf litter of Maple *Acer saccharum*, Aspen *Populus tremuloides*
and Larch *Larix decidua* at North Conway in the Appalachian Mountains
of New England.

Do you remember clutching a branch and pulling, swinging your feet up, balancing in the boughs, gripping, clean and strong? Climbing trees as a child was vertical exploration par excellence. Shiny trees, bendy or brittle trees, trees as rough as rock; all playgrounds for the simian art. These were seminal times and as much a part of growing up as eating. We had favourites up on the edge of the moors south of Manchester, trees so old they seemed to hold secret stories within their stillness.

Single trees have a sentinel character about them and are easily regarded in a landscape. Facts and metaphors referring to age abound around them, but there is more. Trees quietly mark the landscape, giving us a mental map of our daily round. They are part of a life map, often more deeply felt than observed with any grand cognition, perhaps as recognisable in consciousness as friends might be. The ancients regarded trees in their art, poetry and mythology, and with their simple demands for building materials and fuel for fire. But to look out across an entirely wooded landscape it is possible to feel an energy emerging from the land itself, an acknowledgement of democracy and dependency, in which we share the same demands of clean air to breathe, and of space to be shared.

Trees are a vital earth resource and carbon sink; regulating local and global climate; ameliorating weather events; protecting watersheds and water flows; vegetation and soils; and providing a vast store of genetic information, much of which has yet to be discovered. Scientists endlessly debate the relationship between biological diversity and ecological benefits. But trees have an uneasy economic relationship with man, especially concerning land use versus the forest products upon which millions of peoples rely.[1]

Intact forest landscapes are unbroken natural ecosystems that show no signs of significant human activity, and are large enough for all native biodiversity to be maintained. But they are diminishing rapidly. These places include the Taiga boreal forests of Russia, Canada and Scandinavia, the temperate Pacific coast forests of Alaska and Chile, and the swathes of remaining equatorial tropical forests of central Africa and South America. In the rest of the world, forests remain only as remnant ecosystems, as pockets surrounded by incursions from economic demands. Most of the primal rainforest of Central America, Indonesia and the South Pacific islands has been greatly reduced by replacement to cash cropping for world markets.

(1) World Resources Institute, *The Encyclopedia of Earth* [online article], 'Ecosystems and Human Well-being: Biodiversity Synthesis: Key Questions on Biodiversity in the Millennium Ecosystem Assessment' <*http://www.tinyurl.com/6zob2ro*> accessed 24 January 2011.

The narratives I wish to relate are connected to events that happened amongst trees in four key forest habitats. Within each one, new understandings and insights were revealed to me about the life and lore of the woods.

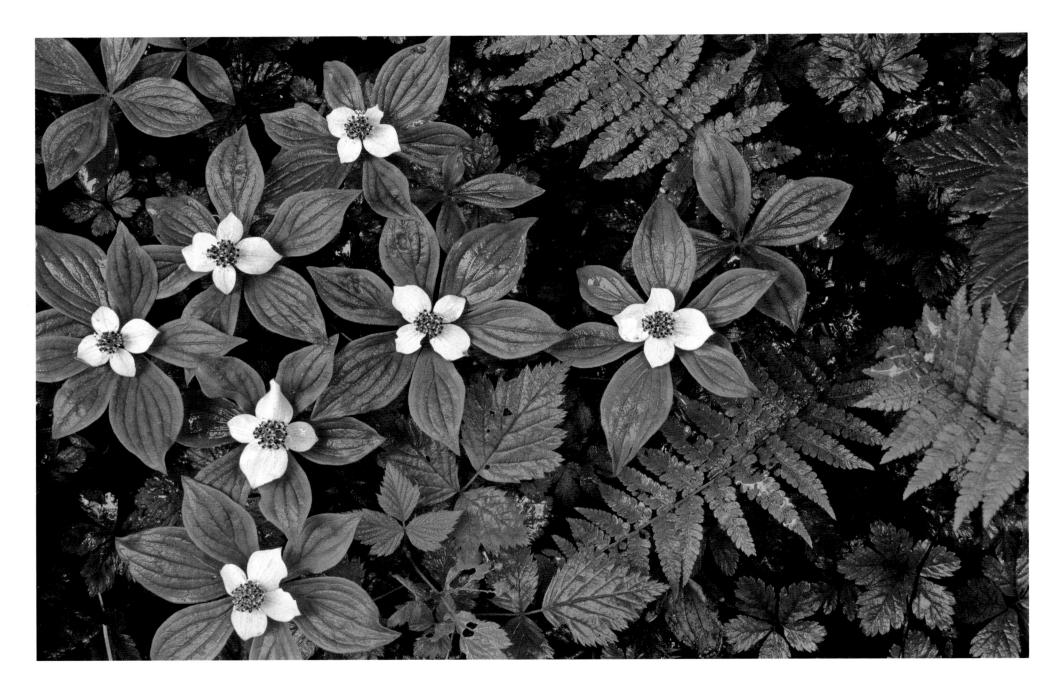

PLATE 76

The Dwarf Dogwood or Bunchberry *Cornus cardensis* is a common ground plant of the forest floor, especially found in light loamy soils. Birds disperse the seeds widely as the berries are a favoured food source in the fall.

PLATE 77

Temperate broadleaf forests in New England support up to 225 bird species, making them among the 20 richest eco-regions in the continental United States and Canada. Mature northern hardwood stands in New England commonly contain softwoods — usually Red Spruce, Eastern Hemlock, or White Pine — and as a result they also contain bird species associated with coniferous forests.

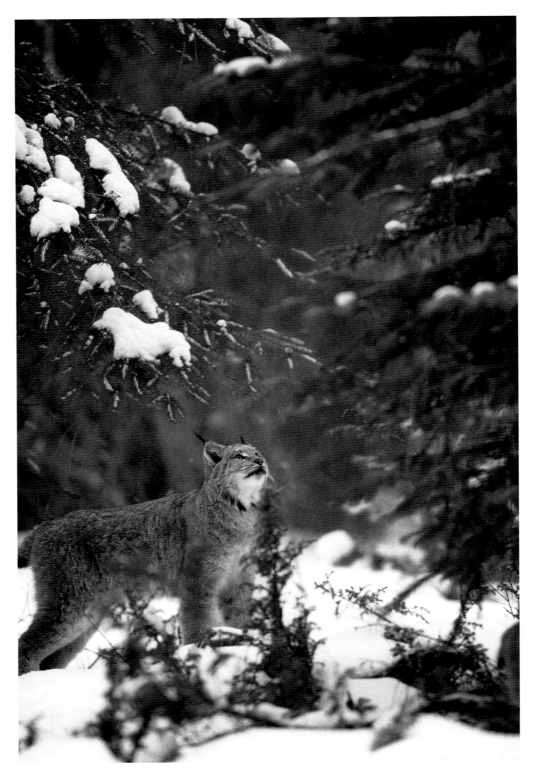

PLATE 78

Lynx *Felis lynx* is a spectacular yet shy feline predator of the boreal forests of Canada and the borders. Sub-alpine forest habitats that support the Snowshoe hare are particularly favoured by the Lynx. I experienced this sudden and amazing chance encounter in the remote woods of the Garnet Range, Montana, following reported sightings by the Forest Service.

PLATE 79

Flotsam of the shoreline along the coast of Moresby Island, Haida Gwaii, British Columbia. Beetle infested driftwood, granite pebbles and leaves; all remnants of the ancient Pacific Coast temperate rainforests.

SPRING — HAIDA GWAII

One hundred kilometres from the coast of British Columbia, at the very edge of Canada's Pacific continental shelf, are the Queen Charlotte Islands. Their surrounding shores are rich in nutrients from the north Pacific while the climate is influenced by the warm offshore currents.

Because the islands were a refuge from the full impact of the last Ice Age, they support an ancient and unique community of animals and plants. Here too is the home of the Haida peoples, an outstanding aboriginal culture who have survived for thousands of years on the abundant natural resources of the sea and the forest.

The name Haida Gwaii means 'Islands of the People' in the language of the Haida, who claim the archipelago as their ancestral lands. A Spanish sea captain, Juan Pérez, first sighted them on 17 July 1774. Blown off course, his crew aboard the Santiago had not seen land for several days when they sighted the area now known as Langara Island, a small island off the northwest tip of the archipelago. Pérez was under orders to claim new lands in the name of Spain to prevent the feared expansion of Russian territory south along the coast. Pérez ventured close enough to observe several large buildings along the shore and to conduct

trade with local Haida who paddled out in enormous canoes each carved from a single tree.

The islands were left unnamed until 1787 when Captain George Dixon, also under orders to claim new lands and to investigate trade opportunities for Britain, named them after his ship the Queen Charlotte.[2] A vibrant trade in the pelts of the sea otter brought early but only temporary wealth to both traders and Haida peoples. European diseases drastically lowered their population to about 580 individuals by 1915, the most dramatic drop of any tribal record in Canada, recovering today to around 5,000 Haida islanders.

Haida Gwaii includes 150 islands in an archipelago located 160 kilometres from the mainland, amongst the most isolated islands in Canada. Also unique is the absence of a continental shelf off the steep western ramparts of Moresby Island, which has given rise to the theory that plant and animal species were able to develop here uninterrupted by glaciation. The deep waters attract the passage of six species of migrating whales feeding on the plankton rich waters, and these unique islands are home to some remarkable old-growth forests with giant stands of Sitka spruce, western hemlock, and red and yellow cedar.

(2) Queen Charlotte was the wife of King George III, the King of Britain at that time.

The coastal rainforests of the Pacific Northwest reach a zenith in these islands and hold the largest accumulation of biomass on the planet, even more than tropical rainforests. The forest floors are deeply carpeted with hundreds of species of mosses, salal bushes, huckleberry and ferns. Indeed, there are moss and flowering plant species here that only occur elsewhere in the world in Bhutan, Japan and Ireland.

The readily accessible monumental stands of western red cedar and Sitka spruce provided another catalyst for European settlement to the area. During WWII the tight grained, shatter-resistant Sitka spruce was of particular importance for airplane manufacturing and logging increased significantly to support the Allied war effort. Logging continued at a rapid pace for decades, until blockades by the Haida nation and international pressure forced the governments of British Columbia and Canada to slow the allowed cut-rate of the island's forests and led to the creation of the Gwaii Haanas National Park Reserve and Haida Heritage Site. The Park also protects the island of SGaang Gwaay, a UNESCO World Heritage Site that features some of the best preserved totems and longhouse remains in their natural setting.

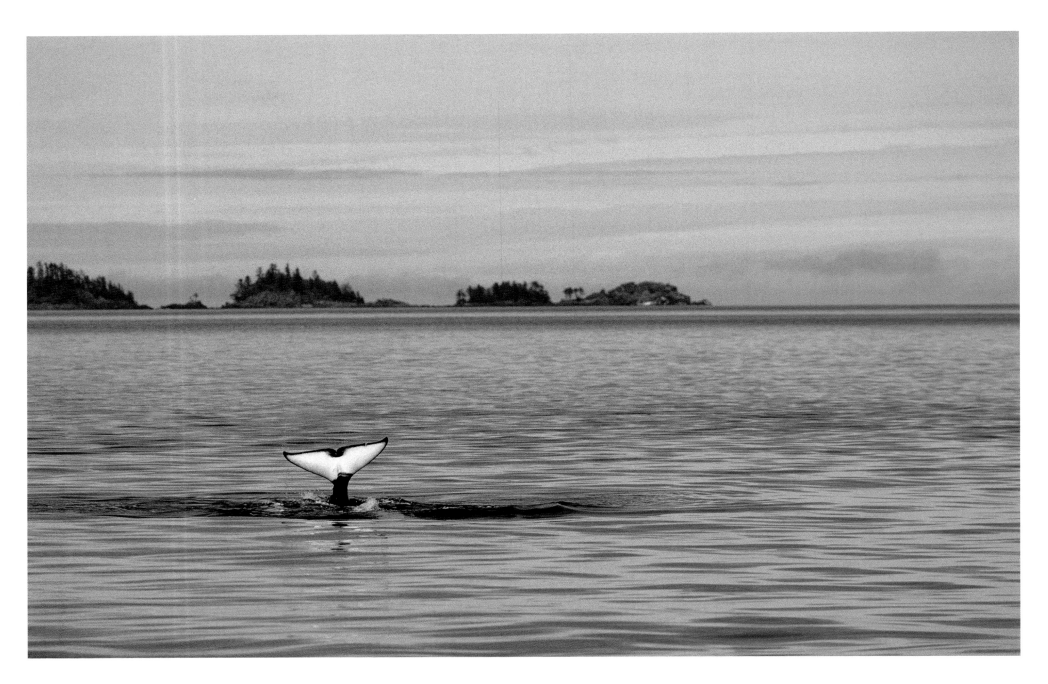

PLATE 80

The Orca or Killer Whale *Orcinus orca* is a large toothed whale common in the
Hecate Strait of British Columbia. Orcas make a local migration to this area
for the annual salmon run. Photographed near Lyell Island, off the east coast
of the Queen Charlotte Island group also known as Haida Gwaii.

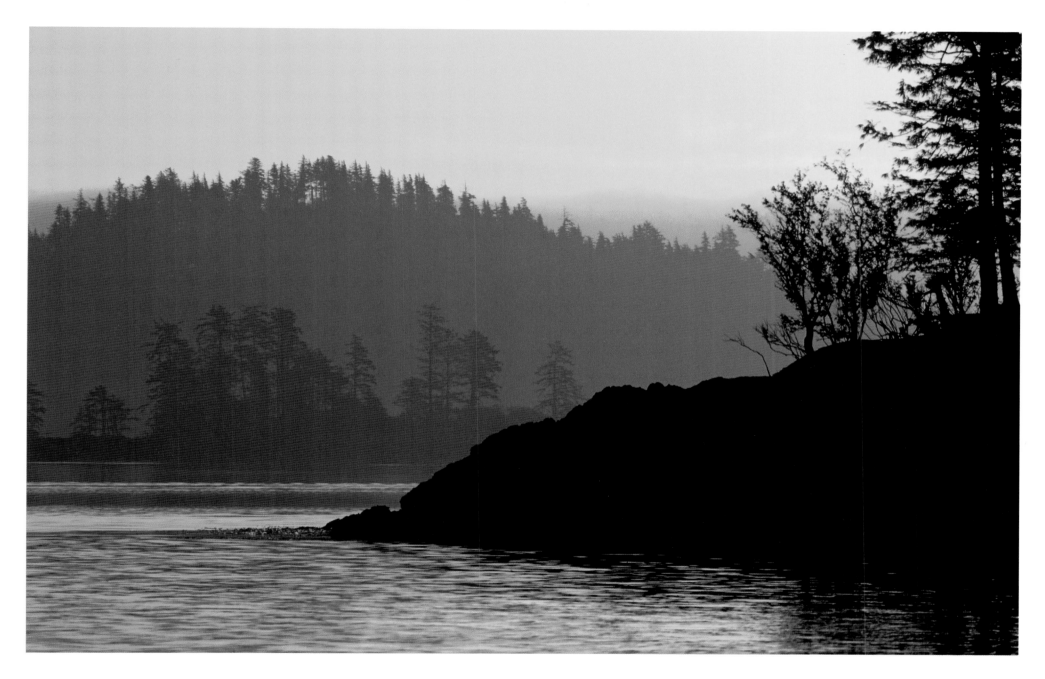

PLATE 81

Kunghit Island, part of the Queen Charlotte Islands, supports extensive stands of old growth coastal rainforests of Western Hemlock, Red Cedar and Sitka Spruce. The unusual and abundant flora and fauna that occur here have led to the appellation 'The Galapagos of the North.'

SPRING — HAIDA GWAII | NINSTINTS

There was only silence and the soft hiss of the sea combing pebbles. Bull kelp rose and fell with the gentle breathing of the incoming tide. Heaps of bleached logs marked the backshore like the forest dead, once adrift for eons on a Pacific swell, now fetched up here on the wild inlet at Kunghit. Beyond, at the forest edge, an open strip of meadow also held the forest dead. Carved logs fifteen metres tall reared into the woodland clearing holding the skeletal remains of the dead. The mortuary totem poles of Ninstints held their secrets.

The Haida people were master carvers of ceremonial poles. Each one depicted the forest moieties of the eagle, the bear, and the orca whale. The bones of the ancestors remained atop the poles since their interment two hundred years ago. I gazed upward searching for meanings in the carved surfaces. Crusted lichens had occupied every groove in the dry wood texture giving them the appearance of stone. The wild forest provided everything for their lives; canoes from the red cedar, lodge poles of western hemlock and sitka spruce for their baskets and nets. It also provided them with transport to the afterlife, in the company of the nature gods around them. I imagined them in the early nineteenth century in their hand hewed cedar canoes rowing out to the strange ships of the Europeans, singing songs of welcome and spreading eagle's feathers on the waters in a symbolic act of welcome.

Further inside the forest redundant ceremonial poles lay rotting back into the earth from where they had grown. A carpet of mosses and tree pelt lichens welded the poles to the forest floor. In the litter, cones of western hemlock sheltered delicate orchids of livid violet hue. More lichens of witch's hair hung in thick veils on all the branches lending a strange and unearthly atmosphere beneath the canopy. Nothing stirred but the ubiquitous evening song of the mountain thrush. I found my way back to the beach walking once again along the line of leaning totems. A wraith of sea mist from the shore lent presence to my passage amongst the sleeping souls.

PLATE 82
The Haida aboriginal culture made monumental totem carvings on cedar trees that recounted familiar legends or represented shamanic powers. This traditional carving depicted the birth of a frog from the belly of an Orca. Anthony Island, Haida Gwaii.

SPRING – HAIDA GWAII | BURNABY NARROWS

The paddle blade dips and slides, sparkling water tumbles then drips as I glide through the champagne clear waters of Burnaby Narrows. This fifty-metre wide channel of sea connecting the waters of Juan Pérez Sound and Skincuttle Inlet on the east coast of Moresby Island has a remarkable nine-metre range between high and low tide that feeds one of the most remarkably rich shorelines in the world.

The kayak floated silently above an incredible sea garden. Below me in the naturally magnified shallows, were crowds of the strangest marine organisms imaginable. This was Noah's Ark of the low tide; rainbow-coloured sea starfish, silver and black striped goose barnacles, jade green mussels, clams, giant moon snails, dark purple urchins, saffron yellow crabs, sponges of all shapes, chitons, and sea cucumbers, all vibrant in the sunlit shallows. I gazed down, and wondered. I couldn't live down there in the water; those creatures couldn't live here in the air. The plane of the water's surface was not a mirror this time, but a portal. I mused on the adaptations and complexity of all living things. I dipped my hands down, but not to invade.

The kayak grounded onto the mud, I climbed out and paced toward a group of exposed tidal rocks that appeared to have some interesting molluscs attached to them. As I walked, razor shells in the mud squirted little fountains of seawater as they burrowed deeper down. The molluscs were drab and plain brown yet quite large – almost twenty centimetres long and humped. I prized one off carefully in order to look at it. To my astonishment, beneath the shell was an exquisite glistening complexity of succulent golden-coloured flesh, arranged in functional labias and tentacles leading to the obvious mouthparts. The flesh moved slowly and rhythmically, clearly aware of its displacement. I carefully returned it to its exact position on the rock. This was the remarkable chiton, a mythical sea form revered by the Haida, and familiarly called 'The Mother.' I remembered the creation legend I'd heard from a Haida 'Watchman' the evening before.[3]

The role of the raven in Haida culture represents it as both a sage and a trickster, but in this particular incarnation, he is the creator of all life.

(3) Haida Watchmen are guardians of information, including myths and legends, who live at five old village sites in the Gwaii Haanas National Park Reserve and Haida Heritage Site of Ninstints. Their role is to live on site and provide security for and protect the cultural features. (4) This apocryphal creation story was retold by Robert Bringhurst and illustrated by Bill Reid in *The Raven Steals the Light* (Douglas McIntyre, 1996). ISBN: 1550544810.

*'One day Raven was pacing about on the beach,
bored with the exasperations of small birds in the forest.
He was tired since he had amused himself by creating
the sun, the moon and the stars and needed some new
friendships. Across the beach he heard faint voices.
On encounter, he looked down and saw that a clamshell
had slightly opened, and inside was a cluster of tiny
human forms of boys. They clearly couldn't get out of
the nearly closed shell. In an instant, Raven remembered
the Mother chiton, fetched one from nearby and
presented it to the clam, whose strong muscles relaxed
for a moment. The tubed 'foot' of the clam extended
toward the chiton, thence men and women were created
on earth.'* [4]

The tide was still falling so I left the kayak and
wandered to the forest edge. The sandy backshore
halted against the forest abruptly, where huge boulders
formed a natural barrier. I scrambled up through the
dense cushions of emerald mosses that covered them
like a soft blanket, just far enough to feel I was inside
the forest canopy where I sat quietly, listening.

Sounds from the shore behind me melted away
to silence. The heavy odours of salt and kelp gave way
to more fragrant aromas of cedar, spruce and mosses.
High overhead in the upper canopy the sea breeze still
combed the treetops, yet below it was quite still. Shafts
of sunlight streamed down through moss festooned
branches, dappling the forest floor and playing across
the massive trunks of Sitka spruce, cedar and hemlock.
This was ancient forest. Mosses and lichens had
colonised almost every available surface. Everything on
the forest floor would be ingested by insects, fungi and
bacteria, and incorporated into deep loamy soils. Dead
trees hosted unnamed hordes of moulds, algae, cellu-
lose-digesting fungi, nitrogen-fixing bacteria and birds
– they are anything but dead. These living 'nurse logs'
will become rows of diminutive spruce and hemlock
seedlings, in a continuous process of regenerating life.

>>

The result of this prolonged intermingling of life forms is a consummate ecosystem about which we know very little. This much we do know: these primeval forests are the largest accumulations of biomass on the planet, even more so than tropical rainforests. I fail to understand how the logging industry can justify its elimination.

The heavy trails of lichens hung off the trees, and the entire moss covering of the woodland floor absorbed all sound. Here, within the peace of nature, I sat perfectly still for twenty minutes. Not even a leaf moved. My hands were flat beside me touching the star mosses, my legs stretched out, resting down the curve of mossy rock. I began to hear my heart beating inside my ears. In the far away distance, the resonant croak of ravens in conversation echoed in the green vault of the forest. A woodpecker gave herself away with the faint scrabble of claws gripping onto bark. My attention averted to a dense clump of calypso orchids hiding in the soft litter. To remain perfectly still within the profound silence of this place was to be absorbed into the heart of nature itself.

It was time to return. I slid down the rock and out of the forest onto the backshore. Amongst the vetch and beach lovage, a tiny ocean strawberry threaded its tendrils in the sand. I walked down the mud to the kayak, climbed in and pushed strongly out of the shallows, gliding into deep water. I startled at a coughing sound behind me as the kayak drifted in a turn. Lumbering down the beach was a huge black bear swinging its head from side to side. It followed my footsteps to where the kayak had beached, and raised its nose to the air sniffing in my direction. To this day I have to assume it had lain extremely close to me in the forest, but preferred to remain entirely hidden.

PLATE 83

The Black Bear *Ursa americanus* of Haida Gwaii is larger than its mainland cousins. It has an adaptation of having a larger lower jaw, most likely due to a diet of foraging molluscs on the shoreline. Burnaby Narrows, Queen Charlotte Islands.

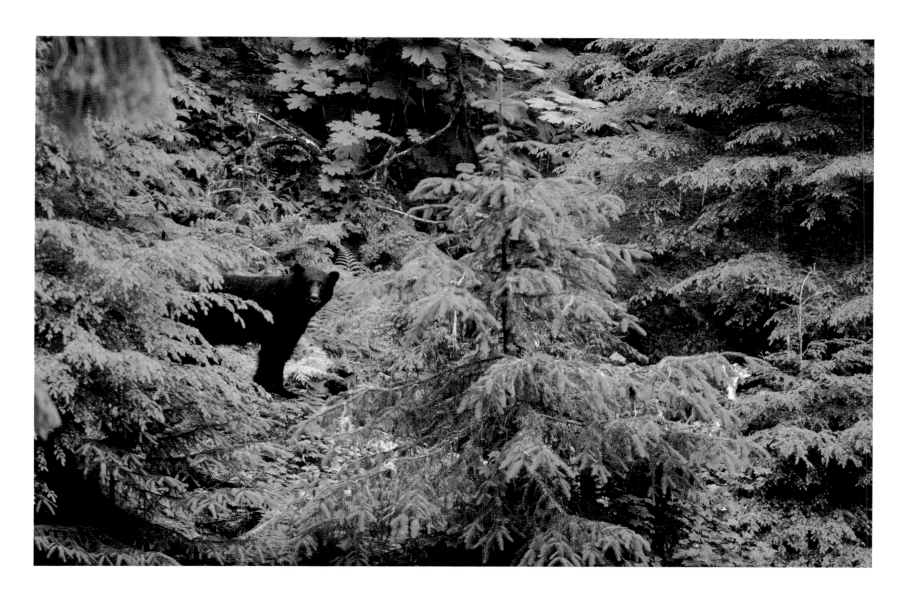

The Chiton *Cryptochiton stelleri* is a large mollusc found at the bottom of the inter-tidal zone of rocky beaches of the North Pacific. Where undisturbed, it feeds on kelp and sea lettuce and may live to 40 years old.

PLATE 85

Goose barnacles *Pollicipes polymerus* are found on exposed coasts where water movements on their tentacles enable them to feed. Along with other common shellfish, they are susceptible to acidification in ocean pH, which reduces their calcium shell structure. Hotspring Island, Haida Gwaii.

WINTER — YELLOWSTONE

In the northwest corner of Wyoming is an area of some two million square miles of volcanic plateau, forest and mountainous terrain scoured by glaciers and scorched by fire. It is also the site of the world's largest calderas with over 10,000 thermal features and more than 300 geysers. Even as late as the latter third of the nineteenth century, the Yellowstone area of Wyoming and Montana was considered *terra incognita*.

Surprisingly, by the time Yellowstone was inaugurated as America's first National Park in 1872, most of the West was already explored and settled. The California gold rush had come and gone, the Civil War was long since over. John Colter of the Lewis and Clark Expedition had walked alone through here in search of furs as early as 1807, and throughout the nineteenth century a series of key expeditions took place including one by David E. Folsom, Charles W. Cook, and William Peterson in the autumn of 1886. The surveying and the findings about the interior regions around the Yellowstone River excited the Surveyor General of Montana, Henry D. Washburn, and Nathaniel Langford:

Wednesday August 31 1870
'Standing there, or rather lying there for greater safety, I thought how utterly impossible it would be to describe to another the sensations inspired by such a presence. As I took in this scene, I realized my own littleness, my helplessness, my dread exposure to destruction, my inability to cope with or even comprehend the mighty architecture of nature …and my dependence upon who had wrought these wonders.'

Nathaniel P. Langford

His research expedition inspired one of the most important and well-funded – indeed the first federally funded – expeditions of the time in 1871, mounted by Ferdinand Vandeveer Hayden. Hayden assembled a large and talented scientific party of botanists, geologists, and zoologists, together with photographer William H. Jackson and artist Thomas Moran. His highly successful expedition gathered hundreds of specimens in addition to producing a wealth of notes, photographs and artistic sketches, confirming the wonders of Yellowstone. In turn these findings were made into reports that impressed the representatives of Government to create an Act that would be signed by President Ulysses Grant, creating the world's first National Park. There are few wild areas of the United States that have remained intact since their discovery: Yellowstone National Park is one of them. In the surrounding millions of acres of national forest, almost every species of plant and animal life that John Colter could have seen when he ventured into the area almost 200 years ago continues to flourish.

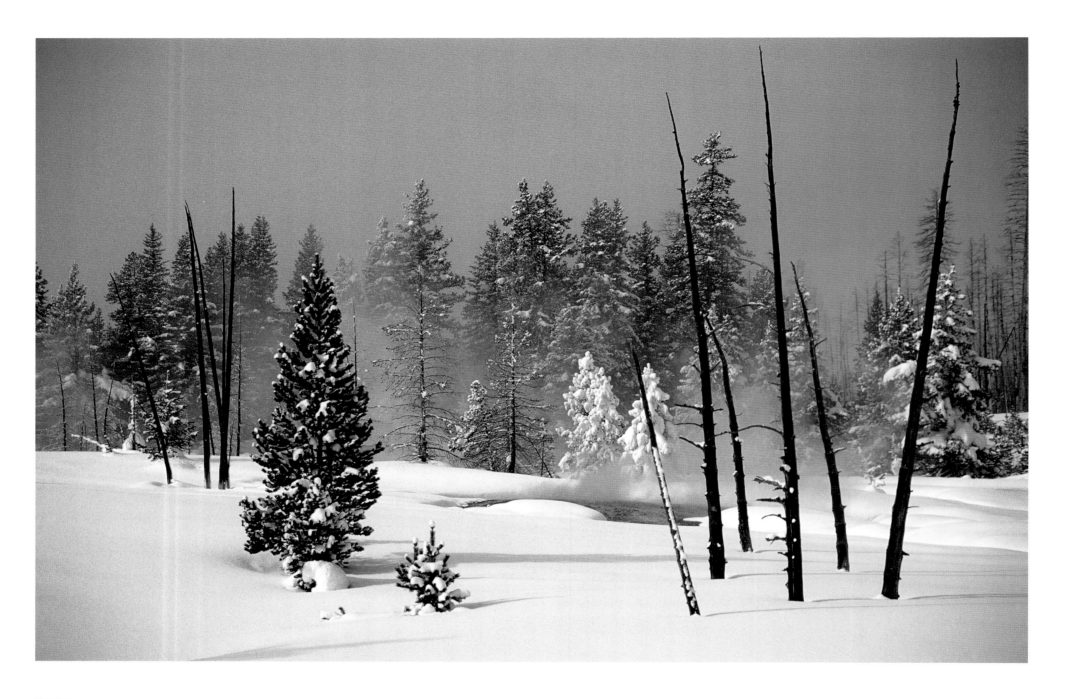

Hot vapours emerge from a steam vent in the forests of Midway Geyser Basin, Yellowstone, Wyoming. The dead trees stand as reminders of the severe forest fires of 1988 that devastated 800,000 acres.

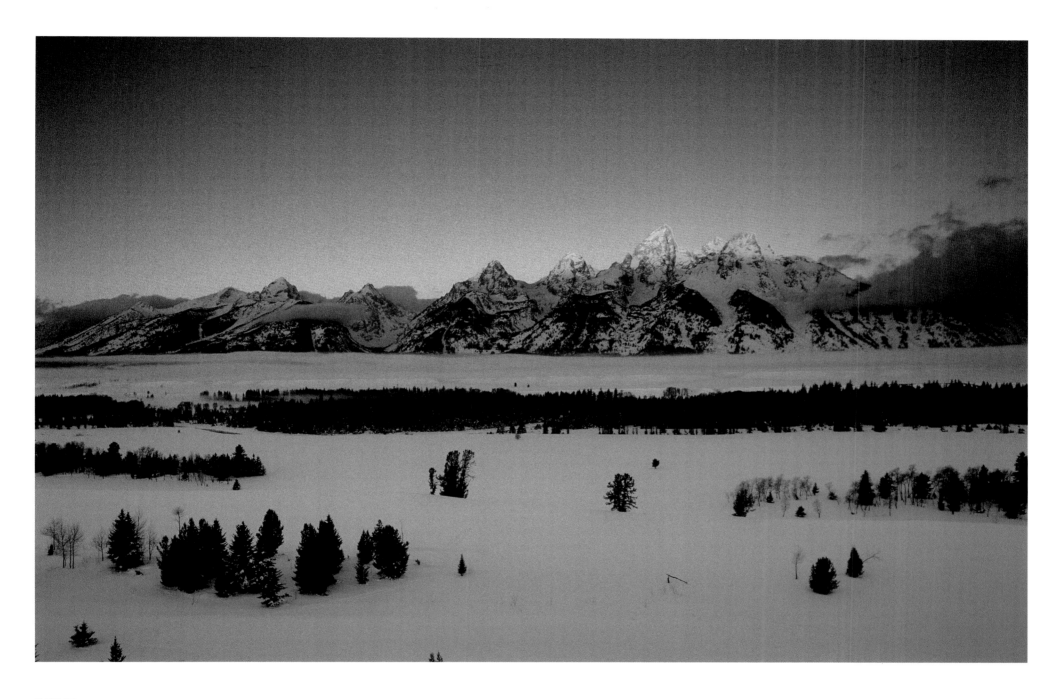

PLATE 87

The Teton Mountains are less than 10 million years old and rise from the valley floor abruptly for over 2,000m. The highest peak in the range, Grand Teton, 4,197m, receives the first dawn light of a cold January morning. Snake River, Wyoming.

WINTER — YELLOWSTONE | COYOTE

In the Native American oral tradition, the coyote is a trickster assuming many forms, but in other narratives, he is also the father of the Indian people and a potent conductor of spiritual forces in the form of sacred dreams.

I was intent on photographing the coyote simply because of its interesting reputation in the mythical stories of New World species. Heavy snow had obliterated all roads across Yellowstone in just a matter of hours. Short daylight and the distance to be covered determined that I would travel through the park by the snow-bus service and then take to my skis to search for them in quiet areas of forest. Reports of a new elk carcass in the high country were a good sign of a possible sighting, so I headed towards the remote (at least in winter) Norris Canyon. The weather was appalling as I passed the alien-looking travertine terraces of Mammoth Hot Springs, all dripping and steaming on the cloud covered hillside, and climbed the drifted roadway south into the park.

After an hour of concentrated snowfall the driver pulled in for a rest at a small frozen lake. With time now shortened I decided to take off from this point on skis into the backcountry, and requested a pick up on its return run through the park. I skied away into far snowfields surrounding the iced-over lake. Leaden clouds were drifting over the snow, revealing then shrouding the view. I was hoping to spy the Quadrant Peak, a high hill of the Gallatins, which backed the lake. The ground was wide and wild, with old stunted trees from the 1988 fires poking above the snow. I halted, removed the skis and settled into a sheltering snowdrift for a bite to eat.

Out in the centre of the lake a melted-out patch, saved from frost by the geothermal upwellings, remained as black water. I lifted binoculars to my eyes, squinting as sun filtered through the mist. Three trumpeter swans, perfectly still on the water, now began to call and flex their huge elegant wings. Away in the distance more calls as other swans flew out of the wintry sky to join them on the water. Their ethereal forms catching the thin winter sun against the forbidding snowclouds gave them the appearance of angels visiting the cold lake. Their commotion of conversation subsided slowly, echoing in the stillness of the afternoon. I lay back and imagined their journey of the last two hundred years.[4]

(4) Throughout the nineteenth century, trumpeter swans, which are only native to North America, were persecuted to near extinction for meat, skins, down feathers for powder puffs, and elegant feathers to decorate hats. By 1830 it is thought only 100 birds remained. Urgent protection saved them when a Wild Bird Treaty Act was passed, and refuges were set up to rehabilitate numbers. Today, the trumpeter swan is considered vulnerable but not endangered.

As I clipped down the ski bindings I noticed
through the corner of my vision a distant movement
on the snow. Two coyotes emerged from the forest
margin and were travelling quickly across the snowfield.
I crouched low, hoping they may pass nearby.
With apparent utter disinterest of my presence they
paced like metronomes in a perfectly straight line across
the snow in single file directly and unnervingly towards
me. I held my breath, their course never altered and
they bounded powerfully by within three metres,
without even a glance. I looked into their steely eyes,
half closed in the lightly falling snow. I had been visited
by princes of the winter woods.

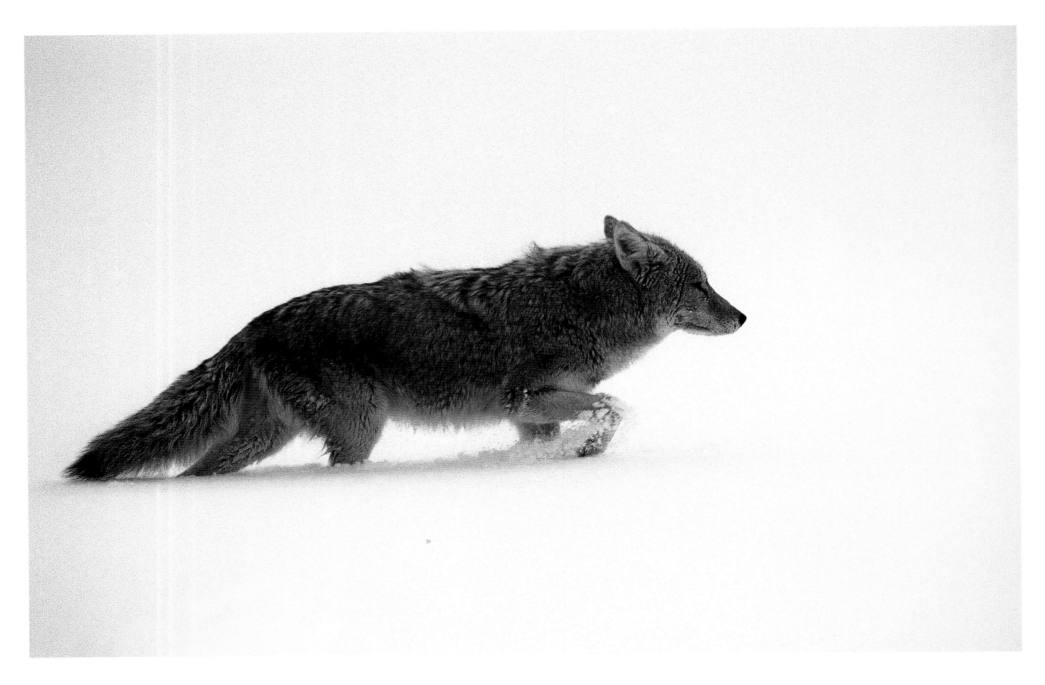

PLATE 88

The Coyote *Canis latrans* is sometimes known as the Prairie Wolf, but, unlike the Wolf, Coyotes have thrived in the presence of human populations. Part of the Coyote's success is its dietary adaptability, taking mostly small mammals, birds, berries and carrion.

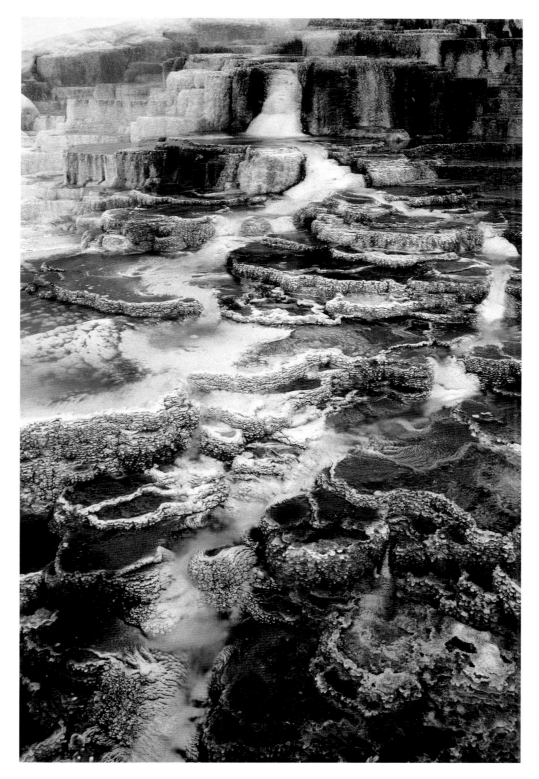

159

WINTER — YELLOWSTONE | HOTSPRING

Bison and elk familiarly survive through Yellowstone winters by frequenting geyser basins and geothermal springs. Migratory birds call by to feed in the ice-free waters. Indeed, for humans too, in any volcanic basins in the world, there are always safe places to bathe.

Hotsprings are the epitome of the most pleasurable cosmic joke in all of nature. It is usual and preferable to enter such places completely naked, but the nudity laws in Yellowstone are Federal and pernicious, so, to avoid a night in jail, I grabbed a towel and shorts and scrambled down the snowy bank to the boiling river below. I inhaled the sulphurous fumes rising up from between rocks. Water bugs spun in circles in the bubbles of a pool. Snow was falling as I sank into a deep green pot amidst the chaos of river rocks. Reclining at first in comfortable boulders was too hot; I waded around mixing the layers of water and felt the soft river gravels with my feet.

Clouds of steam billowed into the air above the river, obscuring the distant view of Mount Everts from where the cold clear river arose. In one small spot, hidden amongst the tussock and sagebrush, a boiling hot torrent of gushing springwater belched out of the earth into the icy winter waters of the main river. Voices were coming close; laughter and chattering voices, a family and friends arrived to bathe at the hotspring. All of us, like children in a primeval play pool, engaging in nature at the essence; the algal rimmed source of life on earth. I stood in the snow cooling down and felt that I had come alive again.

PLATE 90

Bison *Bison bison* and Elk *Cervus canadensis* familiarly survive through Yellowstone winters by frequenting geyser basins and geothermal springs. Migratory birds call by to feed in the ice-free flowing rivers. West Thumb Geyser Basin, Yellowstone.

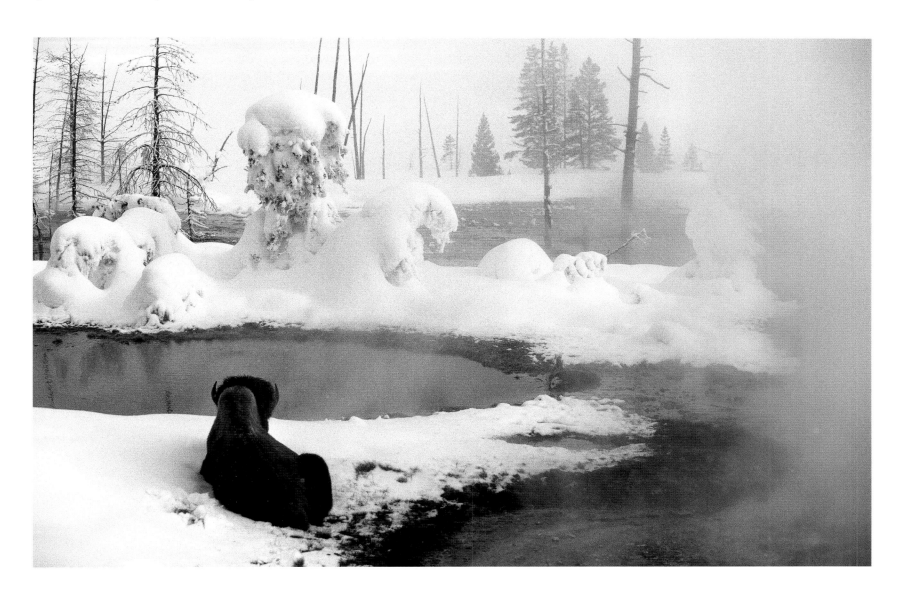

NEW ENGLAND

There must be something in the air about New England woods in autumn – or the 'fall'. Media outlets rev up with tasty headlines; 'Free Leaf Colouring Pages,' 'Leaf Driving Tours,' 'Leaf Peeping Weekends,' 'Fall Foliage Photos,' 'Autumn Screen Savers,' and even, 'Foliage Fun!'

The entire states of New York, Connecticut, Massachusetts, New Hampshire, Maine, and Vermont, all respond strongly to the time of year when nature seems to make its annual breakthrough into everyday lives. There are 'Leaf Colour Forecasts' by the weather bureaus. People love trees, especially colourful big old trees. Hidden in the American psyche is a big dose of fall love; leaf-loving, Thanksgiving, turkeys to eat, leaf-colours, blueberries and apple pie. They have will to engage, and the media to drive it: 'wow, let's jump in the car and cookout at the lookout!' And they do, in their tens of thousands. The clue is in the name, the fall, and it's the leaves that do it! But hiding in there is something more fundamental, more deeply connected.

Maybe it starts with the primitive sense of cycles: of winding down, of acquiescing into winter, of going with the flow. Everyone's body clock slows down as the high temperatures of summer decline; the winter water-fowl appear on the ponds; the woods begin to settle into sleep. And as they settle, lignin flows up the boughs into the leaf stems hardening them off into brittleness. Sugars are trapped in the leaves after photosynthesis ceases with the shorter day length. They turn russet red or yellow, earth brown. The leaf snaps gently and falls. The aroma of leaf decay and the arrival of multitudes of fungi, which emanate strange energy in the community of woodland species, are held in the cycle like the return of swallows and the first call of the cuckoo.

I walked into the New Hampshire woods with all their redolent decay. Walking into the deciduous forests in the White Mountains near North Conway was like entering a cathedral where light poured through the leaves, resembling vaults of stained glass. I left the trail, wading in grasses and ferns, to a thinning where the bright morning had illuminated a spinney of startling yellow aspen and fiery maple. A cluster of rounded boulders were flecked with fallen leaves as if carefully pasted to the surface, reminding me of the plane trees of rainy Paris in October whose fallen leaves adorn the pavements like unseen works of nature art. Squabbling chickadees tumbled through a nearby bush-honeysuckle. I reached down and picked up a single leaf from the litter. Its map-like patterning of slow gradations of emerald through dusky salmon into soft jasmine and deep rosy red, dry and brittle at the serrated edges, soft and supple within – as if it were telling me of its life story.

Through the branches, chandeliers of hanging colours drew me towards a hidden pond. There was breathtaking quietness as the space opened to the sky. The pond entirely mirrored the woodland palette. In the marshy tangle of the margins, a green-winged teal circled, busily picking the surface. Across the water on the far side, a tiny cabin and a rowing boat gave me to imagine as if Henry David Thoreau might have gazed out from here, watching the world accelerate around him, enraptured in the healing world of the quiet woods.

'We need the tonic of wildness – to wade sometimes in marshes where the bittern and meadow-hen lurk, and hear the booming of the snipe, to smell the whispering sedge where only some wilder and more solitary fowl builds her nest … At the same that we are ernest to explore and learn all things, we require that things be mysterious and unexplorable, that land and sea be infinitely wild, unsurveyed and unfathomed by us … We can never have enough of Nature.'

From *Walden*, by Henry David Thoreau 1854.[5]

(5) Henry David Thoreau, *Walden* (Princeton University Press, 2004, 150th Anniversary edn). ISBN: 0691096120.

PLATE 91

Stands of Red Maple *Acer rubrum* and Yellow Birch *Betula alleghaniensis* in the White Mountains of New Hampshire. The vibrant colours of fall leaves in the broad-leafed woods depend on the amount of sugar stored in the leaf after photosynthesis has ceased during September each year.

PLATE 92

A hidden pond near Concord, New Hampshire reflects the fall colours of an
immense variety of trees: Northern Red Oak, Maple, Birch, Eastern Cottonwood,
Balsam Poplar, American Hornbeam, Beech and Fire Cherry, are all present
in these extensive forests.

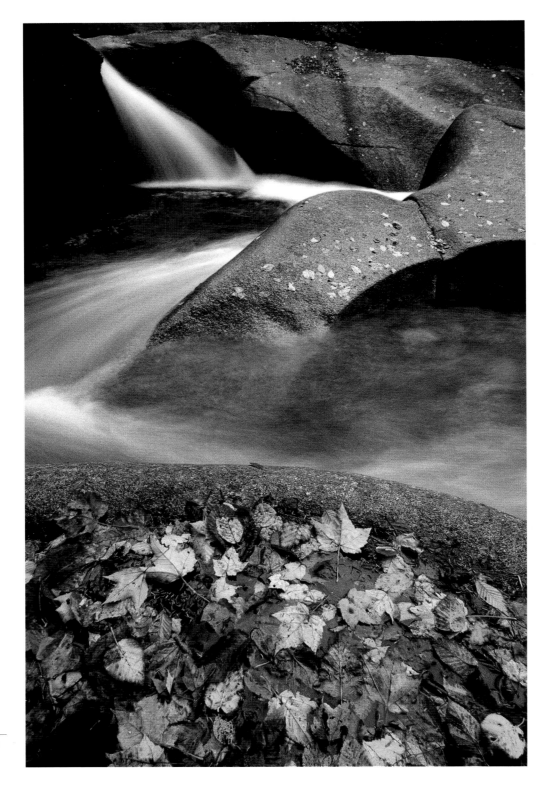

PLATE 93
Water-carved granites in the Flume Gorge of Franconia Notch in the heart of the White Mountains, New Hampshire.

PLATE 94
Fallen Maple *Acer* leaves decorate a rain soaked granite
boulder in the Flume Gorge, White Mountains,
New Hampshire.

ARCTIC SWEDEN

North of the Arctic Circle in Sweden are vast lowland spruce forests with elongated lakes dividing mountainous watersheds. This is the land of the Sami; reindeer herders with centuries of ancient traditional forest skills, survivors from the modernisation of their lands.

Our small winter expedition plan was to sledge with dogs through the old Kungsleden Trail from the treeline at Nikkaluokta through the Singi confluence of wide, post-glacial valleys and down through the wild birch woods of Abisko to Torneträsk Lake. With our young children on board, this was to be a testing family adventure, involving self reliance, and a chance to immerse ourselves in some winter forest and mountain lore.

From the lakes around the massif, especially on the east side, huge birch clad forests with meandering silt laden rivers lead into the range. Vast arterial glaciers would have filled these valleys but they have now retreated up to the high-sided valleys in the wilder alpine heartland of the range, the Kebnekaise. During the winter most of the fauna either migrates or hibernates under the snow. Only very hardy animals like the wolverine and the arctic fox are active, hunting ptarmigan and occasional reindeer which have failed to migrate to the lowland forests.

The Kungsleden is a low passage between the high peaks, interspersed with occasional wooden huts for passing travellers. The Arctic night of mid January brought deep cold through the northern boreal forests of Kebnekaise. I lay in my bunk listening to the hiss of snow blowing in dunes around the foundations of the log cabin. A strong sweet aroma of wood smoke from the stove seeped into my turbulent mind; the day's events had been testing, navigating along frozen riverbeds and over two high passes. Just after midnight I jumped out of my sleeping bag, dressed in four layers of arctic clothing, pulled on my Canadian musher's boots and strode out across the squeaking snow.

The night wind cut like a knife on my cheeks. I was being drawn somewhere, upward to a broad col above the hut, above the silent forest, and out beneath a velvet sky raging with stars. The vista of mountain and forest was more a presence than seen. Deep darkness and the icy cold blinded me with tears. I stood facing the north wind; expectant, excited. Why was I here? How did I get here? I stood firm, gazing at a vague mountainous skyline. A column of grey light briefly pulsed from behind the range – I imagined as if car headlights had passed, but there were no roads for seventy kilometres. Some of the grey lights tinged with yellowy brown shot higher

than the rest. Within a minute many columns were
shooting across the horizon. If sight were a musical
score what happened next would be the *crescendo –
forte – forte*!

I pumped my arms to keep warm in the deathly
temperature of minus 28C. Streaming with tears,
and with a prickling spine, the night sky exploded into
light and colour. The columns coalesced into veils
of swirling colours pulsating east to west, high to low,
in wave forms and rhythmical curtains: silver-blue,
cinnabar into cerise, honey and saffron yellows waving
like heavenly banners in the great vault of sky.

I stumbled back to the hut, lit a candle and woke
my sleeping children. We dragged them off their beds
wrapped in blankets and carried them on our backs
out into the night. With their chins on our shoulders
they gazed aloft, dreaming their dreams and absorbing
the might of the symphony that raged above them.
Light, space and nature merging with the past, the
present and the future in a cacophony of emotion,
like a blessing or a living prayer – simply a gift,
a recognition of the power and beauty of the earth.
Aurora borealis – once experienced, never ever forgotten.

PLATE 95
Frozen river ice above Láddjujávri, with Tuolpagorni Peak
1,675m. Nikkaluokta region, Arctic Sweden.

PLATE 96
Deep winter light Jukkasjärvi, Kiruna region, Arctic Sweden.

CHAPTER 6

The Grand Canyon of the Colorado

> 'Now I see the secret … it is to grow in the
> open air and to eat and sleep with the earth.'
>
> WALT WHITMAN (1819–1892)

PLATE 97

Saddle Canyon, part of the Marble Canyon section of the Upper Colorado River.

In the evenings, the confluence of Saddle Canyon with the Colorado River is a golden doorway. Afternoon shade deep in the Marble Canyon cools down the sandbanks on which I will spend the night, my sleeping bag already laid out under the soft fronds of a tamarisk tree. The tethered raft twists and gyres in the current, as the cold air from the river flows around the rocks. A last amber glow ebbs from the canyon walls above. All is still.

Water-carved bluffs and shelves, which by day offer endless pallets of colour, have become rounded animal shapes, set against towering cliffs that reach into the setting sky. The mighty pulse of the river drags submerged boulders and stones, grinding and bumping the bedrock like distant thunder. An almond glow radiates beyond the rock rim a thousand metres above. All is silent.

Invisible movement and slow time are overwhelming in the Grand Canyon of Colorado. Evidence of constant, inexorable change in the geology en masse and in micro is felt more than seen. The obvious erosive forces of the river itself, and the observation of weathering of the myriad rock types, cause a curious alertness to the experience of living in this elemental landscape. One feels bound up in the processes of change, subjugation to its

grandeur and a sense of being an infinitesimally small part of a greater natural order.

The galleon moon casts free and voyages slowly across the canyon sky, bathing me in the strangest light. I have ceased to belong to this world and have become a part of a new place, transformed into the heartbeat of stone, into the green fuse of living things, into the flow of the river which is the gentle flow of time.

It is thought that the Grand Canyon was originally visited 11,000 years ago by Paleo-Indian peoples who had migrated some 25,000 years earlier from Asia during the Ice Age. Archaic hunters arrived and displaced the primitive groups, who in turn left this desert region when the mysterious cliff-dwelling Anasazi arrived 1,500 years ago.[1] Early agricultural practices took place in sheltered canyons, clay pueblos were made for dwellings and bread was even made in simple ovens. But soon profound drought caused another mass migration and today only modern ancestors like Havasupai, Paiute, Hopi and Navajo communities survive high on the Canyon rim in reserved areas.

In the year of 1540, when the Spanish conquistadors were exploring north of Mexico in search of the fabled

(1) J. Brody, *The Anasazi: Ancient Indian People of the American Southwest* (New York: Rizzoli, 1991.) ISBN 0847812081.

Seven Cities of Cibola, a small detachment of thirteen men and horses from the Coronado Expedition led by García López de Cárdenas halted on the south rim of a huge canyon and gazed into its impassable depths.[2] There was little interest in this discovery until 1776 when Franciscan missionary Tomas Garces descended into what is now called Havasu Canyon, and The Dominguez-Escalante Expedition reached the Colorado near its headwaters at a crossable point now known as Lee's Ferry.

In 1869, Major John Wesley Powell led the first documented expedition to travel completely through the Grand Canyon by boat. The klondike for silver mining and also for considering water resource management was at its height, so Powell's real intention was to clothe his adventure with some science. He had lost a forearm at the Battle of Shiloh in the American Civil war and, despite being poorly funded, carried some scientific instruments to make simple studies throughout the course of the expedition. Heavy oak boats were made for the expedition, with watertight hatches in the bow and stern. Embarking on 24 May from the town of Green River, Wyoming, Powell's party descended the Green River to the Colorado. Even during these early days, one boat was destroyed, food stores lost and a boatman quit. They continued downriver through Cataract Canyon, which now holds Lake Powell, and finally into the Grand Canyon proper. Here, the river increased in ferocity and volume. With his rowers seated fore and aft, Powell had a raised wooden chair tied amidships from where he could guide and direct the craft. Although having safely navigated a multitude of treacherous rapids, and enduring weeks of hardship, three of Powell's men abandoned the expedition sighting cold and hunger, not realising they had already passed the worst sections of the river. At what is now called Separation Canyon they attempted to climb out but disappeared on the rim and were presumed killed by a band of Shivwit Indians. Powell continued without incident downriver to the junction of the Virgin River and the end of the Canyon. The expedition had taken ninety-eight days and covered 1,600 kilometres. This river run was one of the great epics in the exploration of North America.

A second expedition soon took place in 1872, this time better funded by the Federal Government.

The party successfully surveyed two-thirds of the canyon's length, systematically cataloguing all rock formations, plants, animals and archaeological sites. An expedition photographer and an artist produced images of the Grand Canyon river journey which became the first fully illustrated adventure of its time, creating funding for future expeditions and making Powell famous on his subsequent lecture tours.[3] His popularity grew and in 1881 Powell was invited to become the second director of the US Geological Survey.

From this time forward the Grand Canyon caught the imagination of many entrepreneurs who thought they could capitalise on the burgeoning tourism trade, rather than the vain struggle for mineral wealth and agriculture. Further attempts to travel downriver were common, with many boats, men and ambitions lost in the waters. To navigate the full 350 kilometres of the river, and safely negotiate the 127 extreme rapids, is to hear the thunder of river waves echoing against canyon walls amidst the spirits of many departed souls.

(2) Pedro de Castañeda de Najera, *Account of the Expedition to Cibola which took place in the year 1540* (1596). *The Journey of Coronado, 1540–1542*, tr. George Parker Winship (Seville: Fulcrum, 1990). ISBN 1555910661. (3) J.W. Powell, *The Exploration of the Colorado River and its Canyons* (Flood & Vincent, 1895). Powell's classic book, produced from a combination of both expeditions. Re-published and unaltered with exquisite etchings (Dover, 1991). ISBN 0486200949. Recent re-issue (Penguin, 2003). ISBN 0142437522.

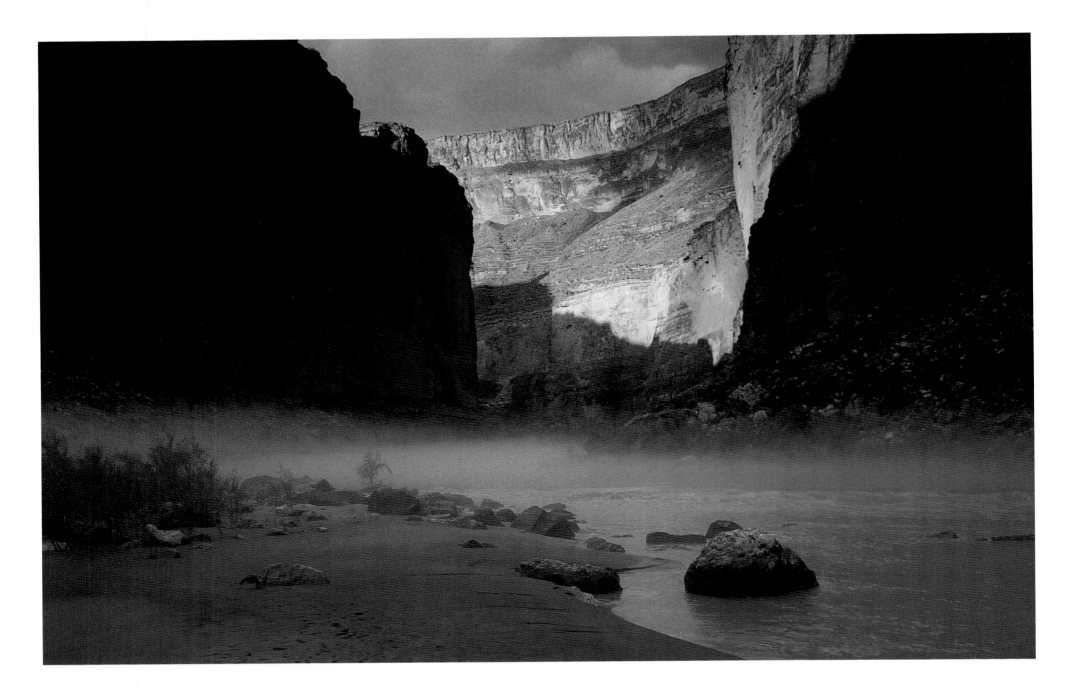

PLATE 98

Cool morning mist clings to the Colorado River as it flows through the Marble
Canyon close to Redwall Cavern, where layers of Coconino and Kaibab
geology become more prominent.

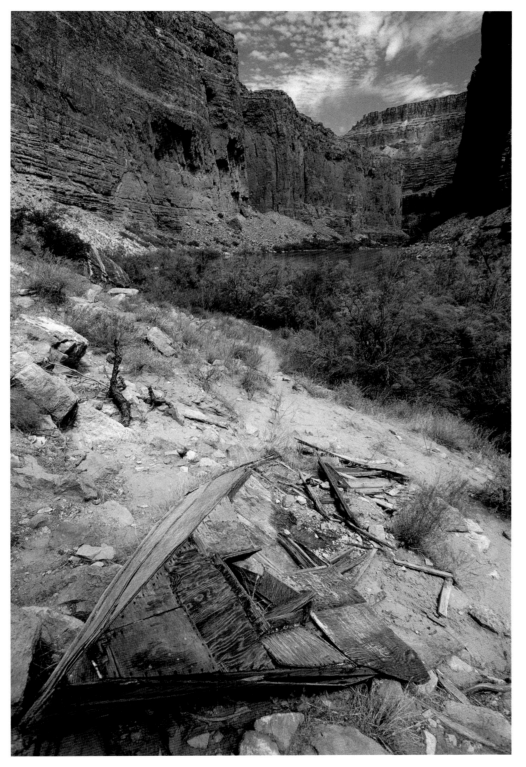

PLATE 99

At 24.5 Mile Rapid in the Marble Canyon, lie the remains of an old river-runners boat called *The Grand Canyon*. Pioneer oarsman Bert Loper perished in this rapid during his early explorations of the Canyon in 1949, at the age of 79.

NANKOWEAP

I was awoken from my beach camp by the liquid song of the canyon wren singing in nearby rocks. A cool morning breeze gusted in the seep-willow by the river's edge. In these vertical walls no sun will shine until its zenith at midday. An hour downstream we came ashore and scrambled through groves of ocotillo and arrow weed, and climbed high above the river up shelves of grey talus to the startling verticality of the Supai Redwalls and the ancient stone Anasazi granaries of Nankoweap.

I crouched in the cool shade of the tiny rock and mud daub window holes beneath the overhanging cliffs. We climbed across a stepped rock wall to enter a hidden cave arch. It was cool on the flat stone floor as we gazed out across distant mesas and buttes, over a landscape that encompassed two billion years of natural history. My friend unstrapped her rucksack and lifted out a heavy grey cotton bag. We sat quietly, for it contained the remains of a loved one. We studied the granules through our fingers and whispered fond stories.

Today was not the day for his release, for that we were bound for the Sipapu, a Hopi salt kiva some twenty miles downriver.[4] Lemon scent of sand verbena drifted up from the river shore, sweeping away the moment with its freshness. Flights of chattering swifts thronged at mud nests clinging to the eaves above.

The great Colorado swung in lazy bends far below, calm now and glittering against the silver light.

(4) A symbolic place of origin in Hopi mythology. A passageway used by ancestors to emerge from a previous world.

PLATE 100

A lone stunted cottonwood tree stands sentinel at Kwagunt Creek,
below the cliffs of Nankoweap.

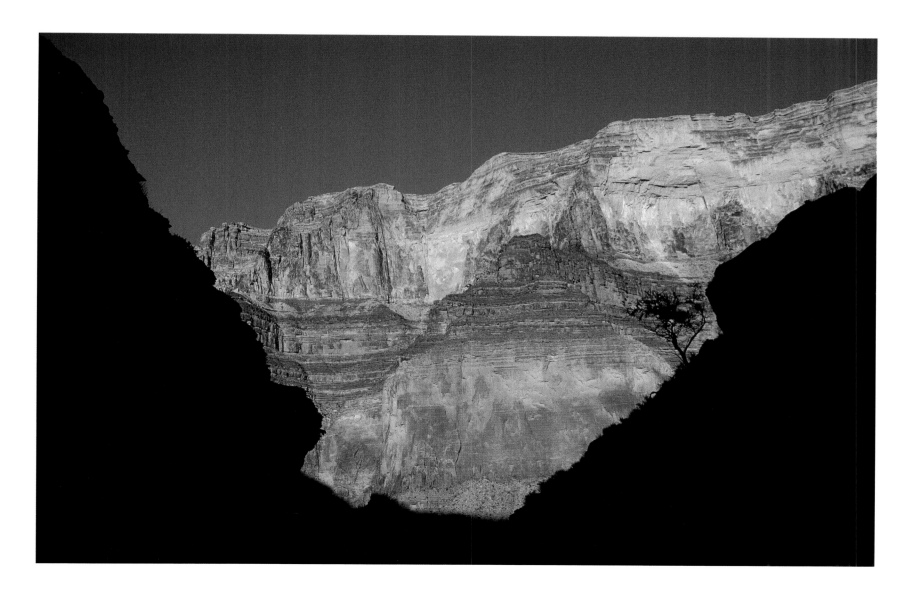

UPPER GRANITE GORGE

We needed fresh water and continued to Tanner Creek where alluvial gravels form a broad fan on which Ute Indians once cultivated squashes and corn. There is a spring here where the canyon lies back, perhaps eight miles from rim to rim. It was getting hotter, the only shade within the tall reeds that lined the creek. We floated on and approached Hance Rapid at the entrance of the Upper Granite Gorge, and the first of a series of grade nine rapids.[5]

This is something of a gateway because from here the river has few landing places and flows powerfully beneath solid rock walls for many miles. Hance Rapid in low water can produce complex and dangerous waves. Ahead of us lay the notorious Horn Creek Rapid, Granite Rapid, and the mighty Crystal Rapid, which, along with Lava Falls, are the most respected and highest graded runs in the entire Grand Canyon.

Floating between rapids there is a silence of space. The cathedral walls accentuate all sound. Midday sun down here can split rocks open. Deadly pink rattle-snakes and yellow scorpions languish in dry river washes in the radiating heat. There is a mirage on the river beach at Grapevine. Water polished gneiss like swiss cheese guards the mouth of Shinumo Creek. White egrets overhead are fishing from beach to beach. A mule deer stag grazes the apache plume in a shady stand of cottonwood trees: a rasp of antler, a clatter of hooves, a trickle of stones from a canyon wall. The greens of grass, burnished gold and sky blue, streak the surface of the ochre coloured river, and in the distance is the ever-present deep rhythmical pulse of rapids.

The current increased in strength commensurate with a change of rhythmical noise, the tone of which rose an octave as the raft began its ghastly and terrifying slide over the lip of dancing spray that had masked the horrifying falls from our view. And we were in it. Waves upon heavy waves blasted over the raft, tearing our grip from the ropework. With total bodyload against the oars, we were sucked down a hole, then heaved up and spat to the left and then the right in this great lung of breathing, pulsing, icy water. Gasping and shrieking with fun we collapsed in the floor of the raft as the noise abated to our stern and the sun beat down on the sodden. We laughed and twirled in a calm eddy, wiped our faces and drifted onward.

(5) John T. Hance was a miner and the first white rancher to settle on the Canyon rim around 1883, inviting the new Victorian tourists to view the wonders of the Grand Canyon from his camp. He became a famed raconteur and, when once asked how he had lost the tip of one of his fingers, replied that he had worn it off by pointing at the Grand Canyon.

PLATE 101

Granite Rapid, graded 7–8, tests oarsmen at Mile 93.4 in the Inner Gorge
of the Grand Canyon.

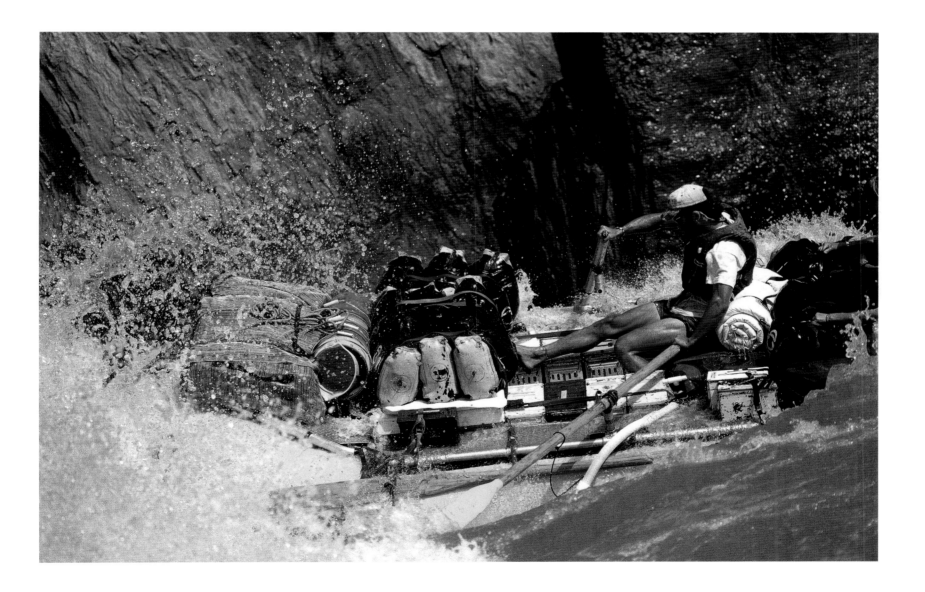

THUNDER RIVER AND STONE CREEK, 1985

Hitchhiking down a dirt road was never going to be easy, but I needed to be at a remote trailhead sixty miles from Jacob Lake before dark. At first light, I would hike and scramble ten miles down into a far-flung section of the Colorado Plateau, to Thunder River, a paradise of canyons and waterfalls rarely visited by hikers. On the north rim the elevation at 3,000 metres is comparatively high, and winter snows can isolate this whole area for months. Yet, on that evening in late June, from my bivouac beneath aspens and fir, I gazed across the void of space that is the Grand Canyon below me, toward the sun slowly setting over the Painted Desert far away in the south.

I began walking at 5.30 a.m. with thirty-five kilos on my back, at first steeply down through the pale Coconino sandstones of rim rock and out onto the exposed Esplanade, a broad terrace of Supai bedrock that forms a level bench of hot desert all around the 1,800 metre contour of the Canyon. Turrets of weathered sandstone boulders perch precariously on the brink of terraced cliffs. I tried to imagine the Triassic windstorms that shaped them and the footfalls of dinosaurs. The pastel dawn ebbed into the bright morning trail, which all but disappeared into smooth, open rock slabs. Sun up brought out collared lizards and whiptail snakes from the shadows, flattening out their skins, like photocells

coming to life. From a tall century plant a black-throated sparrow sang a busy song. Slowly my SIGG bottle emptied; I had to be careful, as there would be no water for five hours at least, and I must descend a loose and precipitous Indian trail through the Red Walls that would lead me to Thunder River. As I walked on, blackbrush and agave spines scratched my bare legs. I felt strong, because I was alone.

I heard Thunder River long before I could see its milk white thread against the orange desert. Riparian woodland followed the river's course from its source all the way to the Colorado River, with cottonwood, honey mesquite and the occasional stunted oak. The spring lines right around the Grand Canyon occur in exactly the same hydrostatic geology, where seasonal thunderstorms percolate from the high plateau through layers of porous sediments but are blocked at the foot of the Supai by impervious Hermit shales. Each of the springs is unique and magical. Here at Thunder River, heavy water gushed from a small cave entrance, two metres in diameter. I climbed crumbling ledges and crawled into the jetting streamway, wedging myself into the slot, knee deep in the crystal water. Around me the tunnel was rippling in golden light reflecting on the narrowing walls. The desert was outside. I was inside the earth, and about to be born.

To find the entrance of Stone Creek was both arduous and scary. It is an extremely remote short canyon hidden in the enfolding arms of vast surrounding cliffs. An ill-defined trail, through loose desert scrub, flanked a high terrace above the deepest and narrowest gorge section of the Colorado. Powerful eddies swirled and sucked the rocks along its length. It was without shade, and temperatures soared into the forties. I had come here for a purpose. I had come here to explore a world I could not see, by opening a new door.

Two weeks earlier, I had made a presentation of slides and music at an international mountain film festival in Telluride and luckily carried away the Special Jury Prize that year, awarded largely by the audience. It was a crazy, fun weekend with hiking and partying. I fell in with the baker from the village, who gave me a little brown bag containing two small, hallucinogenic Mexican mushrooms, adding '*be careful with these babies!*' It was these babies I brought to Stone Creek.

The hike up to the source of Stone Creek was through dense vegetation crowding the canyon floor from wall to wall. Amongst the tangle I counted many herbs – yarrow, equisetum, aster, sage and mint – and I imagined ancient Indians cultivating simple crops here. Indeed, hidden under a dry cliff was a baked mud grain store, tucked into a fold in the shaded rock. The fertile creek eventually narrowed to a cleft of deep shade from which the spring issued in a bridal veil down purple slabs. Cushions of succulent mosses welled with clear water, chandeliers of yellow columbine, alive with bees and hummingbirds, hung down over the inner pool. I waded in to my waist and bathed in this collaboration of secret energy; compelling and irresistible. Perhaps it is in these secret places where magic happens, where memory is expiated by ritual, portals for ancestral voices. **>>**

Sometimes in life, doorways lead to new doorways. It is one's own responsibility as to which doors remain closed. I wandered back out into the heat of the canyon, made tea to drink on my camp stove, sat motionless beneath the tall pampas grass and swallowed a mushroom. The bright stream by the bivouac was lined with smooth tufa, an evaporite from calcium rich water. The tufa had moulded over all sharp edges making perfect bath-sized rock basins in the streambed. Each one was coloured with cobalt, crimson and emerald greens; I tested them all for comfort, and finally laid down in the warmest. With my chin at water level I watched electric blue damsels and striped dragonflies dipping down to drink. A locust passed by over the pool, its head and front legs taking on an almost human-like appearance. I heard the conversation of ravens, echoing from ledges, and I spoke to tree frogs and river gods in reeds by my pool. The intensity of these experiences increased for minutes or hours,

I cannot recall. That night I burned scented juniper and drifted to sleep wrapped beneath a velvet blanket of ten thousand stars. What I had seen and where I had been is a mystery. But on that day in Stone Creek, I fearlessly allowed nature to move in me, deeply.

PLATE 102
The Narrows in Upper Deer Creek.

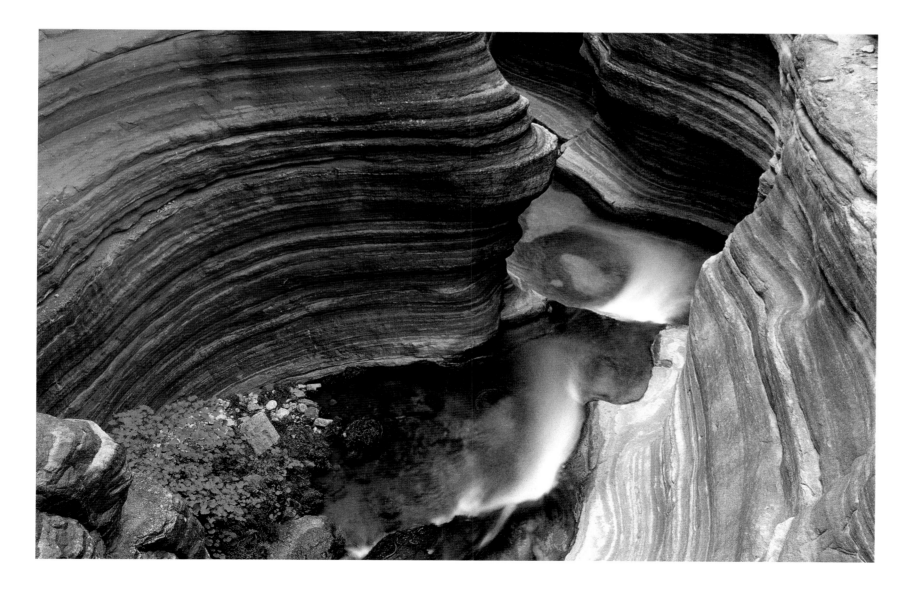

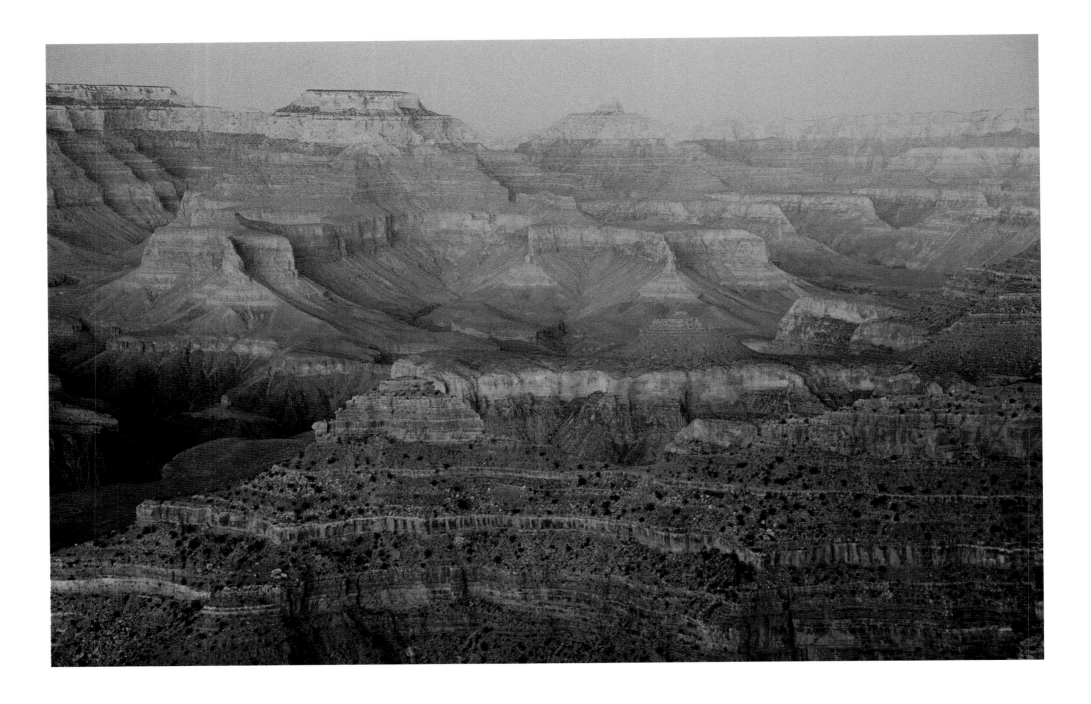

PLATE 103
Sunset reveals the delicate hues and changing geology from Hopi Point
on the South Rim of the Grand Canyon.

PLATE 104

The Chuckwalla Lizard *Sauromalus ater*. When disturbed, a chuckwalla will wedge itself into a tight rock crevice, gulp air, and inflate its body in order to entrench itself.

MATKATAMIBA CANYON AND THE FLOOD

At Mile 114 the current drew us close to the inside left-curving bend of the river cliff, that towered for 200 metres above the water. In a deft manoeuvre our boatman slipped a mooring line around a projecting rock and held the raft fast into a stable position against the undercutting flow of deep water. We scrambled overboard, quickly and carefully out across the smooth, sculpted walls until safely established in a narrow chasm of astonishing geology.

Matkatamiba Canyon has a curiously powerful energy about it. Twisted bands of water-eroded Muav limestone are formed as if made of plasticine. Jammed in the constrictions are huge boulders, probably carried down in a catastrophic flood. We bridged and scrambled up the canyon to a higher level. The black sky that had been darkening all afternoon began to rain heavy globules, splashing the bone-dry rock. The consequences of flash flooding in this position are serious. We hurried through the chasm back to the raft, untied and floated across the river to a series of ledges above river level. Feeling comparatively safe here, we put up our tents on the open rock terrace. Upstream the lightning was striking continuously in the distance. Booming thunder echoed from canyon to canyon. The view soon became veiled by curtains of grey rainfall, and within ten minutes I counted eight 2,000 foot-high waterfalls

pouring off the surrounding cliffs. Above the ledges there must have been a dam of debris and, whatever it was, it burst, sending a violent, brown mud-filled cascade down over the camp. Several tents were washed into the Colorado, which by now had increased in volume and changed from sparkling green to chocolate brown, filled with huge waves. On the terrace, which was now swept by torrents, we decided that despite having a raft, it was probably safer to stay on the ledge and try to save our equipment and supplies. Then, like a tap turned off, the rain ceased quite suddenly. The air temperature decreased by some degrees, and we hurried round like ants in a gutter, gathering the remains of our kit. In the strange stillness, clouds of vapour hung eerily over the swirling river. Stones tumbled from higher canyons above, dislodged by bighorn sheep moved on by the instant monsoon. Two ravens, driven to shelter under our camp table, collected scraps through the evening. The Colorado had bared its teeth, and the next day we were to attempt to run the terrifying Lava Falls, now at grade nine and powered by this flood pulse. I lay in a damp sleeping bag wondering what maelstrom lay ahead.

PLATE 105

Matkatamiba Canyon is an adventurous scramble, but is prone to flash flooding in times of heavy rain.

HAVASU, MOONEY AND TRAVERTINE

In the years since my first visit, I have returned to the Grand Canyon many times to explore new tributaries and fabulous waterfalls. In Elves Chasm we were enchanted by leaping and swimming. In Travertine Canyon the overhead light coursing through the slot canyon roof illuminated the cascading spray as if it were liquid platinum. In Deer Creek Falls a narrow twisting slot canyon stream breaks out in powerful jetting curtains of white spray. Once I waded into the plunge pool below the falls to feel the sheer blast of powerful water and air. But in Havasu Canyon – perhaps the greatest of water features in the Colorado, and home to living descendants of the original Havasupai peoples of old – are the mighty Havasu and Mooney Falls that leap from rims of travertine into turquoise pools of immense beauty.[6]

Some years ago we made a short expedition here with our small children, hiking fifty kilometres from the Hualapai Overlook all the way to the Colorado River. On the way we endured a violent sandstorm, multiple river crossings, encounters with rattlesnakes and some hair-raising unprotected scrambles at Mooney.[7] Above all we experienced a profound sense of travelling through an active and living landscape where nature led us into immeasurable wonders.

The descent of the Colorado River by raft is more than a passage through the geological history of the structure of the earth. More than a going back in time. More the unfolding of an unexpected insight, which is this: that we are dust. That the canyon depths draw out your essence and strip you naked. That the world beyond the surface is dislocated, confusing, wasteful. Here the beauty of stone and water, structure and life, opposing and sympathetic forces, are profoundly close. This is a place where nature touches you so deeply, you are simply returning to the earth.

(6) 'Havasupai' means 'the people of the blue-green waters.' The Havasupai tribe is the smallest Indian Nation in America, totalling about 600 people. Before the arrival of Europeans, they farmed the land where the canyon widened, and the plentiful waters of Havasu Creek allowed them to create a haven. In the summertime, they grew corn, squash, melons and beans and, after harvesting their crops in the fall, they moved to winter settlements on the rim of the canyon where men hunted deer, antelope and small game, and women made beautiful baskets. (7) James Mooney (after whom these falls were named) was a prospector who fell to his death here in 1882, whilst attempting a roped descent over its eighty metre abyss. Today, a hidden passageway in the complex, hanging stalagmitic canyon walls provides a way down to the bottom of the falls. Ancient ladders, iron pegs and chains assist the dangerous descent.

PLATE 106

Mooney Falls in the Havasu Canyon. These falls were discovered by James Mooney,
a mineral prospector who fell to his death from the sheer walls here in 1882.

PLATE 107

Cascades and waterfalls in Travertine Canyon. Travertine is an evaporite rock formed from the rapid precipitation of calcium carbonate.

PLATE 108

Havasu Falls in the Havasupai First Nation land of the southwest Grand Canyon. Havasupai means '*the people of the blue-green water.*' Havasu River is coloured turquoise from the rich copper mineral deposits.

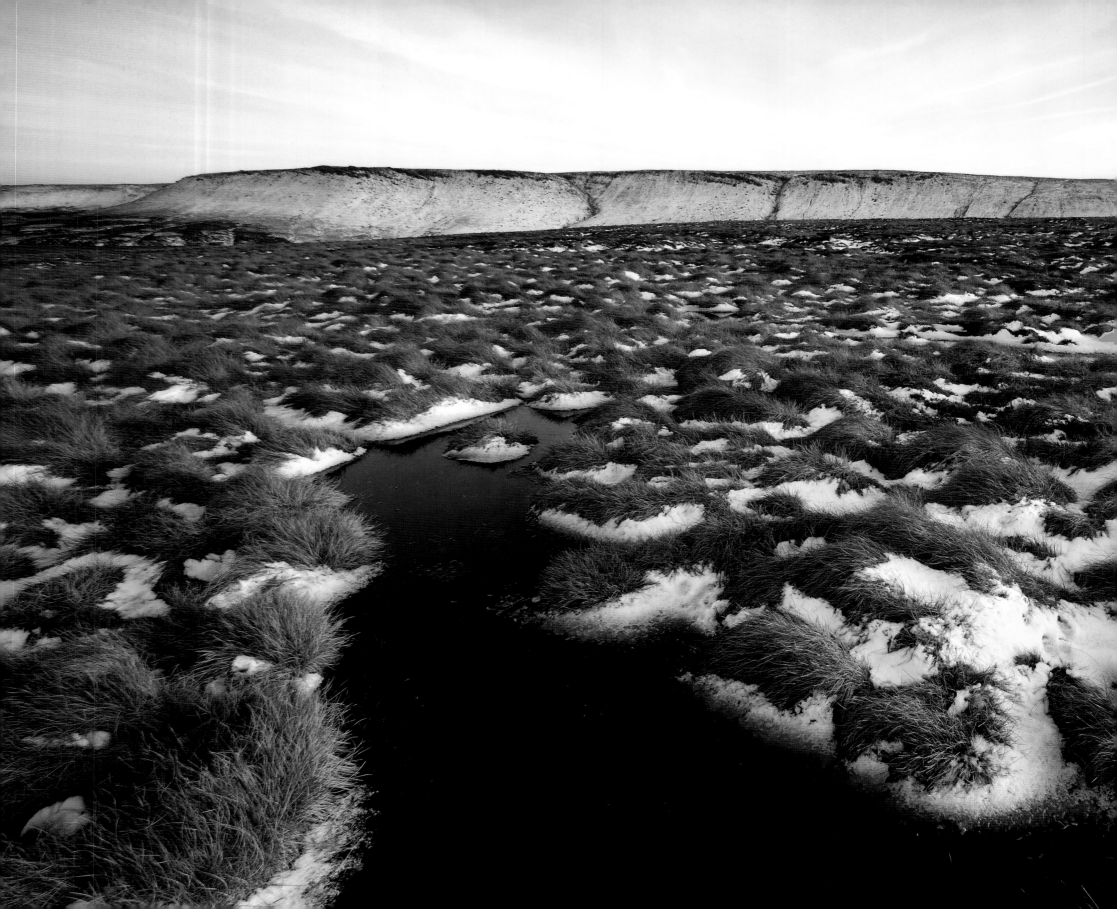

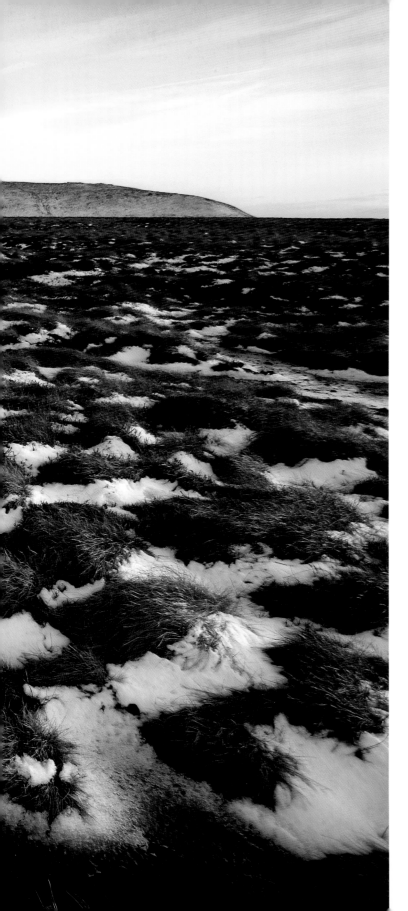

CHAPTER 7

Home

'O may my heart's truth still be sung
On this high hill in a year's turning'

FROM *POEM IN OCTOBER*
BY DYLAN THOMAS (1914–1953)

PLATE 109

Featherbed Moss and Kinder Scout escarpment. Pennine Hills.

The landscape of Britain, and especially its remaining wild places, has been shaped by its geological history and changing climate over millennia. The retreat of the most recent Ice Age around 10,000 years ago plastered a vast percentage of the primordial landscape, one that had been formed by regular tectonic upheavals, with residual clays that reshaped the low hills, inundated the valleys, reshaped the course of rivers and, along with shifts in climate patterns, heralded a new era of human habitation.

After Britain's slow drift away from the world landmass of Gondwanaland, around 475 million years ago, tectonic forces shaped the land with volcanic activity in present-day Dartmoor, Presceli, Pumlumon, Snowdonia and Cumbria, with the most dramatic activity across Scotland, forming the Grampians and the mountains of the Western and Central Highlands and Islands. Successions of ingressing tropical seas flooded low-lying lands, depositing thick layers of limestone that weathered into the characterful uplands of the Chilterns, Cotswolds, South Pennines and Yorkshire Dales. A shallow neck of layered sands joined low-lying East Anglia with Jutland, forming a land bridge, a natural passage for ancient peoples and animals. In more recent times, the raising of sea levels and tilting of Britain's mainland finally ensured our physical independence.

The climate stabilised into a temperate regime, promoting the rich growth of vegetation and creating healthy soils. The forerunners of modern humans, the Neanderthal, crossed the land bridge from Europe and populated southern Britain by developing communities across sheltered parts of the land, intuitively building their settlements around features of the landscape that would most suit their survival. To the south, in undulating hills where well drained loamy soils created good growth for simple grain crops and vegetables, villages grew up around spring lines of fresh water, strategically on hill tops, and at crossing points of big rivers. The land was thickly forested with oak, beech and elm, most of which has now been lost thanks to centuries of clear cutting for material resource and agricultural needs. In the north, wild ancient tribes roamed with domestic cattle and horses, settling only in small groups where microclimates and strategic havens existed.

Britain withstood marauders and invasion from tribal Europe almost constantly during these centuries of early settlement. The Romans arrived in AD 43 and changed the demography and culture by developing larger fortified settlements across most of the country, as far north as Northumbria, bringing invention and skills from Mediterranean lands and a

semblance of structure to the disorganised tribes of Britain. After the Romans withdrew from the country around AD 407, the Vikings sailed in to the north region, and Scotland and the Outer Isles. Saxon tribes invited German friends into Britain and then the Normans established political control after 1066. To the north and west, the land remained wild, a last stronghold of extensive undisturbed natural habitat with cold mountains, rugged coastline and a wild people who embraced the natural laws and who retained a primitive connection to the forces of the land, the Celts.

Britain today has remnant pockets of wild landscape that have survived the changes wrought upon it by modern civilisation. Much of it is coastal and mountainous, but I am inclined to look much closer to home and have discovered that the wildness for which I search may be momentarily around us most of the time. In various incarnations of visibility, signs and symbols of lost wild kingdoms have presence amongst the familiar; patterned ice on a pool, a fern unfurling, the liquid song of the blackbird. All of our landscape in Britain has its own physical and cultural history enshrined in its detail. I have chosen to narrate three experiences that represent both drama and humanity and exemplify the possibility of a meaningful interaction with the land. The imagination can create its own narrative – an inner landscape – to reveal textures and atmospheres that resonate with the emotional senses of spirit, purity, and wonder, all of which may reveal that wildness is actually within us.

PLATE 110

Bluebell *Hyacinthoides non-scripta* is an ancient shade-loving plant of British woodlands, flowering in late April and May. Though common, it is a protected species. Hope Valley, Pennine Hills.

PLATE 111
Ragged Robin *Lichnis flos-cuculi* is common in July and August in damp pastures and machair. Achmelvic, Lochinver, Western Highlands, Scotland.

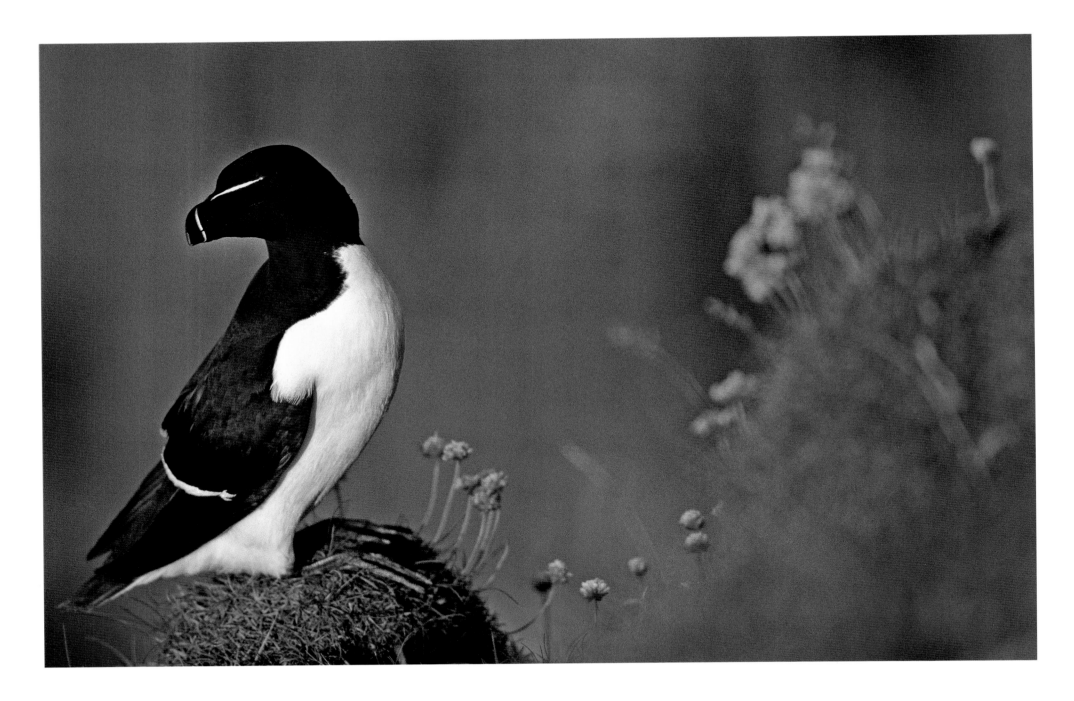

PLATE 112

The Razorbill *Alca torda* is a member of the auk family of birds that dives deep in the sea, 'flying' underwater in search of the small fish and sand eels on which it depends. Handa Island, Lochinver, Scotland.

PLATE 113
The Common Blue Butterfly *Polyommatus icarus* in Wavy Hair grass *Deschampsia flexuosa* and Quaking grass *Briza media*. Miller's Dale, South Pennine Hills.

SULA – THE SEABIRD HUNTERS OF LEWIS

After returning from an expedition to sledge across the Greenland Icecap in 1982, I headed for Scotland to attempt to make a serious documentary of photographs in the Western Isles. These were great and simple days as I scrambled alone with my camera in the wintry peaks of Cuillin, where brocken spectres tantalised me in the mist shrouded ridges of October, and the bent rowan, heavy with berries, clung to the granite banks of the Etive River.

In an unplanned and wistful daze I crossed by ferry to the outer isle of South Uist in the hope of observing the massed flocks of white-fronted geese that had flown down to the Monach Islands on their winter migration from Greenland and Svalbard to Britain. On a day with near gale force winds sweeping across the wild machair about the crofts of Lochboisdale, an extraordinary series of events began to unfold.

A kilometre out of the village heading north, and weighed down by a heavy rucksack, I started to hitch-hike. A red van belonging to the Highlands and Islands Post Office sped past, followed by a stalker's Land Rover and a MacBraynes service vehicle, but no-one stopped. The wind was severely strong, and I was stuck with no passing traffic on a single track road to nowhere. Uist is an exposed, treeless tussock landscape of wind-swept coarse pasture and extensive west coast dunes.

In the summer months skylarks sing continuously here, and lapwings dive around along the roadside roughs, but in the bitter wind of this autumn day gusts of rain swept across the wet russet grasses making it a wretched day to be out walking.

Up ahead a man was leaning on a gate by the road. He watched me steadily as I approached. 'You looking for a lift?' he enquired. 'Yep, I'm trying to make it up to Lochmaddy today, need to catch a ferry north,' I replied. 'OK, follow me,' he said. This was curious, since there was no sign of a vehicle anywhere, nor in any direction across the open moor. We walked around the back of a low hill where a helicopter was parked! 'Push your rucksack into that locker and jump on board,' he shouted through the din and clatter of the starting process. Oh my goodness, we were airborne and heading north.

The pilot explained he was air-lifting telegraph poles up a local prominence, but had abandoned it because of the gale, and was heading back to base at PLM helicopters in Inverness. 'Would I like to travel back east?' he enquired. 'No thanks, I'm trying to make it to St Kilda on the Navy mailboat.' 'OK, I'm refuelling in Benbecula, I'll drop you there.'

In the crowded café at Benbecula airstrip, I related my crazy story with a gentleman at the table. He was

a journalist heading back to London, and he told me there were only three great stories left in the Hebrides; one of them was about how ten chosen men from the northern villages of Lewis sail out to a remote Atlantic rock every summer to harvest seabirds, a centuries old ritual still intact, the last subsistence bird harvest in the northern hemisphere. I was spellbound, but realised that such dramatic activity was entirely secretive and inaccessible to the world outside the Hebridean Islands.

A couple of years went by, but I returned to the Outer Isles one May and found my way to the distant and mountainous islands of the St Kilda group, eighty kilometres west of the Sound of Harris. For two hundred years a community had survived here, mostly by occasional support from the mainland, but also on a day-to-day basis by farming with sheep and cows, and also eating the dried flesh of the fulmar petrel and by using its valuable fatty oil. An island favourite was porridge with a puffin boiled in the oats. Birds' eggs of all kinds supplemented this ocean island diet, along with simple root crops of potatoes and barley. When St Kilda was abandoned in 1930, the birds were left in peace.

During the days on St Kilda we forced a landing on the vertiginous island of Dun, the outer westerly arm of Village Bay. By rowing a light rubber dinghy

alongside the cliffs, we managed to grab a short-knotted rope and hold firm against the huge swell, each of us jumping on to a slimy sea-washed slab. The sunshine cleared the mist and salty haze as we clambered up thick mounds of sea pinks beneath which ten thousand puffins lay in earth burrows incubating eggs.

This epic landscape of plunging gabbro cliffs, was carved by deep echoing zawns where the black-serpentine sea boomed below us. The clamour of gulls and auks and the catch of guarno in the sea air created an ecstatic atmosphere reminiscent of every remote island I have ever visited. Later that day high on Conachair, the island's highest peak, an Atlantic fog spread out in a heavenly carpet as far as we could see towards Scotland and Iceland, and, who knows, America too. The great sea pinnacles of Stac Lee and Stac an Armin, although dwarfed by the bulk of Boraray, appeared through the fog like Saturn 5 rockets on the launch pad. These were the locations where vast colonies of gannets and fulmars competed for nest sites, and where the St Kildans had collected most of their quarry. >>

On the morning we returned from St Kilda, I was standing on the jetty in Village Bay with the skipper of our boat, knowing he was a Lewis man himself. Because our conversations had been about collecting seabirds, I remembered the story that I'd been told some years before in Benbecula and ventured to ask the skipper if he might shed some more light on it. With a curious furrowed glance he turned to me and said, 'I know these men!' During the crossing back to Oban we were sailing into shelter on Canna. I entered the wheelhouse for a quiet chat about the Men of Ness, as they had been called. He reiterated their reasons for secrecy and explained that pressure groups had recently disturbed the privacy of their harvesting. I now took a chance and asked him, since he knew the men, would he deliver a letter to them containing my request to join them for the duration of their activities and to photograph the entire adventure.

Two weeks later I answered a late night call. The voice was intoned in rich Gaelic; 'Mr Beatty, we wish to meet you.' It was John 'Dods' Macfarlane, the chief representative of the Ness community involved in harvesting. I was invited to go to Lewis to have discussions with the mysterious Nessmen. A door was opening into the strangest adventure of my life.

The six communities at the Butt of Lewis are some of the most remote in all the British Isles. Crossing the island from Stornoway to Ness there is a harsh bleakness, a land ravaged by ice, wind and rain. The constant gales prevent trees growing in this desolation of peat hags and small pools. The Sabbath is still sacred and Gaelic remains the first language amongst the tight-knit villages and crofts that dot the landscape. I drove to the old Stephenson lighthouse at the Butt and gazed far out to sea. Waves blasted the rocks below, a storm was brewing and we were to sail on the midnight tide bound for Sula Sgeir.

I was awoken by silence and a heaving swell: below me I could hear the bilge water glooping rhythmically. An anchor chain rushed and rattled from a locker. For a moment I was unable to move in the cramped berth into which I'd wedged myself for the previous, terrible six hours. The seawater no longer poured down the central hatch, the discarded oilskins had gone and the thudding diesel engine had ceased. The night passage from Port of Ness, some seventy kilometres, had stunned me with the violent gale that stormed around us out at sea. Giant seas on a south-westerly beam rolled and pitched us across one of the most notorious approaches in the Atlantic. Out here, buried in the arms of the sea, is a bleached and naked whalebone of rock rising in a spine

of sheer cliffs; a forgotten and ancient citadel of seabirds – Sula Sgeir, the Gannet Rock.

I struggled past the wheelhouse out on to the slippery deck of the old trawler. Through the gloomy half-light cliffs reared around us in the relative calm of Geodha a Phuill Bhain, respite from the surging tide where a cave arch divides the rock. It was four in the morning. I heard voices from the bow; work had begun.

The first documented evidence of seabird harvesting on Sula Sgeir was by Hugh Munro in 1540. Munro claimed the practise had been in existence for two centuries, when Lewismen were still subjects to the kings of Norway. Up until the mid sixteenth century, it is believed that the principal quarry was the eider duck for its downy feathers, but this species has all but disappeared from the Rock. As the North Atlantic populations of gannets increased at the turn of the nineteenth century, so the trend of harvesting changed. Massive colonies on St Kilda, Sule Stack and Sula Sgeir were being raided for food and feathers. Rowing in open boats made of tar planking was the only means of travel to these isolated skerries. Today, only the gathering on Sula Sgeir survives, in the middle months when '…*the barley is golden, before the heather blooms.*'

The Wildlife and Countryside Act of 1981 contains a dispensation for the harvest to be licensed for the killing of 2,000 young gannets or *gugas* annually. Ten men reaching back through the twilight of their forefathers, with centuries of sea adventures to be retold around the fires in the homes of the Lewisian islanders.

An aluminium punt was lowered overboard and a small landing party, myself included, motored up the neck of the creek. A heavy surge was swelling over the kelp and purple algaes against the cliff. We tied up to an old iron ring set in the rock. In the days before this makefast, supplies were cast into the sea to be towed ashore on ropes. Sacks of peats were manhandled from the boat and cached on dry ledges at the foot of the cliffs.[1] More supplies arrived all morning – peat to fuel the fires, drinking water in metal barrels, mattresses, tarpaulins, food boxes, tools, a car battery for the radio link and forty sacks of curing salt. Finally, a tiny rubber dinghy was dragged ashore and lifted twenty metres above the tide. The trawler pulled anchor and, with a wave from the stern, made its way beyond the streamers of sea foam that ringed the creek, and disappeared from view into the open sea. We were effectively marooned for two weeks on a bare ocean rock. **>>**

(1) Sula Sgeir is merely 300 metres long and encircled entirely by 100-metre high cliffs. The top of the rock, a narrow twisted jumble of bare rock and salt resistant vegetation like sea cabbage and cushions of campion, is a mere 100 metres across. In winter, storms thrash this wild place with mountainous seas crashing over its summit.

We sat quiet and reflective as the warm rain streamed down the rock. There were arduous hours ahead as all supplies had to be hauled up the hundred metre high cliffs to be assembled on the summit rocks. Calum, the lighthouse keeper and also the cook for this harvest, set a kettle on a bed of peats. We drank tea together and contemplated our task ahead. The ten men were from all walks of island life: joiners, fishermen, weavers and engineers, their fathers had been here before them, each for thirty years. I had become involved in an historic thread of culture and friendship – the first *Sassenach* to witness and photograph this extraordinary event.

Atop the rock were three ancient stone bothies at least two centuries old. One was an old chapel called An Bearnnaich, the others, monastic cells for those souls entering privations. We cleaned out the mud and bird nest debris, threw tarpaulins across them and lifted in a brazier of glowing peats to dry them out. One would be our mess, the other a sleeping billet. One night of mounting wind and rain, I heard a pit-pat… pit-pat… pitter-patter inside the blackness of the bothy onto the stone slab on which I slept. In the head torch beam I found it was not rain falling on me, but thousands of earwigs falling from the stonework above. I switched off the beam and drew my head inside the sleeping bag.

Next morning the rain continued and we sat dismayed around the breakfast fire. Nobody moved, many mugs of tea had been drunk, the heat from the peats was enervating. We sat shoulder to shoulder wondering if the rain would ever cease. For two days the rock had been still, misty and very wet. All the thin soil was now slippery mud, the lichenous rocks and boulders were dangerous to walk on. Only the crackle and spit of the leaking roof could be heard in our meagre home. One of the Nessmen, Murdo Campbell, arranged his glasses, crawled forward on his stone bench, allowing a shaft of dim light from the roof hole to cast on the pages of his tiny taped Gaelic bible. Each day we waited, and each day after every communal meal he read Psalms out loud in soft and fluid tones. Not strident, but wistful incantations from an ancient language. I grew to love the melody of the native tongue.

Through the rain outside, we listened to the cries of wheeling gannets and, with heads bowed, followed their shadows on the earth floor round the fire. 'What to do, what to do,' muttered Dods, breaking the spell, deciding on impulse and out loud that not a moment must be lost. 'We catch the *guga!*' Nobody spoke, we just struggled for the entrance tunnel and stepped out into the incessant rain. Lashed up in tattered oilskins we walked in single file carrying sticks and knives

toward the highest and most dense gannet colony of all.

Into the sheeting rain rose a thousand gannets like arrows of the Greeks. The killing was swift, efficient and humane. At the end of the sweep the tally was counted and noted carefully. Through the brightening mist Calum appeared in luminous yellow waterproofs carrying a black kettle of hot tea and a tomato box suspended on four corner strings containing mugs. We chatted and drank tea with cake. The birds were loaded into sacks, carried across the rocks to a high cairn where the plucking would take place.

Brunhilde's cairn was purportedly the memorial of a recalcitrant Norse princess who was once exiled alone here, and who was found dead with a cormorant's nest on her breast. In respect, the Nessmen adorn the cairn each year with the wings of the first killed bird. We walked wearily back to our bothies and met together again for a meal. That evening a curious incident occurred. During the meal a tiny black fledgling storm petrel with obsidian eyes fell from the stone walls onto the earth floor by the hot brazier. The men were immediately anxious for its life; they carefully lifted it up, cradled it in those killing hands, and posted it back to its nest hole where its parents could find it. It was nearly midnight, I walked back to my beehive dwelling with the sound of the swelling tide as constellations of stars appeared overhead in the night chill around me.

Throughout the days on Sula Sgeir I had come to know the Nessmen and their ways. They explained each process with the birds. There was always plucking to be done, then singeing in the flames of a hot foundry exposed in the west winds. And finally the salting phase where the carcasses were arranged in a huge circle of meat whose weight would weigh down and form the essential pickles for preservation over the period. Working and eating together for fourteen days, taking part in each process and learning the legends and rituals of the men from Ness over the centuries as they honoured the memories of their forefathers, was a strange and enriching experience of life for me. They often talked about the bounty of the sea, as if it were their garden. Let it be that the seas remain rich, and their harvest long. >>

After fifteen days marooned on Sula Sgeir a boat returned to deliver us to the mainland. With our hold full with harvest we pulled up the anchor and turned out in to the heaving ocean. Every eye on deck strained upon the Gannet Rock until she was swallowed by the waves. Sunlight danced up on the wavecrests and the grey bulk of Sula Sgeir smoked with ten thousand gannets pouring from its crest like a flurry of snow. Ahead of us the sky was lowering. The island had dropped beneath the horizon and had gone from view.

In eight hours we would be against a harbour wall delivering the *gugas* to the community awaiting our return. Only the thrashing sea remained and the livid light on the darkening water. Petrels glided effortlessy through the troughs as curtains of rain swept the sea, a languid rainbow struggled for life. Most of the Nessmen went below to rest, some of them waited on deck to watch the sea and to release Sula Sgeir gently astern for another year.

PLATE 114

PLATE 114

The seabird hunters of Lewis climb down into the treacherous cliffs of Sula Sgeir, a lone Atlantic skerry. Their annual harvest is for the *guga*, the immature stage of the Northern Gannet seabird *Morus bassanus*. Outer Hebrides, Scotland.

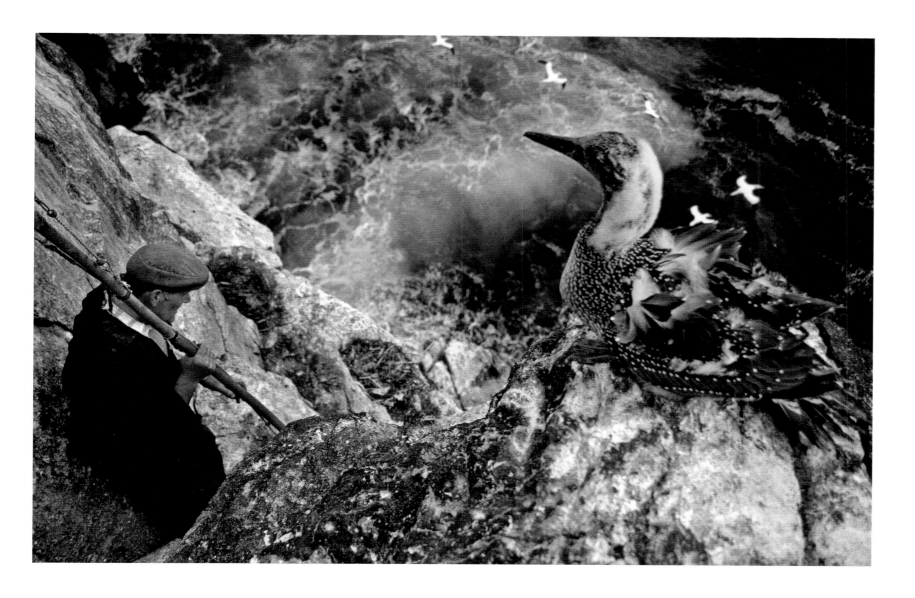

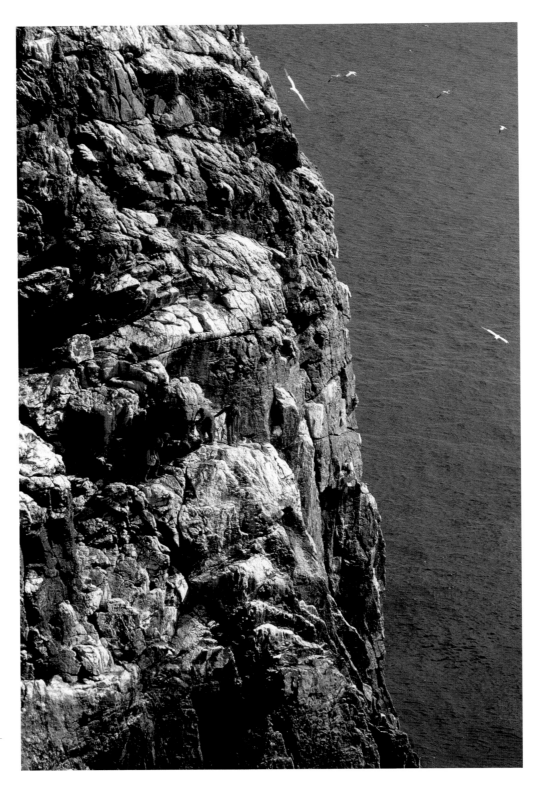

PLATE 115

The Nessmen at work harvesting seabirds from the
highest cliffs of Sula Sgeir, in the northwest approaches
of the Atlantic Ocean. Outer Hebrides, Scotland.

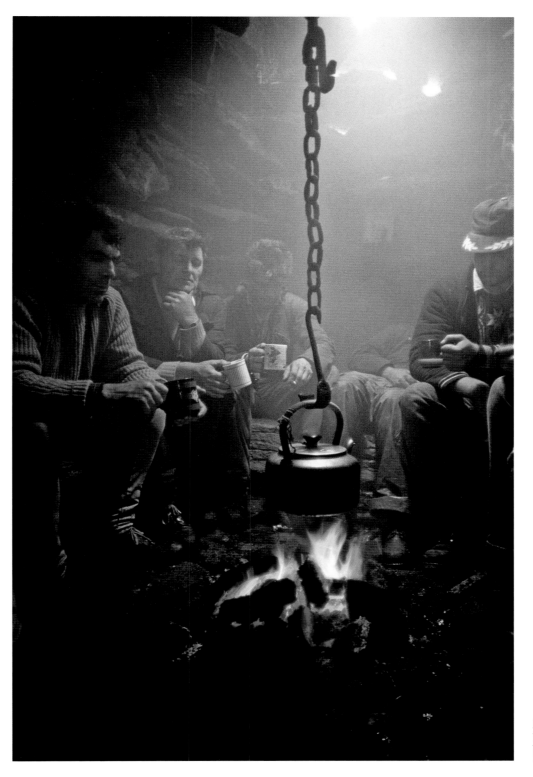

PLATE 116

The old slabhraidh, or kettle chain, hangs over the fire, as the Nessmen gather round for food, in the ancient stone beehive dwelling. Sula Sgeir, Outer Hebrides, Scotland.

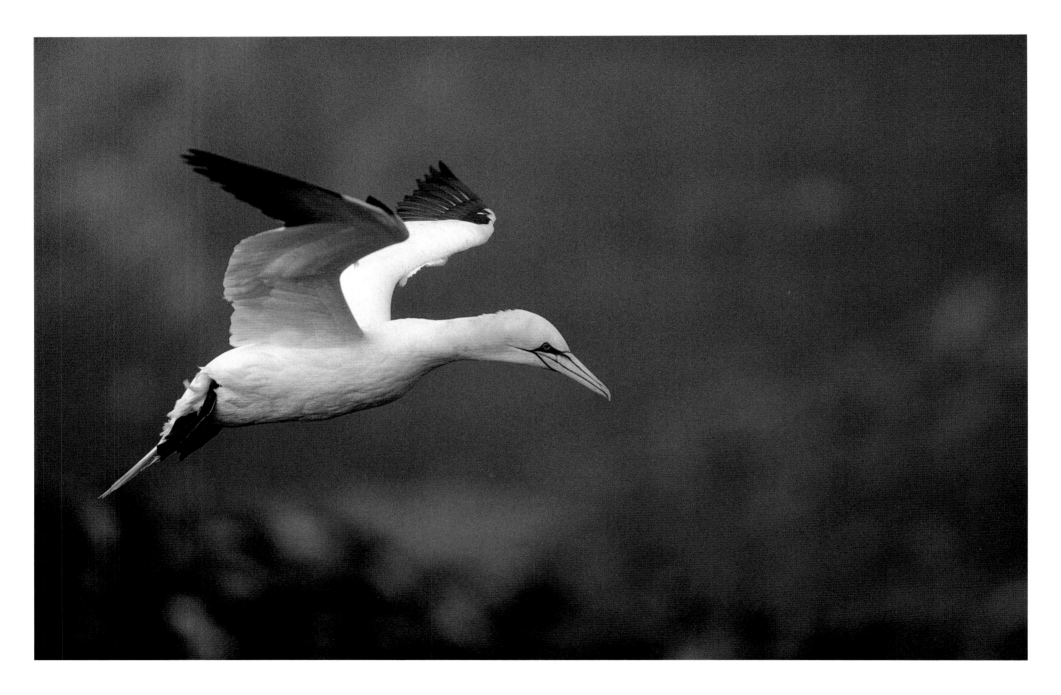

PLATE 117

The majestic Northern Gannet *Morus bassanus*. These birds migrate to the coast
of North Africa each year, returning to breed on remote islets and cliffs of
north and western Britain. Sula Sgeir, Outer Hebrides, Scotland.

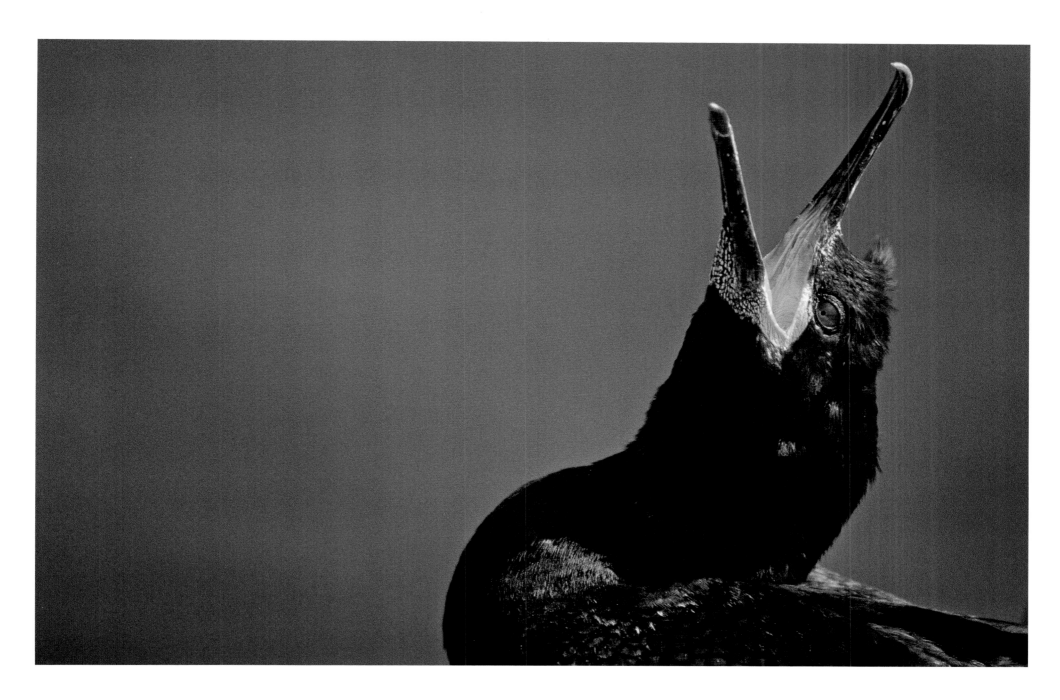

PLATE 118
The Common Shag *Phalacrocorax aristotelis* nests on rocky ledges on remote islands off the British coast. The shag is capable of diving for fish to a depth of 30m or more. Mangersta, Isle of Lewis, Scotland.

THE LORD AND KING OF THE ROACHES

Far away, across the other side of the county, lies a group of wind-sculptured rocks called The Roaches. This remnant of ancient beach gravels, eroded into a fairytale escarpment, has been a popular haunt of rock climbers, lovers and picnickers from the Potteries of Staffordshire for eight decades. Legends of strange animals abound here: a yak once lived on fallow ground in Goldsitch Moss, and wallabies escaped from a nearby private zoo and were sighted frequently for forty years before a sequence of hard winters finally wiped them out. Sir Philip Brocklehurst, the last survivor of Ernest Shackelton's epic survival in Antarctica 1908, is related to a local hostelry, the Ship Inn at Wincle.

The exquisite skyline extends for two kilometres above a dense wood of larch and Scots pine, with luxuriant understory of bilberry and heather matting together into huge springy cushions. Atop the edge, a strange moorland pond of feted water called the Doxy Pool gave rise to hauntings of Mary Queen of Scots and other apparitions of the day. The sheltered back of the escarpment falls away gently in to the wild reaches of Goldsitch Moss, which drains into the magical River Dane at Lud's Church, a wooded cleft

associated with the medieval literature of Chaucer whose Sir Gawain fought the Green Knight in this ancient rift. The Roaches hold a legion of myths and legends enshrined in its landscape, one of which has special interest to me.

Beneath the lower tier of cliffs is a strange dwelling known locally as Rock Hall. Its tiny arched gothic windows and door belie an inner secret. Within its old sandstone block walls is one internal arch cut through solid rock into a cave-like chamber hidden beneath giant boulders. The flagstone floor and stepped back wall give it the appearance of being of religious significance, although there is little evidence. This was once the home of a man named Doug Moller who, with his wife Annie, lived a troglodyte existence here, without furniture or services, upon its earth floor and before its lowly hearth.[2] Indeed, one missing window pane was replaced by a rucksack brand catalogue poster, which, when backlit by sunlight, reflected as if it were stained glass.

(2) Dougie famously objected to rock climbers who frequently showered his home with stones from the cliffs, until one day he threatened them with his felling axe.

One winters day, when deep snow cut off all access to his home, I dragged a large sack of coal and a box of groceries over the snows to greet Dougie with provisions (under the watchful binoculars of Peak Park Rangers nearby). I was invited inside, sat down on crates, and warmed myself by the open fire. Annie made tea with digestive biscuits and served polo mints for dessert. This same ritual repeated itself for all visits during the next five years. Many a day I sat with Dougie on his garden terrace and fed the feral wallabies, talked to the blackbirds and listened to epic tales from his early life that brought him eventually to this tiny house-cave beneath the rocks. Annie loved the fire, and often wrote poetry which was posted on signboards in the garden for all passers-by to view.

The Roaches Estate owners, the Peak Park Joint Planning Board, began to object to the lifestyle of the Mollers, citing their insistence against the felling of local Scots pine for the fire, and indeed to their subsistence living in the bowels of Rock Hall. By now even Dougie was writing lengthy pleas to government officers, Royalty and the National Park Authority explaining his plight, and requesting help, suggesting that he could perform a warden-type role for visitors to the rocks. Most of this fell on deaf ears. Something had to be done.

With the help of friends, Alistair Macdonald, an environment journalist and film-maker with the BBC, nature writer Jim Perrin and the visionary Director of the Peak Park Joint Planning Board, Michael Dower, we hatched a plan. We proposed that the British Mountaineering Council considered using a memorial fund for the then recently deceased climber Don Whillans – who had made many famous first ascents at The Roaches – to jointly purchase Rock Hall, refurbish it into a hostel-style bunkhouse for climbers and walkers and, in doing so, re-house Dougie and Annie into a safe haven moorland cottage on nearby Axe Edge. >>

After protracted discussion, a compassionate agreement was made that resulted in the day Dougie and Annie finally left Rock Hall behind and moved into their new home near Flash Bar. This was also the end of an era for historic tenancies in this amazing dwelling. Rock Hall is now a climbers hostel, renamed the Don Whillans Memorial Hut, and has been accommodating groups of visitors for many years. The cave section is now the kitchen, and running water and bottled gas have been introduced.

Dougie and Annie lived for several years together in their new-found rented cottage on Axe Edge until a spark from their familiar fire ignited Annie's clothes. After three days fighting the severe burn injuries sustained, she passed away peacefully. At her funeral in the village of Flash, in freezing winter fog, on a day when the morning sun finally broke through onto the gathered friends, we sang a hymn heartily, *'Rock of Ages, cleft for me, Let me hide myself in Thee.'* An irony to an era ended, Doug retired to survive alone in his cottage. To this date, he continues to live at peace with the surrounding nature, within sound of the curlew and the tumbling river Dane.

PLATE 119

The last ever resident, Doug Moller, at home in the cave-like dwelling of
Rock Hall Cottage, The Roaches, Staffordshire Moorlands.

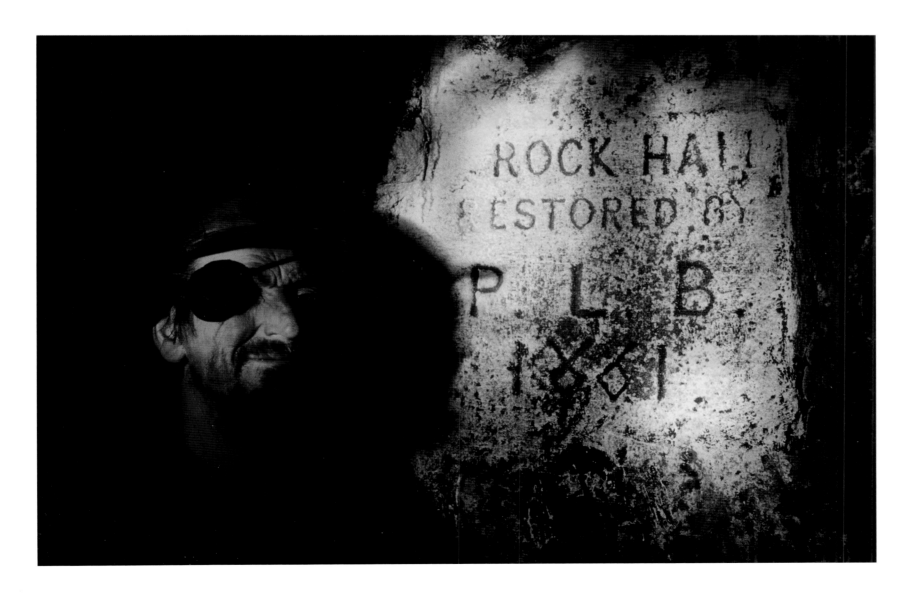

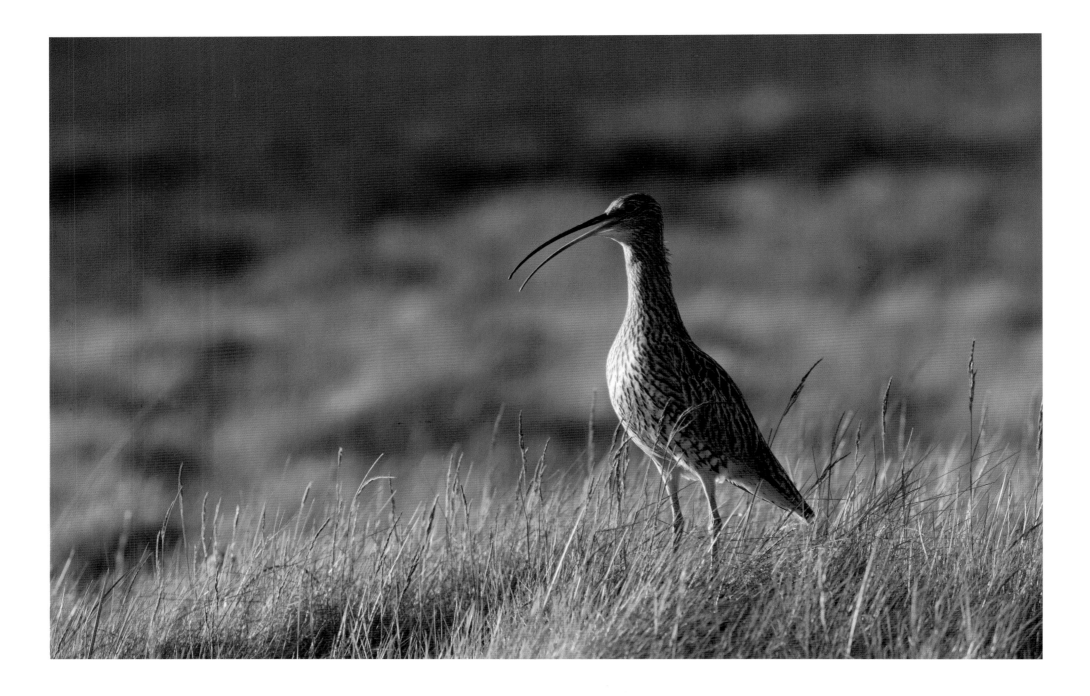

PLATE 120
Curlew *Numenius arquata*, arrives to breed on the moorland of the Pennine
Hills in early April. Its plaintive call is most evocative of wild places.

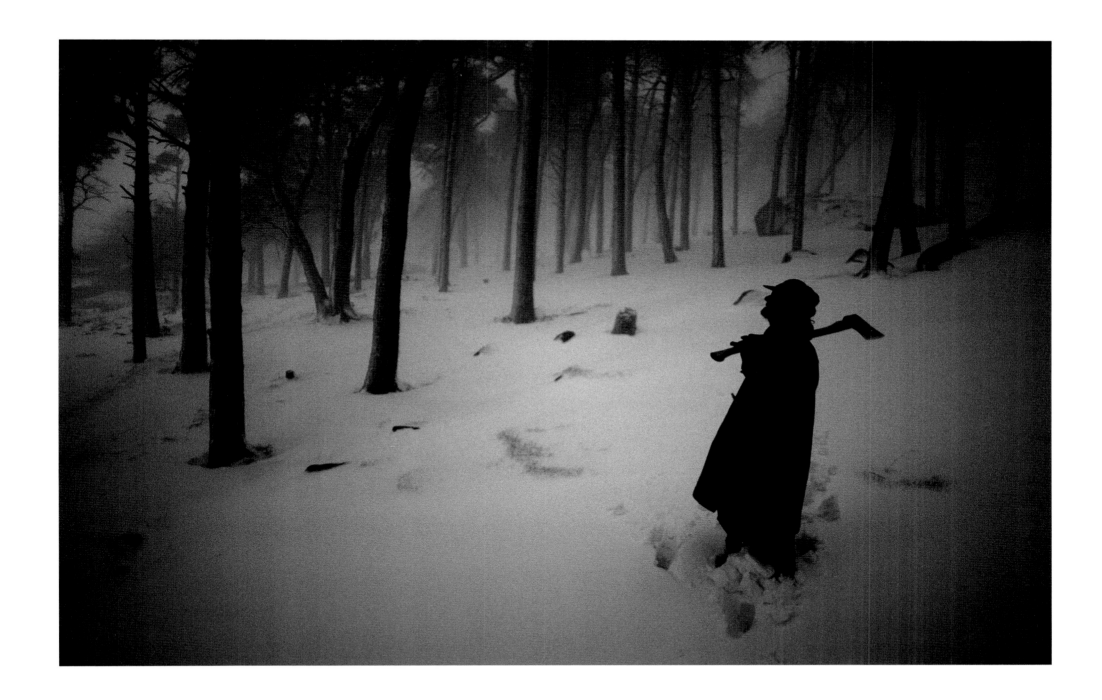

PLATE 121
Doug Moller, The Lord and King of the Roaches.

THE WILD MOOR

'...this howling Wilderness'
Daniel Defoe, 1726

For a bleak place, the moors of the Peak District are surprisingly alive. Perhaps it is in apparent starkness that one can truly know the life of a place. This is merlin country of sweet summer scent and of winter survival, a land where the slender curlew trills to the empty beauty of the wide sky and the simple curve and sweep of distant hills. Like a visual mantra, and voiced by spirits of the long gone by: Wildboarclough, Cloudberry Moss, Crowden and Adders Green – all sultry blanket bogs and home to thriving forms of moorland life – have borne witness to great geologic and climatic changes since their formation 60 million years ago, when the tropical Carboniferous forests were inundated by shallow seas and, in turn, sheets of crawling ice and torrential melt moulded the land into its present wind-eroded, rock-edged fastness.

Winter brings an arctic echo to this dark landscape, with temporary permafrost not unlike the tundra of the northlands. But soon, among the roughest sedge, marsh marigold, lady's smock and cotton grass fringe the peaty pools with delicate colours and swathes of bobbing heads. In any moorland stream, lined with hanging heather and flowering rowan, you will find the stoat and vole, or may be honoured by the strange presence of the ring ouzel. On any day of the year there is space up here; space to reflect, time to listen to other voices, and to have a conversation with the land.

Midwinter often brings a northeastly wind across the bare tussock of Howden Moor, which may remain for several days. Snow flurries, ghostly veils in a charcoal sky, dust the wild moor with a brief magic before the weather turns to the warmer west. During these small episodes, the wren lies low in the alder root, the stormcock clasps strongly to the berried thorn. These things happen in common weather.

But there seems to have been changes recently with extreme cold snaps settling over the country, preceded by continuous heavy snowfall up to a metre deep over the moors. This weather event inundates the moorland with extensive snowfields unusual at all in Britain, and continues for weeks. The biting wind shapes the drifting snow into huge dunes, bare birch twigs become fringed with hoar frost bending the branches over in fabulous chandeliers. Out on the high moors the snow cover can become entire, burying all vegetation, encasing it below an icy crust. It is in this natural refuge from the arctic blast that one of Britain's most enigmatic animals shelters from the cold winds and freezing rains that sweep over. The mountain

or blue hare survives in small relict populations on these northern moorlands. Through the winter months the hares, in white pelage, live along the rocky heather fringes of the moor feeding on coarse grasses. To be surprised by their dashing beauty is one of the pearls of a moorland experience.

On a cold February afternoon one recent winter I ventured out to a distant, trackless part of the moor on the northern flank of the Abbey Brook. The winds of the past week had stilled to a calm. It was deeply cold as I strode awkwardly through the knee-deep, crusted surface, floundering at times with the urgency and alertness of expectation. To observe the hares closely, I had to remain concealed in a watercourse that would lead me into the heart of the snowfields where up to a dozen individuals were grazing. There are moments when one must actually lie flat in the snow and remain motionless for periods. At these times the hares will relax and tolerate other presences.

Before me now were six hares scampering across the corniced snow banks. Some seemed intent on feeding from the thin protruding grass stems, others gambolled around with each other as if rapt in the excitement of courtship. The westering sun descended over the distant edges of Ashop Head and Mill Hill, suffusing the snow with a soft roseate hue. One by one the hares momentarily sat upright as if aware of the sun's finale and then disappeared from view in to the secrecy of snow scrapes for the night. I was in for a cold and dark descent. >>

The full moon was not going to rise for an hour, so I lingered after sunset until a silvery brown glow appeared in the easterly sky. Striding quickly I descended from the open moor to a five-bar gate, half buried in drift, beyond which sycamore woodland dropped away into the valley. Several days of snowfall had built up a great depth amongst the trees and in the severe cold its texture had become a light powder. In the windless wood the moon sailed into the sky casting a mighty light through the trees. The canopy of tangled branches mimicked on the snow as perfect shadows, like roots of the very trees. I waded downwards through the tangle of shadows…

Shadows and light, shadows and light,
form become shadow,
flowing deep through snow,
downwards, through tangles of light.

In moments like these I imagine to have left this world, captured by some natural process, when a new perception takes physical form leading me to deepest joy, which is home. I wanted to remain in this place forever, but stumbled against a tree that was not a shadow, and was jolted from my reverie. Night owls calling across the silvered ice lake below guided my way back into the world.

PLATE 122
Pikenaze Moor on the Derwent Edges of the Derbyshire Moors.

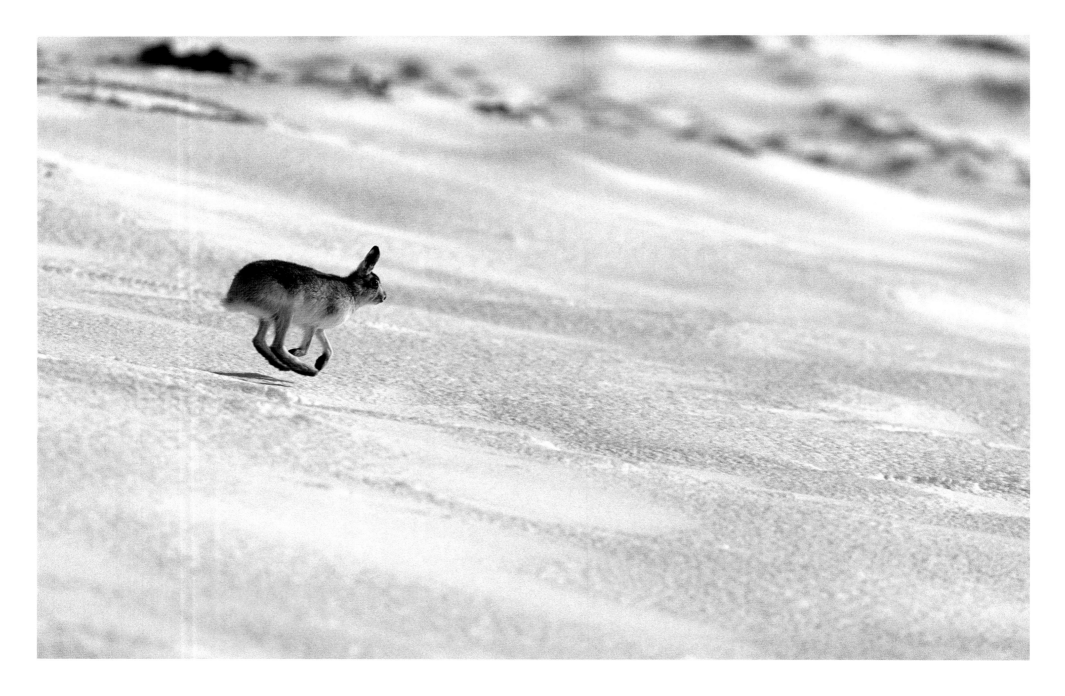

PLATE 123

Mountain or Blue Hare *Lepus timidus*, survive in isolated moorland, close to tussock and woodland margins. The coat of the hare changes colour throughout the year according to the length of daylight. Bleaklow, Pennine Hills.

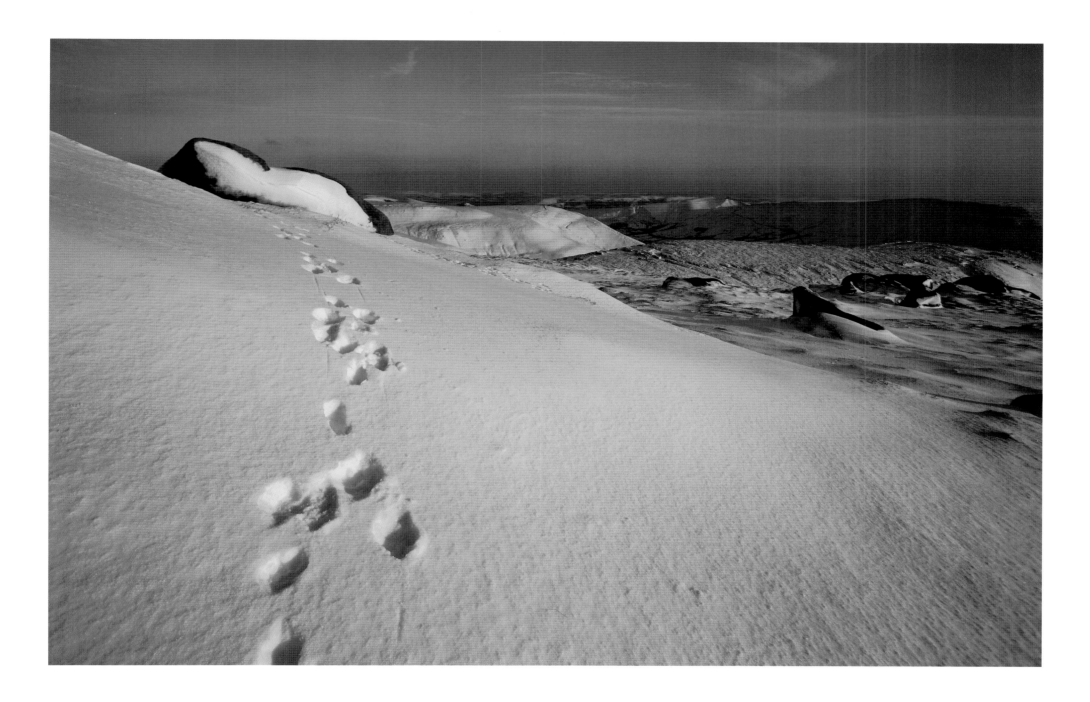

PLATE 124

Hare tracks of *Lepus timidus* at The Woolpacks, a cluster of high gritstone boulders on the Kinder Scout escarpment above Edale, Pennine Hills.

PLATE 125

The western escarpment of Kinder Scout rises to 636m. In severe winter months the landscape adopts a frozen tundra-like appearance.

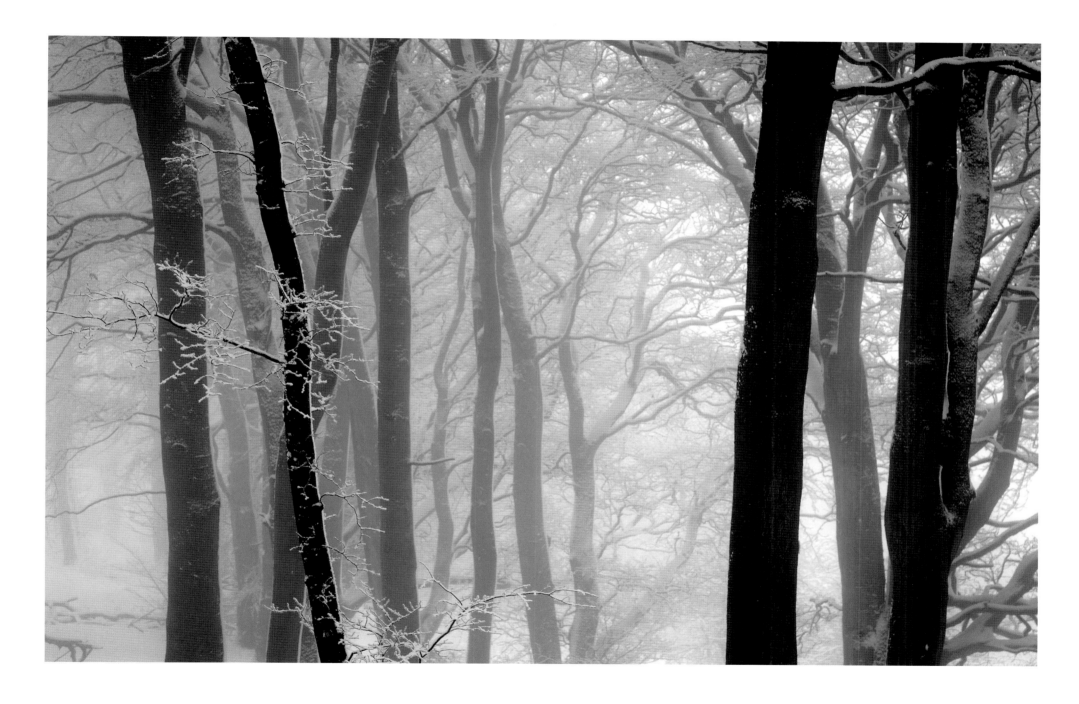

PLATE 126

Winter comes to the Beech Woods *Fagus sylvatica* at Grinlow,
Great Hucklow, Pennine Hills.

NOTES ON PHOTOGRAPHY

*'One should photograph objects, not only for what they
are, but for what else they are.'*

Minor White, 1908–1976

**My father always made a good job of recording family
holidays, and as children we always had stacks of black
and white prints to enjoy afterwards. He used a
simple Box Brownie, and I recall the reflex mirror
where we viewed the image from above and the wrong
way round, and of course the red window on the
camera back that showed you how much film you'd
pulled through.**

The first camera I owned I found in a charity shop
– a Kodak Retinette priced two and sixpence (12p).
Today, I have embraced the digital world and experience
the luxury of total technical control. So, what is
photography today? For me it is all about framing,
what is inside that rectangular viewfinder, seeing with
the heart as well as the eye.

My love of nature and my love of photography go
hand in hand. Through them I connect with the world,
its people, and the elemental forces of life. As a moun-
taineer it is the drama of landscape and wild weather
that attracts me most. Photographs can reveal unexpected
and mysterious meanings where suggestion and metaphor
play a part.

Throughout my life in photography I have placed
less emphasis on the technical equipment (which makes
great photography increasingly easier) but instead
concentrated on what I regard as the emotion within a
scene. That in itself drives my motivation to sharpen the
technical skills. I've learned to be patient and how to
concentrate on small details and events over long periods
of time, and to be mindful of timing in the natural world.

Without light we have no colour and without light
there would be no photography. The derivation of the
word photography in Greek, is 'writing with light!'
Despite our basic understanding of light, like the rising
and setting of the sun, we cannot take it for granted
and we need to learn its many nuances. Light creates
colours that change moods. Light models form, which
is crucial for seeing shapes and three-dimensional space.

Bright sunny days are not the best for photography.
The sun is an advantage but the time of day is critical.
At dawn and dusk the low sun projects warmer col-
oured light and creates longer shadows that define our
scene both more strongly and with a wider variety of
mood and atmosphere. The natural world has edges,
margins, like the ocean and the land, the mountain
and the forest line, the mountain summit and the sky.
Near the end of the day transmitted light becomes ever
warmer, reflected light ever colder. It is at this visual

edge of light that I prefer to take photographs: a geographical edge converging with a visual edge of light.

Landscapes are not objects to be photographed, but the quality of light falling on them. Remarkable light might achieve a remarkable photograph, without which it will most likely remain lifeless.

Photographing people or animals in a landscape is nothing new, though some commentators suggest it is 'impure' to introduce figures into a natural scene. I disagree. In fact sometimes it enhances and clarifies an image by describing a possible relationship between the figure and the environment. In my photography this is a recurring theme, a mechanism I use frequently to express size, proximity, drama, colour, special-ness. To capture a moment when something living is in fine balance with natural forces around it is very satisfying. Perhaps the most valuable aspect of this technique is to challenge the viewer of their visual assumptions of a place, to take an expected piece of information, a landscape or a texture, and give it an entirely new meaning.

One of the most important keys to photographing patterns in nature is to imagine that these small details manifest the whole, as part of the bigger picture. For example, the peeling paper bark of the birch trunk can evoke the entire birch woodland in autumn. The black and white scarring on the bark creating concentric rings up the trunk may cause us to think, not of contrasting colours, but of time. Perhaps a symbol of one's inner journey rather than outward response. Small details help us envisage a wider and more complex landscape. A mountain stream flowing through a chasm, wind eroded rocks and cloud shadows chasing across a hillside can make us think of how landscape was formed by air and water and elemental forces. Patterns of the earth emerging all around us have within them the quality of storytelling.

Nature has a great variety of organic shape and motion within it, which is always visible but often little understood. It is possible to use these natural patterns to make more dynamic photographs. In everyday life we live with assumptions about what we see. Sometimes we can turn these recognisable objects into new objects for perception using our tools – lens choice, colour, point of view and composition – to make abstract or symbolic images. Pre-cognition of such things is unlikely, while exploration through a chosen lens can lead one on an amazing journey of visual discovery.

For me, this is part of my process of learning to see, where clarity is not to do with technical observance but more in understanding the role of abstraction, metaphor and relationships between patterns and designs. Understanding flow, change and growth in the natural world is best expressed through composition, lens choice and focusing, a practical pathway to achieving a more precise visual description. Many intriguing images contain uncertain meanings that can stimulate one's imagination in a rewarding way.

Knowing that I have used top class Canon cameras and lenses for all but the beginnings of my interest in photography 36 years ago is not important. And as for exposure data, each transparency and digital file was adequately exposed. The important thing is to consider the content. When walking through a landscape with my camera I see form, shape, line, and texture revealed by light and colour. Shape juxtaposed with shape becomes a composition, a found composition. The photographer has to merely recognise the composition and capture it. In this incredible world of light, for me it is all a sculpture, and each earth gesture is a work of art.

The more I experience the patterns, process and illusion of life all around me, the more my photographs hopefully express multiple meanings and emotion about the beauty of the earth.

ACKNOWLEDGEMENTS

My life and my work have always included many friends and colleagues who have helped and encouraged me along the way. It is to them I give heartfelt thanks. To John T. H. Allen for introducing me to a mountain life. John Cleare for generous advice in the early days. Jean Courtenay for saying '…just do it'. Stanley Baron at Thames and Hudson for publishing me in 1987. The late Jerry Derbyshire who showed me the magic of the earth. Rob Beighton and Barry Thomas who were on the same journey but changed trains. Ben Osbourne and Simon Fraser who stayed on the train and paid the fare. The late Alfred Gregory for his generosity and inspiration. To Jim Perrin in the watch-tower. And all thanks for friendship and good counsel from; Alistair Macdonald, Greg Smith, Sean Wood, Ed Douglas, Maud Tiso, Mike Sharp, John 'Dods' Macfarlane, Andy Towne, Jon Olafur Magnusson, Brendan Quayle, Mike Cudahy who taught me the meaning of running, Niel Fox, Kate Wood, Mike Ebert, Bill Wilkins, Ken Wilson, Phil Rothwell, and Rob Macfarlane. Thank you to Jon Barton at Vertebrate Graphics for believing in this project and to my editor John Coefield who has helped me believe in it too. If I have missed anyone, sincere apologies and thanks.

A special word to my family; Jan, Robin and Jodie Beatty. Thank you for sharing this crazy life, and making the music that keeps our spirits high.